Cosmic Underground:

A Grimoire of Black Speculative Discontent

is a fictional work. All characters, places and incidents either are the product of the author's imagination or are used fictitiously. Any resemblance to actual persons, living or dead, events, or locales is entirely coincidental.

Library of Congress Control Number: 2017953026

ISBN 13: 978-1-941958-78-0/eBook ISBN 978-1-941958-79-7

1. LITERARY COLLECTIONS / American / African American| 2. ART / American / African American| 3. COMICS & GRAPHIC NOVELS / Literary

For more information, contact *queries@cedargrovebooks.com*

www.cedargrovebooks.com

CONTENTS

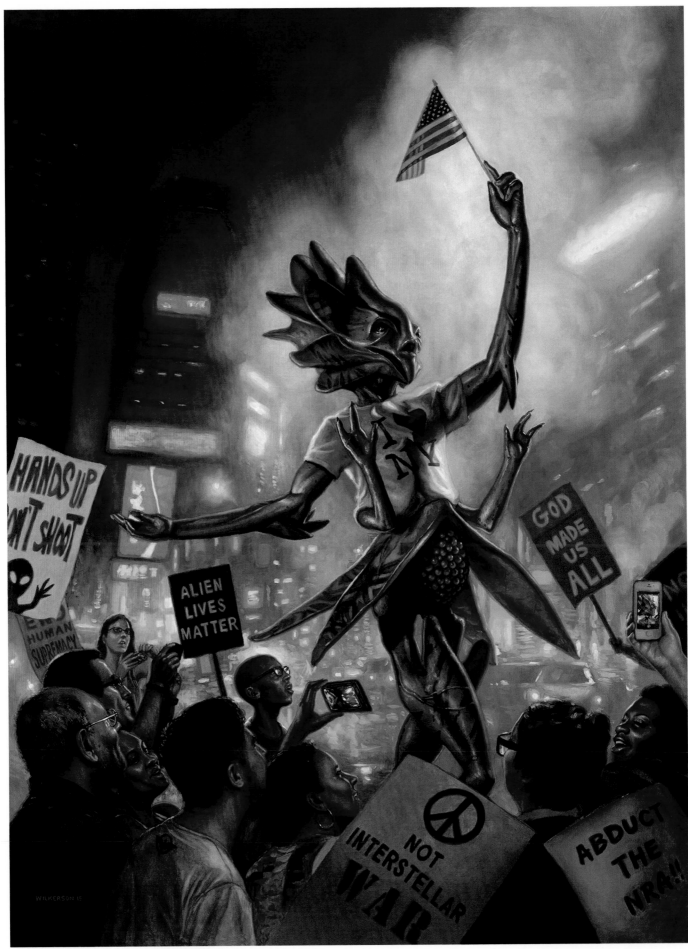

ERIC WILKERSON // ALIEN LIVES MATTER

FINDING THE PLACE

Reynaldo Anderson

On Tuesday, September 6, 2011 at 11:47:52 local time I sent John Jennings an email with the subject line: **John...how about Paris next summer?** I had reconnected with my Jackson State University classmate around a set of ideas that connected sequential art and Afrofuturism. I recently completed scholarship on the Black Panther Party and wanted to revisit the conceptual development of Afrofuturism I noted as a doctoral student in the 90s but deferred in interest of other activities. John was, and is a comic scholar and visual artist. We reconnected over social media, and after I noticed a call for papers for a cultural studies conference hosted by Sorbonne Nouvelle University and UNESCO in Paris, France, I suggested to John we make a submission. We presented our work around concepts John developed with his work on the comic artist Jack Kirby, and I presented work on Critical Afrofuturism and Sequential Art.

During our discussion I proposed if we were able to successfully present the material in Paris it would go over well in the United States. We started to develop ideas aorund what historically has been known as black speculative thought (BST) but is currently referred to as Afrofuturism. The rationale for the presentation locale was the Europeans had previously informed Americans that Jazz was dope as hell and a great art form, ergo, they would inform their North American skin-folk that *Afrofuturism was the new Jazz.* Moreover, during this time, the perceived political limitations of Barack Obama, the rise of the American Tea Party, the Alt-Right, the NATO invasion of Africa and subsequent overthrow of Gaddafi, contributed to the matrix of discussions we had surrounding the belief that Black folks needed a new planetary vision to move into the future. These discussions ultimately led to the development of the *Unveiling Visions: The Alchemy of The Black Imagination* project that was showcased at the Schomburg Library in New York City in the fall of 2015.

The goal of the project was to present the reservoir of Afrotopian desires and images deeply embedded in the Black imagination as a response to a contemporary dystopian social context. Furthermore, we wanted our people to see artistic representation of themselves in a non-elite setting such as a public library provoking thoughtful exchanges and discussion. This project would have been impossible to pull off without the work of Isissa Komada-John, Dierdre Holiman and the staff at the Schomburg. Moreover, the ideas contributed by people like Andrew Rollins, copyediting by Vida Samuel, printing by Jeff Sherven, art direction by Stacey Robinson, and the 87 talented artists who lent us their visions of their darkest dreams and most incredible fantasies.

The Unveiling Visions project produced the artists, intellectuals, and activists that gave birth to **the Black Speculative Arts Movement**. However, the art produced by that initial exhibition has now morphed into *Cosmic Underground: A Grimoire of Black Speculative Discontent*, where for the first time, the rest of the world has the opportunity to look upon a selection of the art and concepts through which thousands of people across the United States and other countries were able to catch a glimpse of regarding the **new** emerging renaissance that was birthed in Harlem.

NOTES ON UNVEILING VISIONS

Greg Tate

Sun Ra loved to wade through packed houses astound the world high and low and yoke patrons around the neck, demanding "Give me your Death! You don't need it! Give me your death!" Far as Ra was concerned Blackfolk needed to kick Death to the curb and embrace immortality like their ancient Astro Black ancestors had done in Nubia, Kush and Khmet. And thus was the Futurism of the Afros was born.

Thanks to social media, #BlackLives Matter and the vital uptick of online citizen reporting against police brutality we've spent the last few years hella focused on Black-bodycounts and the virulent plague of the Black death meme. Now more than ever our Movement's forward progression demands the invocation and reclamation of our graphic, sonic and narrative imaginations. The moment and The Movement demands that we go about extending our range of radical vision and exult in the regenerative powers of same. Because members definitely get weary if their daily media-imaging diet consists mostly of yellow tape, white chalk outlines and protest against the unending stream of unarmed martyrs being hurled at us by America's most delusional supremacists. Fortunately we have always known how to get some life and some vistas of brighter tomorrows up in the mix.

A people without visionaries is a people without an inspirational path to the future. The Astro-Black pantheon as we now know it is vast, inter-disciplinary, transnational, inter-sexual and trans-corporeal. As Sun Ra pointed out, the very re-ified idea of America has always depended on dependent on a host of fantastic myths and heroic symbols to sustain, enable and re-enforce the national dream state: The White House, the stars and stripes, the star spangled banner, the dollar bill, my country tis of thee, the Statue of Liberty, The Constitution and the Bill of Rights The Liberty Bell, George Washington's cherry tree, etc. The force of patriotism has raised these revered icons to near religious status. For as long as Black Americans have been freed from chattel bondage we've been free to claim those totems with ambivalence or reject them with vehemence. Inside a racialized purgatory flush with our doubly-conscious sense of rejection ---as perpetual outsiders and dehumanized pariah's--Blackfolk from the 1700s on have taken it upon ourselves to produce counter-narratives of the race's unfadeable glory in the USA. Hence we perennially pay tribute to the most militant avatars of Astro Blacknuss on the antebellum scene:The Masonic orders of Prince Hall and The Knights of Liberty;the fearless abolitionists David Walker, Nat Turner, Toussaint L'Overture, Frederick Douglass, Harriet Tubman and Sojourner Truth; to Marcus Garvey, WEB DuBois, Duke Ellington, to Langston and Zora, on through to The Black Arts Movement, John and Alice Coltrane, Amiri Baraka, Cecil Taylor, Ishmael Reed, Jayne Cortez, Jimi Hendrix, Miles Davis, Nina Simone, Chaka Khan,Toni Morrison, Ntozake Shange, to Samuel Delany, Steve Barnes, Octavia Butler and her highly literate brood--Tannarive Due, Andre 3000, Nnedi Okorafor, NK Jemisin, Erykah Badu, Wangechi Mutu, Janelle Monae.

The multiplicity of protean futurists archived in Unveiling Visions: The Alchemy of the Black Imagination couldn't be more timely in their supergrouped arrival. They represent a by-all-means-necessary recognition of the Movement's most passionate and prolific imagineers in popular, and populist and even one-percent patron supported art making. The exceptional degree to which to an Astro-Black continuum are represented here underscores a dream esthetic--one where Blackness is ferociously and unrepentantly depicted as intergalactically infinite, fungible, fluid, pluripotential, spectacular and ever-evolving.

A couple of examples are in order.

An image such as Krista Franklin's "Do Androids Dream of How People Are Sheep?' leads us into experiencing a snap-action flash forward/flashback motion--one which a vision of our high-tech future selves and older plantation-bound incarnations blur, merge, and bear witness with maroon sagacity on a cloud redolent of infrared plasma and cosmogrammatical lace. The Afrosurrealist paintings John Jude Paalencar composed for Octavia Butler's Patternist book covers compels us to contemplate the psychic labyrinths woven into that authors work.

Unveiling Visions revels in the complexities of a lush and sumptuously variegated Black Imaginary unshackled from ethnographic cliche and anthropological exoticism and driven to viscerally shoot for the stars while energizing dark spaces and Astro-Black dimensions known and unknown down here on the ground.

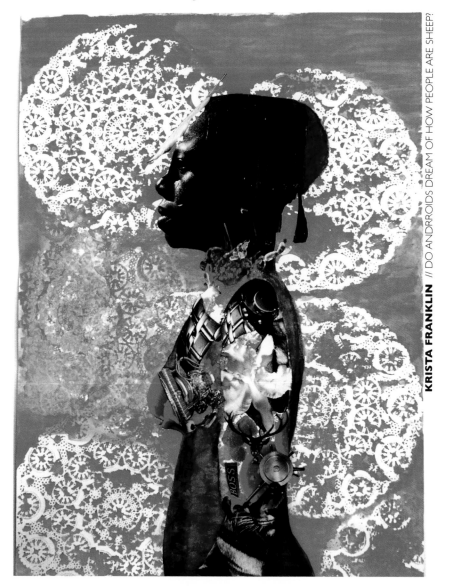

KRISTA FRANKLIN // DO ANDRROIDS DREAM OF HOW PEOPLE ARE SHEEP?

THE BLACK SPECULATIVE ART MANIFESTO (SPELL)

Linda D. Addison

"Birth waters of the future
Birth waters of the past
Calls 2 star dust in your bones
Calls 2 all the lives u own
& the ones u don't."

"Photons decoupling from the first epoch 2 Now
New macro/micro cosmic epoch make a vow
2 redshift from extreme reclamation
Red beaten from immortal imagination
Born from the Alchemy of The Black."

"De-radicalize this Earth
De-locate the Matrix
Ascend from human race/split
2 neo-hue expansion obit
Let absence of light reflect no limit
Let absorption of light compel no limit
4 all the magic, 4 all the science
Open pathways 2 multi-fantasy
Open dimensions thru tomography
So mote it be."

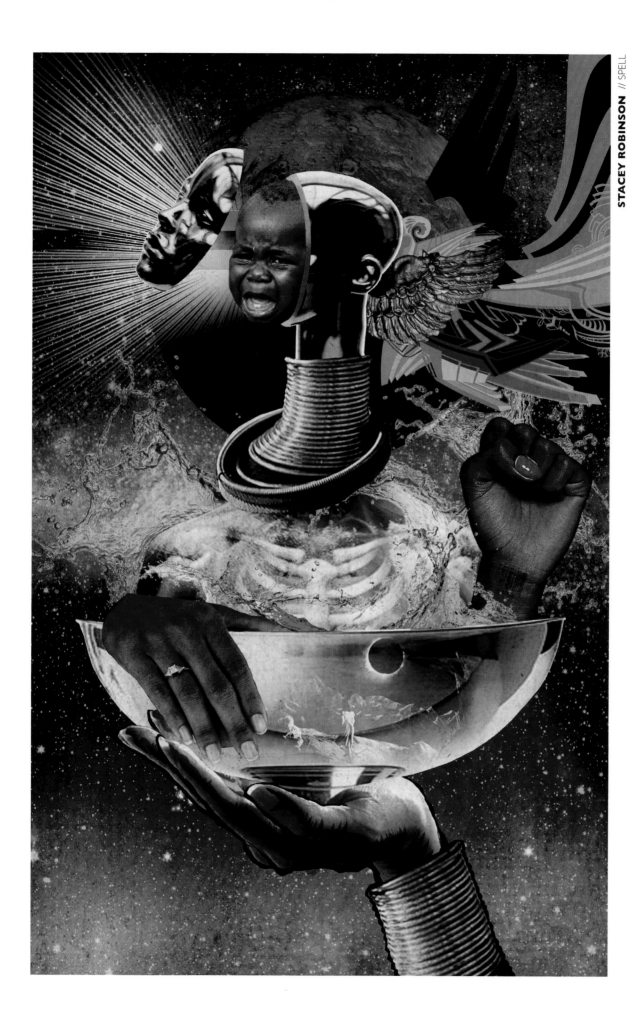

11

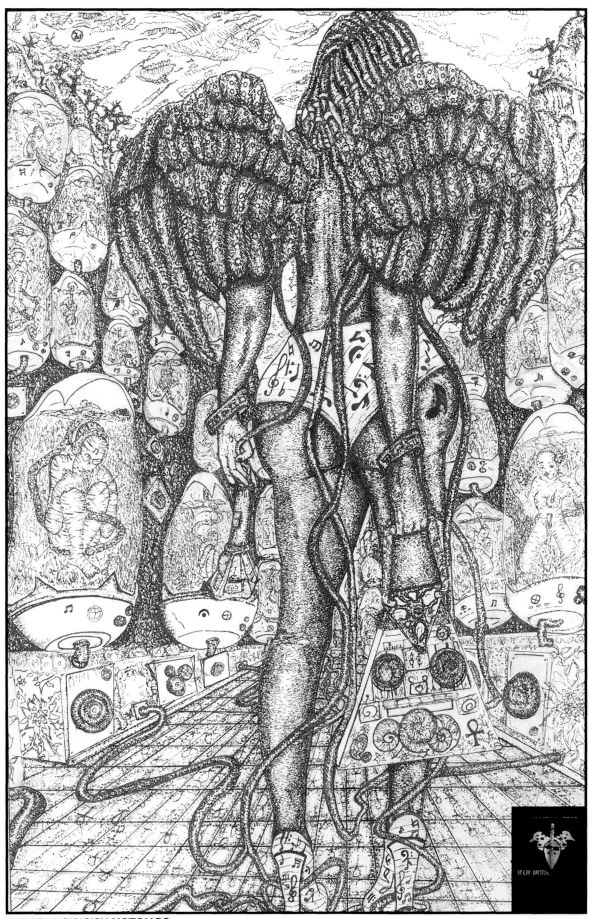

SURREAL SIBISISU XOTONGO

INSTALLATION PHOTOS

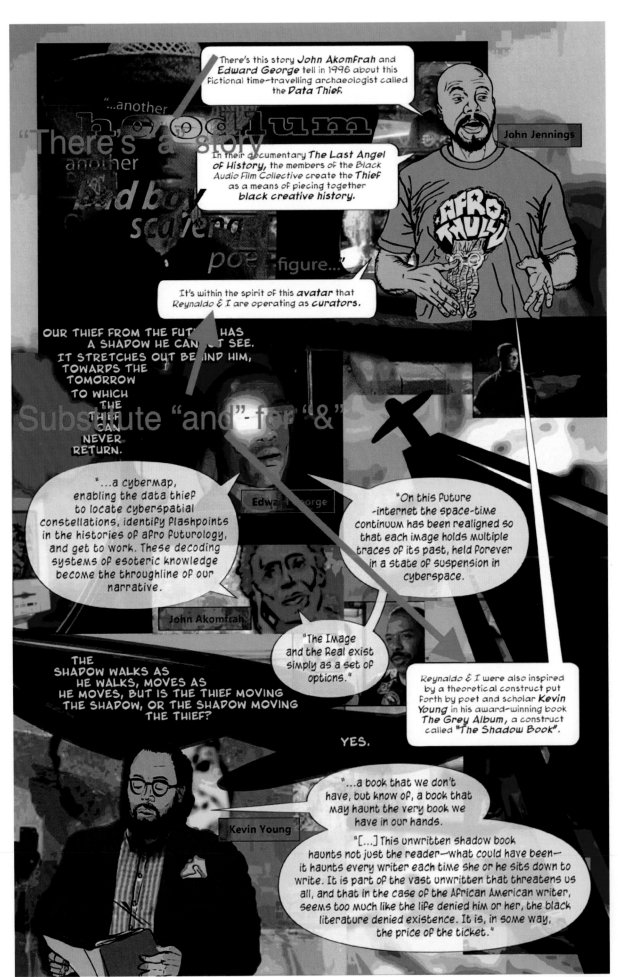

i m a g e c r e d i t s

FRONT COVER
Illustration by Stacey Robinson

LOGO DESIGN
Stacey Robinson

COVER DESIGN
Stacey Robinson

"Sun Shepardess" by Julie Dillon, Digital Media, courtesy
of the artist, copyright 2015

"The Offering" by Paul Lewin, acrylic on canvas, courtesy
of the artist, copyright 2015

"Brave New World" by Damon Davis, Digital Media,
courtesy of the artist, copyright 2015

"Do Androids Dream of How People Are Sheep?" by
Krista Franklin, mixed media collage, courtesy of the
artist, copyright 2015

"Mind of My Mind" by John Jude Palencar, oil on canvas,
copyright 2016, all rights reserved

"Z-5" by Vigilism X Ikire Jones, Digital Media, courtesy of
the artist, copyright 2015

We would like to thank all the artists from the orignal
Unveiling Visions show. Schomburg Center programs and
exhibitions are supported in part by the City of New
York; the State of New York; the New York City Council
Black, Latino and Asian Caucus; the New York State Black,
Puerto Rican, Hispanic and Asian Legislative Caucus; the
Rockefeller Foundation Endowment for the Performing
Arts; and the Annie E. and Sarah L. Delany Charitable
Trusts.

MANZEL BOWAN // VANITY AU

a c k n o w l e d g e m e n t s

CURATORS
John Jennings and Reynaldo Anderson

EXHIBITION DESIGN
John Jennings and Isissa Komada-John

ART DIRECTOR
Stacey Robinson

ARCHIVIST
Clint Fluker

CURATORIAL ASSISTANTS
Tim Fielder; Damian Duffy, Chimene Jackson

DIRECTOR OF EDUCATION AND EXHIBITIONS
Deirdre Lynn Hollman

EXHIBITIONS MANAGER
Isissa Komada-John

COMMUNICATIONS MANAGER
Candice Frederick

EXHIBITION CONTRIBUTORS
Mei Tei Sing Smith and Sanders Design Works, Inc.,
Fabrication and Installation

COPY EDITOR
Vida Samuel

PRINTING
Jeffery Sherven

PUBLICATION DESIGNERS
Thơ Đinh and John Jennings

Art & Artifacts Division/Schomburg: Tammi Lawson
and Serena Torres; and Jean Blackwell Hutson Research
and Reference Division/ Schomburg: Maira Liriano.

17

MANZEL BOWMAN // DAVID BANNER GOD BOX COVER

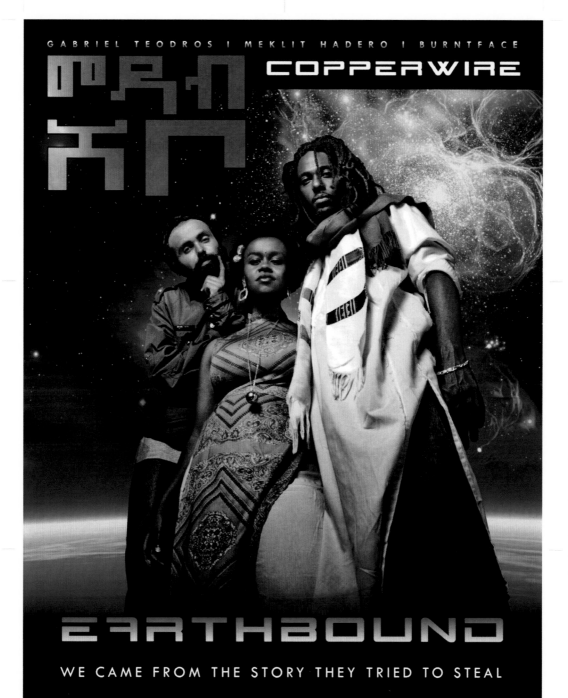

19

THE
ALCHEMISTS
OF
KUSH

THE ACCLAIMED NOVEL BY
MINISTER FAUST

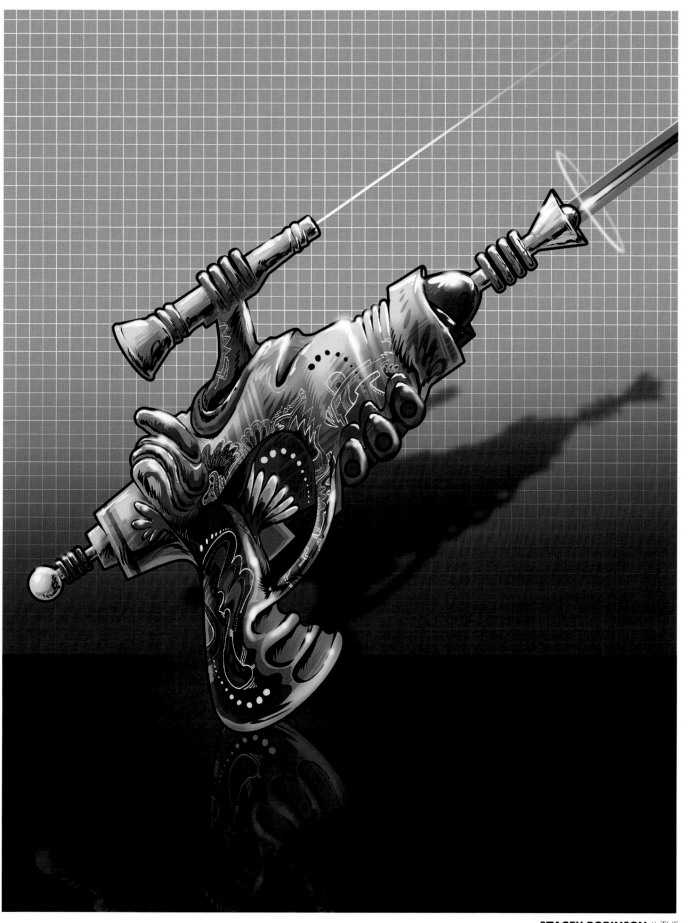

ASTRO BLACKNESS

For people of African descent, it is a an audacious and emboldened notion to envision a collective future. For generations, amidst trauma and oppression, the very idea of a "black future" has been, at the very least, an oxymoronic phrase. Writer Rev. Andrew Rollins describes Astro-Blackness as an "...Afrofuturistic concept in which a person's Black state of consciousness, released from the confining and crippling slave or colonial mentality, becomes aware of the multitude and varied possibilities and probabilities within the universe." The works of Samuel R. Delany, Walter Moseley, Octavia Butler, Nisi Shawl, Steven Barnes, and many others, provide the guiding map towards this bright black future. These writers serve as galactic griots, sharing their data with every turn of a phrase. Astro-Blackness is about transcendence and becoming a complete and whole individual. An Astro-Black body is a subjective, nuanced, and flexible one. It denies the fixity of the stereotypical chains put upon it by others and itself. It's about not only seeing the possibility, but also about becoming the possibility.

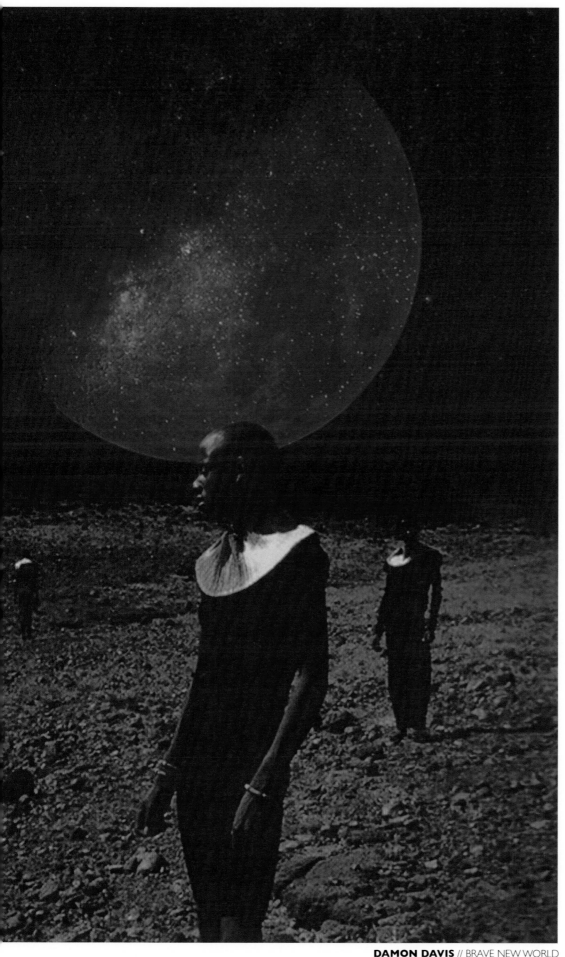

DAMON DAVIS // BRAVE NEW WORLD

ALEX HUCHIWOOD // BROTHER JPEG

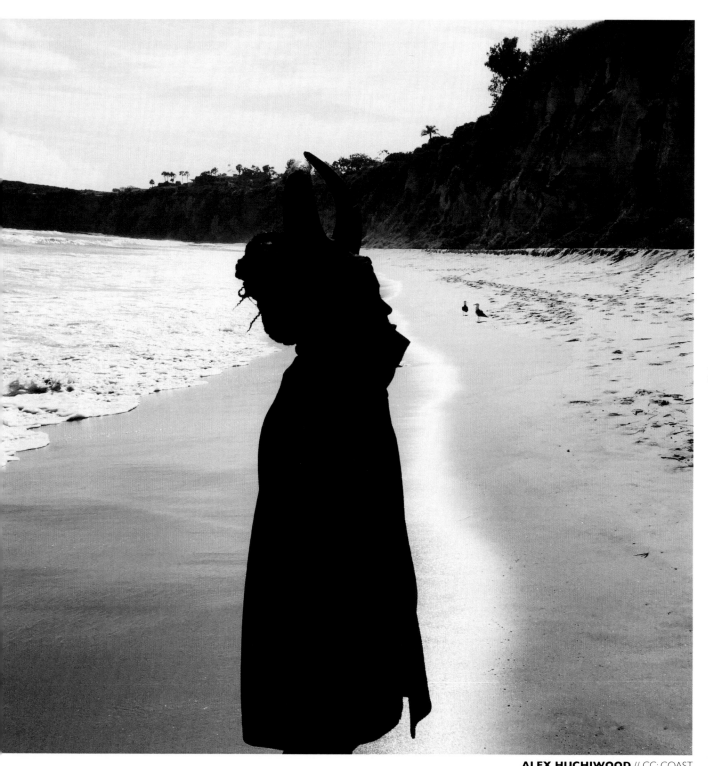

ALEX HUCHIWOOD // CC: COAST

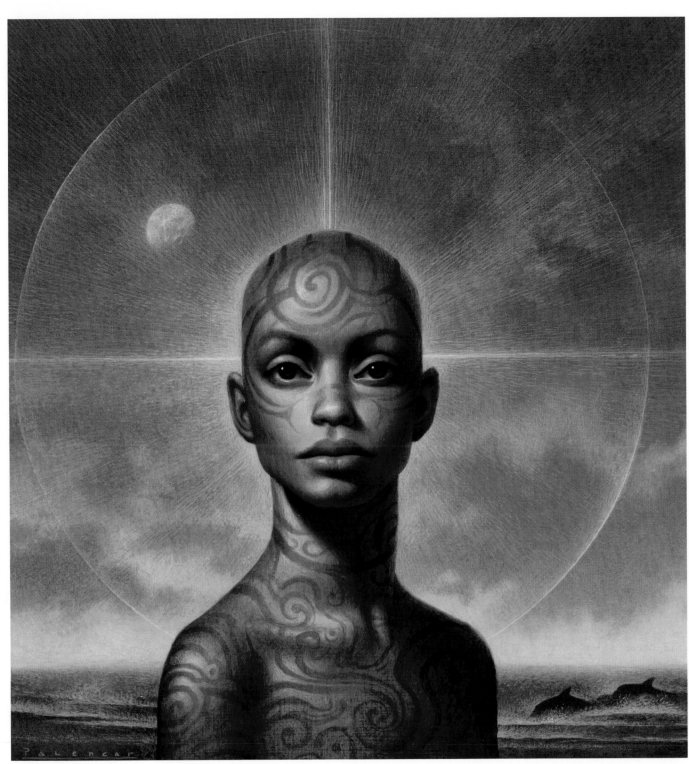

JOHN JUDE PALENCAR // WILD SEED

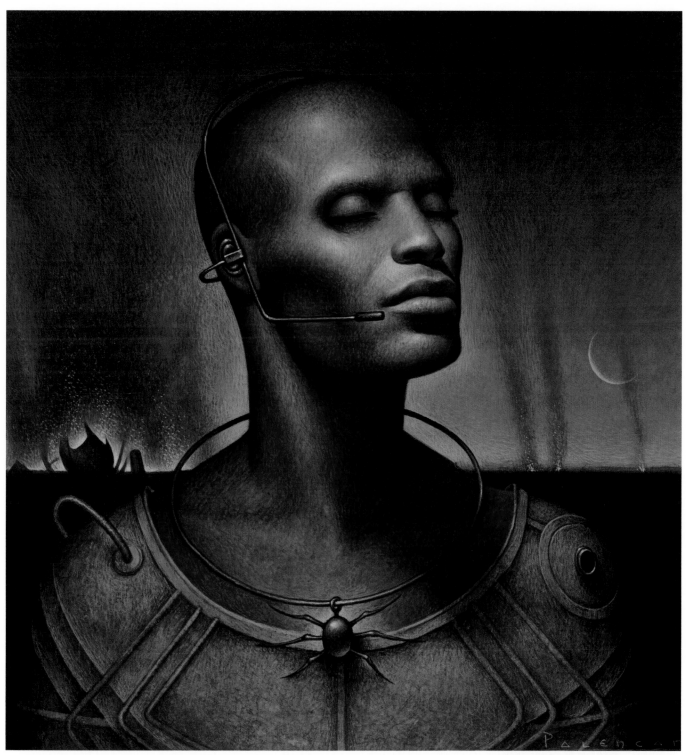

JOHN JUDE PALENCAR // CLAY'S ARK

TIM FIELDER // BLACK METROPOLIS SKETCH

TIM FIELDER // YEMEJA GIVES BIRTH TO THE WORLD (BLACK METROPOLIS SERIES)

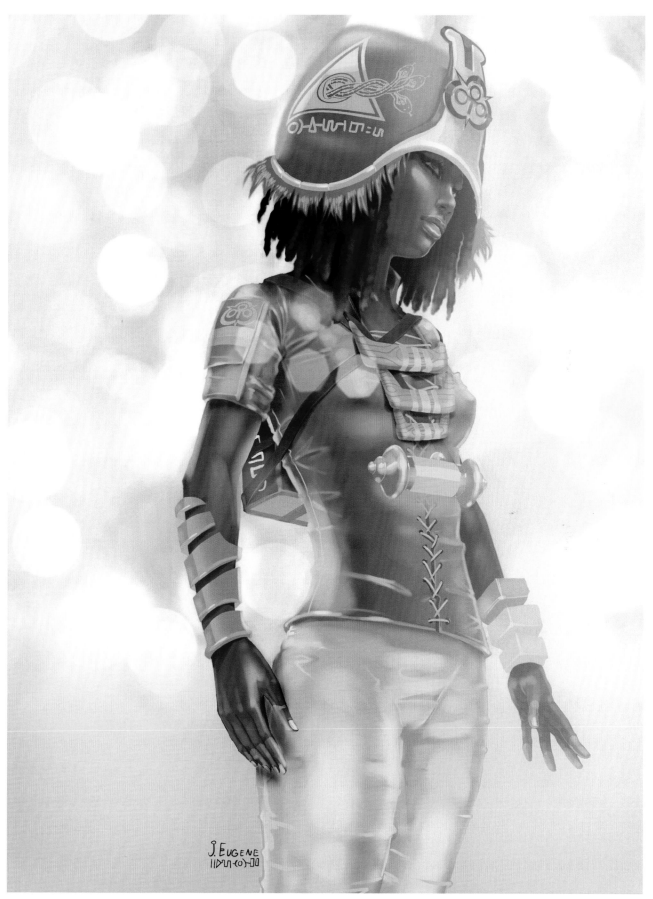

JAMES EUGENE // GOD HAT

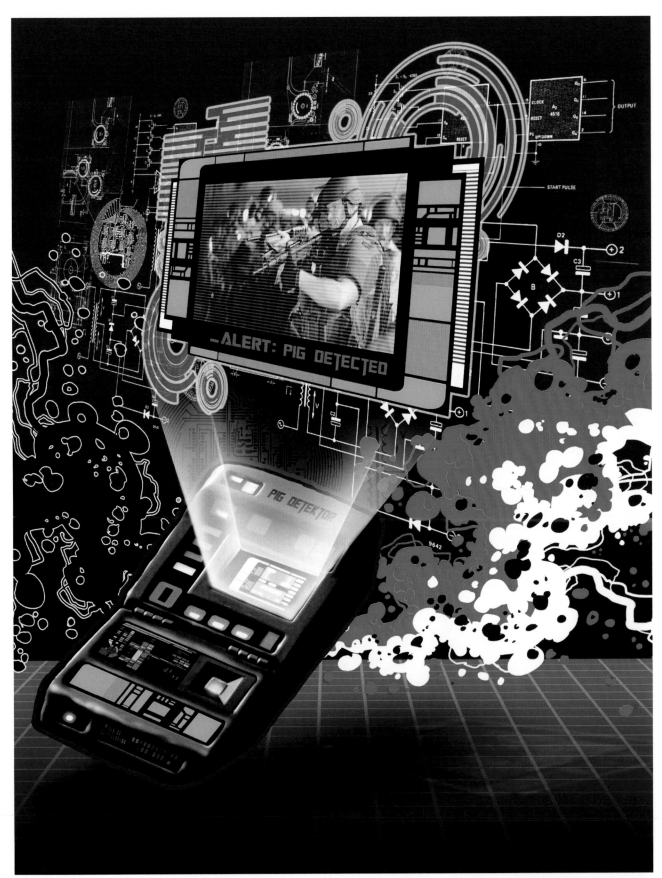

STACEY ROBINSON // PIG DETECTOR

DAVID BRAME AND JOHN JENINGS // CYBERTRAP WORLD

DEPROGRAM THE PROGRAMMERS: AFROFUTURISM AND DETROIT TECHNO

tobias c. van veen

"The music is just like Detroit, a complete mistake. It's like George Clinton and Kraftwerk stuck in an elevator". — Derrick May, Transmat Records

Somewhere on the outskirts of Detroit in the early 1980s, the Belleville Three — high school friends Juan Atkins, Derrick May, and Kevin Saunderson — were rolling with the windows down, listening to the new romantic sounds of European new wave bands, particularly the machinic funk of German electronic group Kraftwerk. Their listening taste somewhat at odds with the pop charts of early '80s Black radio, it reflected the onset of unusual times in Detroit; its youth disillusioned and increasingly unemployed. Detroit was already showing signs of industrial decline, as the high hopes of automotive futurism collided with the harsh realities of global capitalism. Evidently some sort of new world playlist was in order, something as strange and uncanny as the changing economic landscape.

In Kraftwerk, the Belleville Three found the epitome of what Afrofuturist Kodwo Eshun calls "the white soul of the synthesizer" (07[100]). Dressed in mannequin suits, their vocoded lyrics celebrating computer technology while their robotic movements emulated the rhythms of automation - Kraftwerk couldn't have been a starker contrast to Detroit's Motown heritage, even as their komputer muzik uncannily reflected the city's fear of losing its human labour to robotic overseers. "For us", says May of bands like Kraftwerk that fetishized machinic production and performance, they "were doing this thing like it was from another planet".

Immersed in Detroit's alienated landscape, the Belleville Three were looking to reimagine Planet Detroit by creating alien music. They did so by transforming white synthetic soul, already an electronic remake of African American funk, into an innovative and imaginative musical entity far more explosive than its influences — not the least by rewiring it through what Paul Gilroy calls "black Atlantic futurism." Detroit techno is lush with emotive strings that rise above the paranoia and anxiety of its often mechanical and sparse beats. Though the blues, soul, jazz, gospel, and funk are all deconstructed in Detroit techno — as celebrated techno producer Carl Craig emphatically reminds us — the primary impulse of Detroit techno is an imaginary and visionary one. Detroit's science fictional state would require a soundtrack. Now it needed a name. Juan Atkins had already recorded a seminal cut called "Techno Music," and so the 1988 export album that separated the genre semantically from the disco-driven and acid grooves of Chicago house music was called Techno: The New Dance Sound of Detroit.

But if Kraftwerk is one component of the soundtrack to Detroit's industrial ruin, then the funked-out space entity known as George Clinton is the genre's gearbox. Clinton's influence upon techno is not just in sound but in concept, particularly in the extravagant performance of interstellar blackness, as he and Parliament/Funkadelic called upon their followers to funk-out from Earth and join the Mothership. The outer space and alien identities of Afrofuturist musicians and artists, from Sun Ra and Afrika Bambaataa to Dr. Octagon, Grace Jones, and Janelle Monáe, have often sought to express a profound sense of alienation with the White world — or rather, Alien Nation, as Public Enemy put it — by subverting and transforming whitewashed projections of the future. Yet, as Eshun has demonstrated, one of the temporal strategies of Afrofuturism — its chronopolitics — is that it creates new futures by infiltrating the present with novel repurposings of the past (2003). As Dan Sicko, author of Techno Rebels: The Renegades of Electronic Funk writes, "these young techno rebels thought they had found R&B's polar opposite, when in fact they were just hearing American soul music through unfamiliar filters" (28). The Three's rewiring of soul through the unfamiliar filters of electronic music, in what Detroit techno collective Underground Resistance and Derrick May both call "hi-tech soul" or "hi-tech jazz" — is integral to grasping the powerful mutations and speculative imaginaries of Detroit techno, where not just sound becomes plastic but bodies, ideas, and planets.

Against the economic backdrop of a Detroit already becoming a lived science-fiction — its collusion of corporate capitalism, crime, and spectacle satirized in Paul Verhoeven's RoboCop (1987) — Detroit techno begins with a search to create music that calls forth Other Worlds as much as it reflects the failures of this one. In the first Detroit techno track ever pressed to wax, Juan Atkins, recording as Model 500, refused to give in to the popular diagnosis of Detroit's ruination as nothing but dystopia incarnate. On "No UFOs", the first release on Atkins' label Metroplex in 1985, the vocal version has a sparse lyrical chant punctuating its raw hand-claps and electro-styled beats: "They say there is no hope / they say no UFOs / but maybe you'll see them fly."

From the creative energies of May, Atkins and Saunderson, alongside Eddie "Flashin'" Fowlkes, Blake Baxter, and Anthony "Shake" Shakir, arose a rhythmic call-and-response to the exhaustion of the Fordist factory system, inspiring the minimalist and militant but still sublime sounds of Second Wave artists Underground Resistance, Jeff Mills, Robert Hood, Plastikman, Theorem, Claude Young, Stacey Pullen, and Carl Craig. Since the mid-90s, Detroit's Third Wave has amplified its routing through funk and free jazz in the releases of Kenny Dixon Jr., Theo Parrish, Mike Huckaby, Omar-S, and Rick Wade. In all of its manifests, Detroit techno would announce itself abroad as an electronic music requiem for the all-but collapse of the city-state, while at the same time, dropping timeless techno anthems that to this day destroy dance floors with their rhythmic innovation that combines cosmic impulses and raw electronics with hi-tech soul.

Interstellar Fugitives and Black Atlantic BecomingsDetroit techno artists continue to explore the science fictional uncanniness of a city and a world in which labouring bodies have become disposable robots. Juan Atkins was the first to embrace the machine aesthetic that became a template for techno producers worldwide, adopting multiple heteronyms that reflect how techno is a form of automated production — Model 500, Frequency, Audiotech, and Channel One, to name a few. Other producers became different sorts of bodies. Formed in 1989, the techno and electro duo Drexciya are key members of collective and label Underground Resistance. The unique mythology of the Drexciyans profers an aquatic vision of what Richard Iton calls "the black fantastic" — those "minor key sensibilities generated from the experiences of the underground, the vagabond, and those constituencies marked as deviant" (16). The Drexciyans are genetic deviants, as the mutant offspring of enslaved Africans thrown overboard during the Middle Passage. Drexciyans

have adapted to the underwater depths with gills and aquatic technologies, thanks to their "mutant R1 genes" that also (apparently) bless Malcolm X and Nelson Mandela. Announcing their underwater agenda on album sleeves and liner notes, the Drexciyans are poised to "harness the storm" and return the descendants of transatlantic abductees to a new utopia on the African continent. By combining Marcus Garvey's politics of exodus with a science fictional twist to the clichés of biological racism, Drexciya's aquatic MythScience — to use Sun Ra's term — is at once a powerful measure of the Black radical imaginary as well as a political metaphor that reflects the insistence and urgency heard in Drexciya's aquatic beats.Underground Resistance is likewise populated by its "interstellar fugitives" — Black techno personas from various planets who are on the run from authorities that enforce order and obedience through the banal beats of consumer radio programming. UR's often-masked members conceal their identities and use pseudonyms to explore the black secret technologies of rhythmic sound. "As Interstellar Fugitives", says Banks, "I see our future as always on the run, trying to preserve what we are. The bad part about it is most of us don't even know what we are. It's fucked up and it's good at the same time".

Founded in the late 80s, UR's manifesto calls for its listeners to "deprogram the programmers," to challenge the mediocrity of corporate music and to "transmit these tones and wreak havoc on the programmers!" UR continues under the direction of its elusive co-founder "Mad" Mike Banks — a former bass player for Parliament — who on stage reveals his skills as an exemplary gospel keyboardist and on record is responsible for the crew's most outstanding fusions of electronic techno funk.

Co-founder Jeff Mills; formerly known as The Wizard, Detroit's legendary four-deck turntablist, has developed his own cosmic mythology through releases on his labels Axis, Tomorrow, and Something In The Sky. Mills' minimalist techno tracks range from industrial and abrasive DJ tools, meditative and mesmerizing scores to early modern science fiction films such as Fritz Lang's Metropolis (1927) that likewise allegorise a slave labour underclass ruled by automation. Beginning with his 2001 album Time Machine, and following from his early 1990s X-101 releases with Mad Mike and Robert Hood, Mills continues to score an ongoing saga of alien contact and planetary exploration. Initially UR's first Assault DJ — taking raves by turntablist storm in the early 90s — Mills has since pushed the outer limits of conceptual DJ performance under the monikers of Time Traveller, the Sleeper Wakes, and One Man Spaceship.

Since Model 500's initial impulse that afforded hope for the alien, some thirty years later Detroit techno has spawned a legacy of electronic music infused Afrofuturism. Detroit techno is not just electronic music, but an ever-evolving assemblage of science fictional artworks, comix, film, animation, performance, and immersive rhythmic events — including the annual Detroit Electronic Music Festival — that have sought to imagine other worlds and alien modes of living to a soundtrack of machinic music.

Detroit techno remains multidimensional: it not only is a sounding-out of science fiction, but a universe of Black fantastic becomings. Today, it reminds us, as a kind of subliminal soundtrack to a Black cyberpunk, of the more exciting future that awaits us if we deprogram the whitewashed future of yesterday's programmers.

References
Eshun, Kodwo. 2003. Further Considerations of Afrofuturism. CR: The New Centennial Review 3 (2): 287–302.
———. 1999. More Brilliant Than the Sun: Adventures in Sonic Fiction. London: Quartet.
Iton, Richard. 2010. In Search of the Black Fantastic: Politics & Popular Culture in the Post-Civil Rights Era. Oxford: Oxford University Press.
Sicko, Dan. 1999. Techno Rebels: The Renegades of Electronic Funk. New York: Billboard Books.

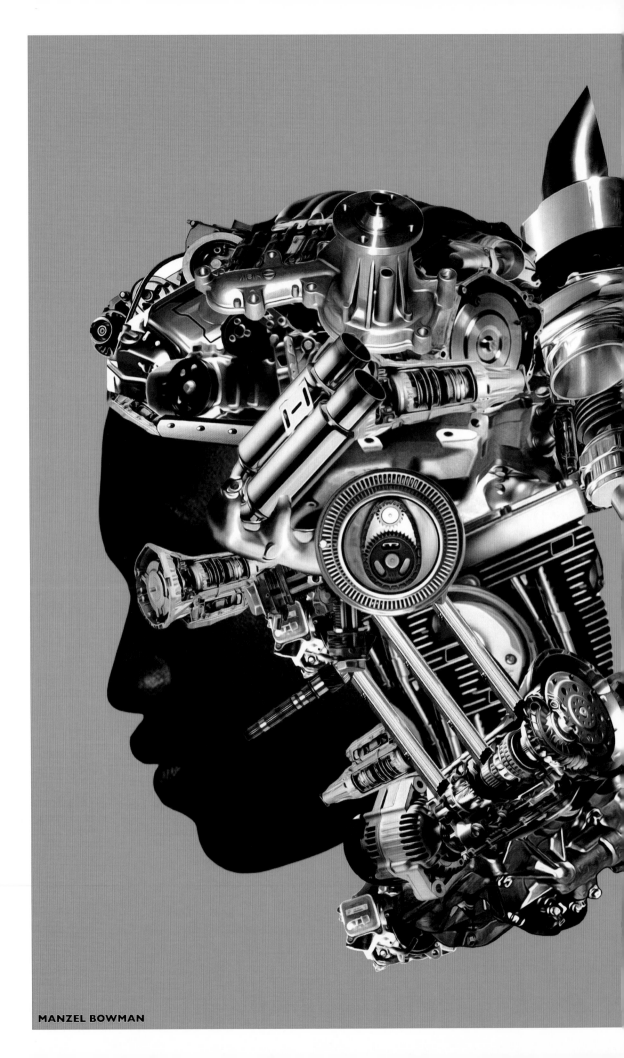

MANZEL BOWMAN

OUT OF THE NIGHT, INTO THE NIGHT: THE MOORISH EFFECT ON THE ENLIGHTENED & MODERN WORLDS

Ryan M. Branson, Sr., 32°

The Masonic Fraternity, commonly known as Freemasonry, is the oldest and most beloved fraternity of men that this world has ever known. Its accomplishments are as vast as its conspiracy theories that were developed throughout the Common Era. Among the ranks of its membership "freemasonry" is defined as "...a beautiful system of morality, veiled in allegory and illustrated by symbols" (Duncan, 1976). Not many people beyond its membership know the real meaning of this phrase. When this phrase is broken down, fraternally, we learn that freemasonry is subsequently: a beautiful system of truth [morality], veiled in lies [allegory], which is then illustrated by symbols. Often times, the first thing that the uninitiated are confronted with is(are) the symbol(s). After receiving the symbol(s) and the so-called knowledge thereof, a lie is given, and finally in order to find the truth it must be sought out; or find it to know that which is real, relative, and to be used in everyday life. Hence, we refer to the biblical scripture, "Ask, and it shall be given you, seek, and ye shall find, knock, and it shall be opened unto you: For every one that asketh receiveth, and he that seeketh findeth, and to him that knocketh it shall be opened" (King James, 1611 Edition). Such is the case of the Moors, commonly referred to as the Black Moors - moreover, with concern to Most Worthy Brother Angelo Soliman—The Moor. Within this body of work I will present compiled information representing a snapshot of how the Moors impacted the Masonic Fraternity, the world and its affect on contemporary culture.

 Of his own accord, Angelo Soliman professed that he was born in 1721 in Africa, which in the tongue of his ancestors was called Pongutsiglang or Gangsiglang and that his original name was Mmadi-Make. He was also purported to call his birth country Magni Famori, which ethnologists associated with Manna Farah (House of Joy) of the Galla tribe. His home was probably Somaliland or Abyssinia, perhaps even Central Africa (Nettl, 2013). In 1783, Soliman was initiated into the Fraternity of Freemasonry in the Lodge called, Zur wahren Eintracht, which translates into the phrase "True Harmony." It should be noted that this lodge was known for bringing together the Viennese elite and aristocratic class

on the recommendation and behest of the Most Great Master, Ritter von Born. Moreover, it was within this lodge that Soliman became friends with Wolfgang A. Mozart (1756-1791) and Joseph Haydn (1732-1809), who were known in that era of music innovation as "The Terrible Brothers." Soliman later became Grand Master of this lodge, under the name of Massinissa, who is the famous Amazigh king of Numidia (Wunga, 2011).

As the Grand Master of his lodge, Soliman exhibited superior knowledge, wisdom, and understanding concerning the fraternity's esoteric teachings, specifically concerning the teachings that involve the seven liberal arts and sciences that are still used today. It should be noted that within the Masonic Fraternity, its membership are advised to study the seven liberal arts and sciences which are: Grammar, Rhetoric, Logic, Arithmetic, Geometry, Music, and Astronomy. When Freemasons study the historical background for this list, they uncover layers of Masonic meanings in each of the seven areas of knowledge (Marcus, 2012). Soliman was recognized for his mastery in these disciplines in such a manner that his teachings became known as, "The Soliman Freemasonic Literacy Style." It did not take long for this new wave of Masonic thinking to spread all over Europe, and around the world. A great abundance of modern Freemasonic literature and ritualsinfluenced the writings of prominent Masonic scholar, Albert Pike. Consequently, Soliman is known to this day, as The Father of Pure Masonic Thought. As a result, the Masonic Fraternity hails Angelo Soliman as a patriarchal figure and a profound model of early Moorish (Black) achievement. He is still celebrated today in song and dance in Vienna (Moore, 2008).

Alessandro de' Medici who was called il Moro (the Moor) was born July 22, 1510 and was both the Duke of Penne and the Duke of Florence. He was the ruler of Florence from 1530 to 1537. Though considered to be the illegitimate son of his father Cardinal Giulio de Medici who later became Pope Clement VII, he was the last member of what was considered to be the "senior" branch of the Medici family to rule Florence. Impressively, he was also the first to be a hereditary duke. It was not until the present era that Alessandro's African ancestry was openly acknowledged or discussed. During the Renaissance era Alessandro commissioned portraits that depicted his hair covered by a headdress, and his face darkened by shadows, which helped to obscure the historical record of his ethnicity. Nevertheless, Agnolo Bronzino's 1553 portrait included in the exhibition, demonstrated that Alessandro had both European and African ancestry; he in essence was the Frankenstein of his time period (Africans In Renaissance Europe, 2015). Alessandro, himself, is an example of the Moorish Gothic era.

The principle submissions that Moors made during the Gothic era included, but are not limited to: sculpture, panel painting, stained glass, fresco, and illuminated manuscripts. There are easily identifiable changes in architecture from Romanesque to Moorish Gothic, and Moorish Gothic to Renaissance styles. Late Moorish Gothic art, specifically, continued to be produced well into the 16th Century before being considered European Renaissance art. Moreover, Moors proved proficient in alchemy during the Gothic period. Alchemy was considered to be the barbaric harbinger of chemistry, based on the hypothetical transformation of matter. However, alchemy was considered to be concerned predominantly with efforts to convert base metals into gold, or to find a universal elixir that would heal the body or give an individual immortality. Nonetheless, these practices would significantly influence the Italian renaissance and early esoteric European masonic thought.

Bibliography

Africans In Renaissance Europe . (2015, August 11th). Retrieved from The Ultimate History Project: http://www.ultimatehistoryproject.com/africans-in-the-renaissance.html

Duncan, M. A. (1976). Duncan's Ritual of Freemasonry. Mineola, NY: Dover Publications.

King James, V. (1611 Edition). The Holy Bible. In Matthew, The Book of Matthew (pp. 7:7-8). New Kensington, PA: Hendrickson Publishers.

Marcus, R. D. (2012, October 9th). A Stroll Through The Seven Liberal Arts and Sciences. Retrieved from MasonicWorld.com: http://www.masonicworld.com/education/files/artjan02/marcus/sevenliberalartsandsciences.htm

Moore, K. (2008). Freemasonry, Greek Philosophy, the Prince Hall Fraternity and the Egyptian [Africa] World Connection. Bloomington: AuthorHouse.

Nettl, P. (2013, August 12th). Angelo Soliman--Friend of Mozart. Phylon (1940-1956), Vol. 7, No. 1 (1st Qtr., 1946), pp. 41-46. Atlanta, Georgia, U.S.A.: Clark Atlanta University.

U.S. Public Health Service Syphilis Study at Tuskegee . (2013, September 24th). Retrieved from Centers for Disease Control and Prevention: http://www.cdc.gov/tuskegee/timeline.htm

Wunga, K. R. (2011, September 27th). History of Africa Otherwise. Retrieved from The Fantastic Story of Angelo Soliman: http://historyofafricaotherwise.blogspot.com/2011/09/fantastic-story-of-angelo-soliman.html

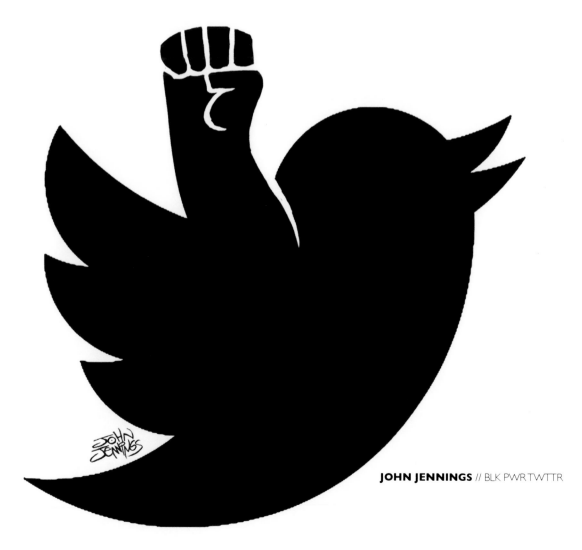

JOHN JENNINGS // BLK PWR TWTTR

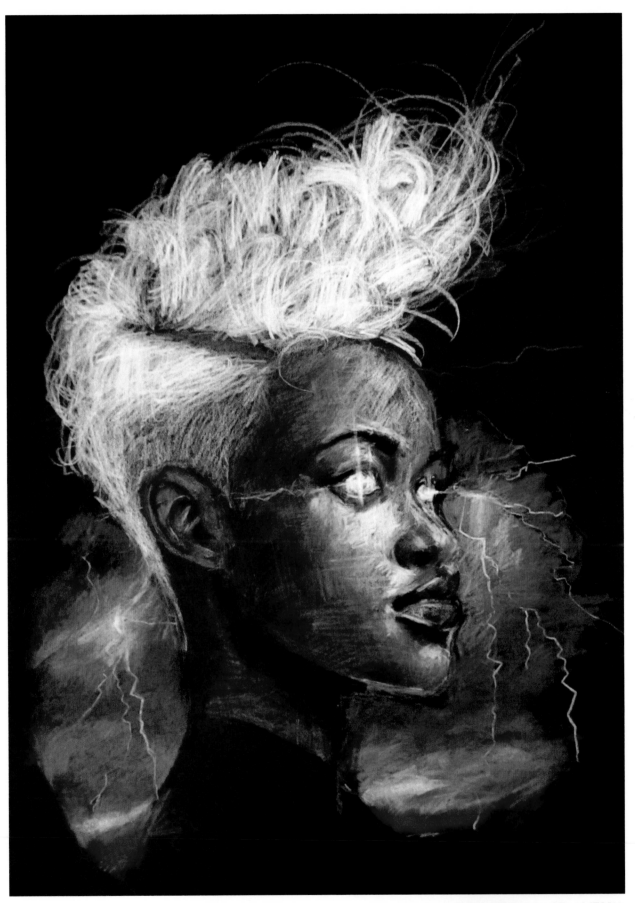

MAYA SMITH // LUPITA AS STORM

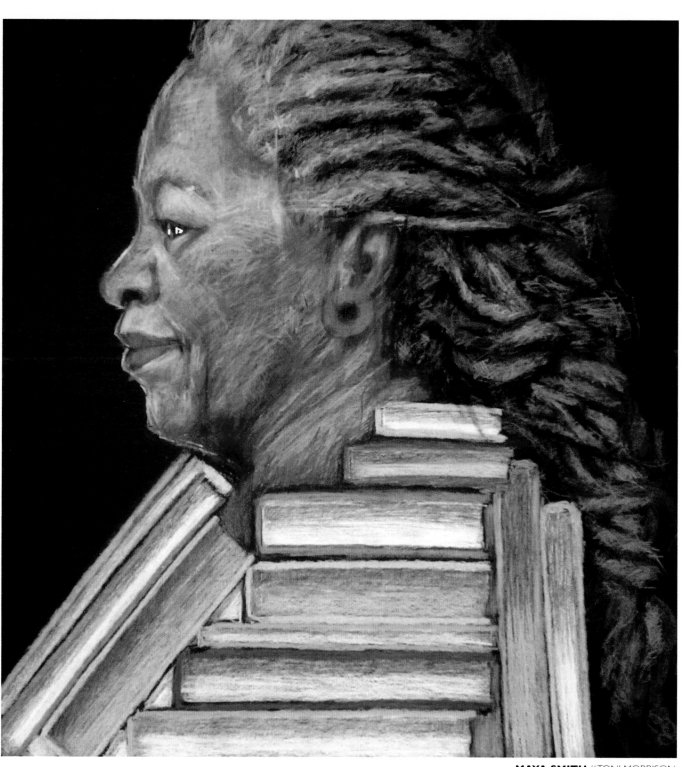

MAYA SMITH // TONI MORRISON

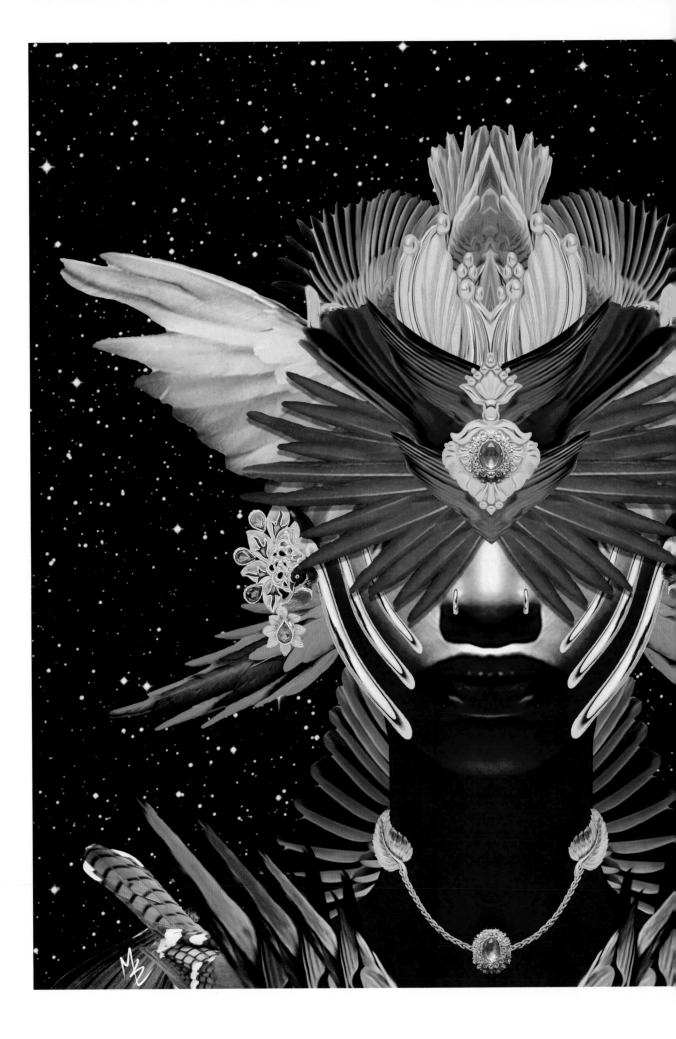

ONTOLOGIES OF ORISHA TECHNOLOGY: WEST AFRICAN SPIRITUALITY IN AFROFUTURISTIC VISIONS

Kinitra Brooks

The loas are the technology! —John Jennings

The intervention of Afrofuturism is a chronopolitical act. —Kodwo Eshun

Prior misreading of Afrofuturism has focused on its obsessive privileging of the future with only a passing acquiescence to the past. Yet, the chronopolitical intervention of Afrofuturism disrupts the linearity of time as the past/present/future exist together at once as lines of code in grand application that is time. It is in this frame of reference that choose to forward by looking back to best articulate the binary code of the present. I intentionally speak of the microcosmic nature of coding, the tiny bits of language that construct the grander ideas and technologies that populate our world. Amiri Baraka proclaimed: "What are the Black purposes of space travel?" referring to the realms of outer space, the intergalactic. But I ponder, what of the potentialities of inner space? What are the Black purposes of that which is inside, the nanotechnologies that itch to hack into the mitochondrial DNA that inhabit the very cells of which we are composed?

Some Afrofuturists speak of hegemony as a large system us Black folks are outside of and insist that our outsider status offers us a unique ability in which to hack into the system to subvert, induce change and even destroy. And yet, what if the hegemony is actually inside of us? What if, and this is a very interesting what if...it is the white supremacist heterosexist capitalist patriarchy that composes the phospholipid bilayer of our cells' very membranes? For it is our cell membrane that "protects" what is inside of it—mitochondria, nucleus, cytoplasm, etc.,-and prevents those substances it deems "unsafe" from entering or communicating with the valuable intellectual real estate inside. I propose that it is our mitochondrial DNA, that part of us that is directly grounded in the African, the ancient, that

which is pre-modern, pre-historic and connects us to Lucy (Eve) a fount of self-knowledge and power. But if we have absorbed the dictates of colonialism and enslavement into the very essence of who we are has the battle not been lost? What is left to be hacked and who will do the hacking? Are we to begin hacking ourselves?

In explicating her theory of race as technology, Beth Coleman assures that her framework is an effort to "...turn from tool of terror to mechanism of agency not on magical thinking but rather on the ethical choices that one makes ever day." I disagree. In this essay, I examine the conflation of race and technology as a framework based in magical thinking; For what is magic but "a science that we don't understand yet?" (Arthur C. Clarke) Baraka insists that "new technology must be spiritually oriented because it must aspire to raise [wo]man's spirituality and expand [wo]man's consciousness." The interweaving of the spiritual with science allows Afrofuturism to push past Coleman's insistence that "scientific information does not give us the totality of knowledge." The Afrofuturistic vision of reading the orishas as cellular nanotechnology, hacking the electronic synapses of cellular activity working to unlock the totality of knowledge buried in crevices of the cellular powerhouses, the mitochondrion.

Imagine the most awesome team of hackers ever - using electricity and orisha power to free the knowledge buried inside of Afrodescendientes the world over. In the fierce heat of the back rooms we find Ogún, the divine blacksmith and father of all technology, as he shapes and cools the metal for the nanobots. Later, we observe as he constructs the microscopic tools with the surgical precision honed through his power over knife-edges. In the virtual switchboard room, we encounter Elleguá, orisha of communication and crossroads lords over the nanobots' electronic communication with the proteins imbedded in the cell membrane that ferry synapses within and outside of the cell's borders. Walking through the ship we pass Yemayá in the galley, preparing fixin's for a seafood stew to be served piping hot full of motherlove as its warmth is prepared to seep into souls and psyches damaged by the traumas of enslavement and degradations of Jim Crow as well as soothe the anxieties that paralyze every time we see a blue uniform. Oshún stands in the control room as she powers the movement of the aqueous cytoplasm within the cell, optimizing the flow of electric synapses from the large protein receptors towards the prized mitochondrion. To the left, we see Shangó acting as the grand strategist, mapping out and negotiating the best methods to interrupt the tyranny of the cell membrane and infiltrate the mitochondrion. And in the center of the room we find Obatalá sitting in his captain's chair as he oversees the hacking, ready to unlock the mitochondrial DNA and nurture the release of ancient African knowledge systems found in the complexities of its helix form. It is through such a fresh reading of the orishas, of race and nanotechnology that we can discover "forms that will express us truthfully and totally" in order to free us all, one cell at a time.

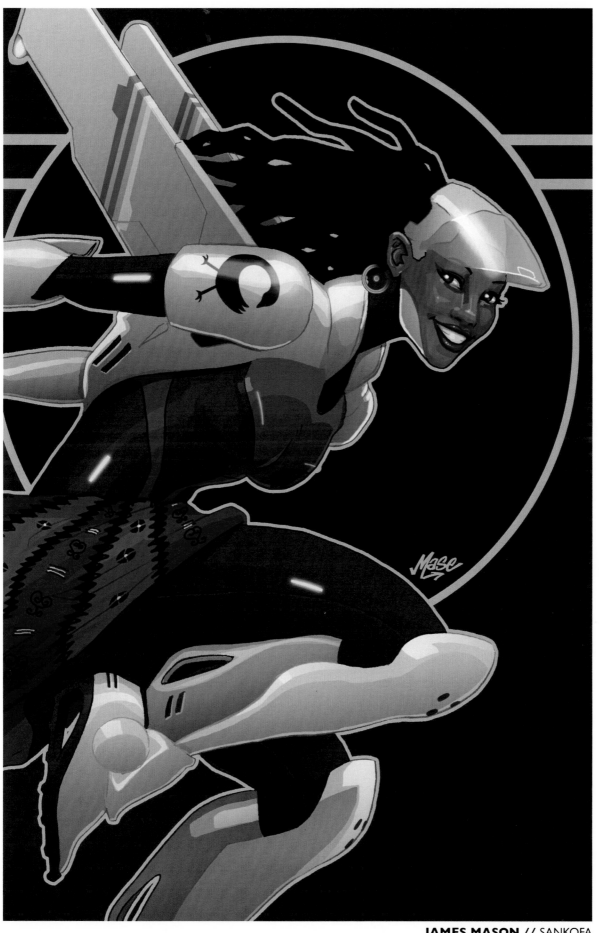

45

JAMES MASON // SANKOFA

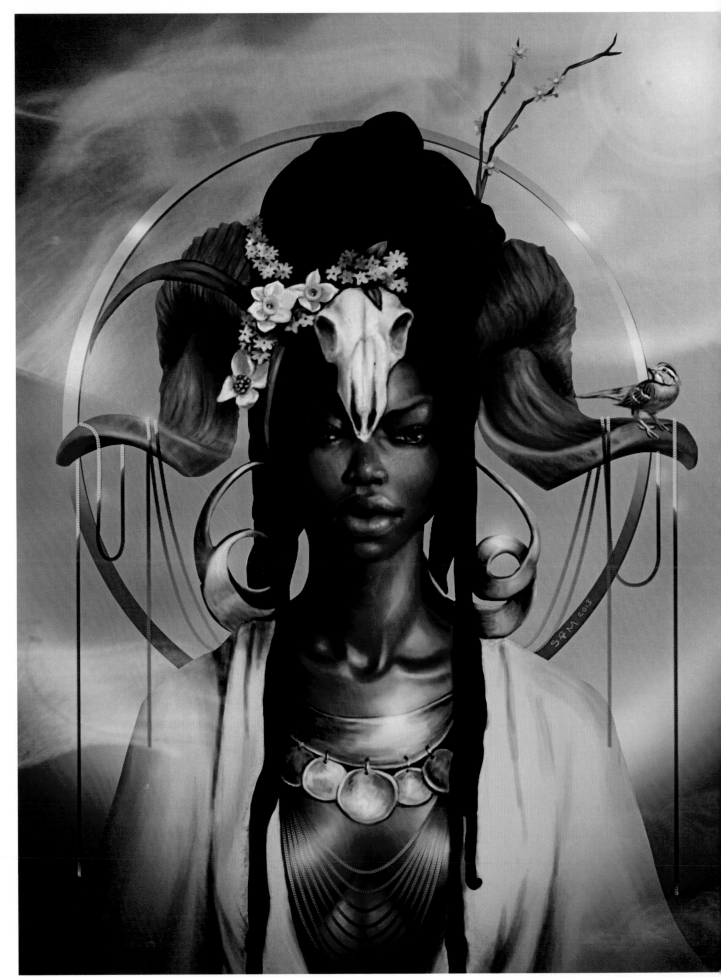

SHEEBA MAYA // ANCESTRAL MAJICK

ANDRE LERO DAVIS // MF DOOM

#FREEBree CLIMBS SO WE CAN FLY

Clint Fluker

Over the last few years, several artists and scholars in the field of Afrofuturism have fostered a connection between the world of black imagination and social activism. Octavia's Brood: Science Fiction Stories From Social Justice Movements, edited by adrienne maree brown and Dr. Walidah Imarisha, is a collection of short stories written by social activists. Artists Against Police Brutality is a Facebook page started by editor Bill Campbell and artist John Jennings dedicated to posting information and art related to injustice at the hands of America's police force. The forthcoming conference held at Princeton University, "Ferguson is the Future", organized by Dr. Ruha Benjamin, promises to be a gathering where artists and activists join together and forge avenues toward a better future. These examples of Afrofuturism at work all operate under a shared assumption about the world. Namely, if Black lives are to improve globally, then everyone, including those in traditionally quantitative fields, must learn to yield the powers of imagination in order to create a more inclusive and adaptive future. Read—the status quo simply won't do.

Bree Newsome Inspires

The particular nexus between Afrofuturism and activism was never more present than during the aftermath of the horrific Charleston, South Carolina shooting at Emanuel African Methodist Episcopal Church on June 17th, 2015, where nine church members, including Pastor Clementa Pickney, were murdered during bible study. Following this tragedy, a national debate ensued regarding the confederate flag as it continued to fly at full mast at the South Carolina state capital during the days following the massacre. Though Black people around the world have long lamented the history of racism associated with the flag, this shooting was especially relevant because the gunman, Dylann Roof, a racist, used social media to post a series of photographs of himself holding the flag, along with other globally recognized symbols of injustice, prior to June 17th.

While the government and news outlets debated on if, when, and how to remove the confederate flag from the state capital grounds, activist Bree Newsome, in conjunction with an activist group, scaled the pole and took the flag down herself. Several news outlets captured both film and photographs of the event, enabling the public to witness in real time as she scaled the pole using a pulley and rope. We listened as she recited the Lord's Prayer and watched with anticipation as she successfully cut the flag loose. On her way down she remarked to the awaiting authorities, "I'm coming down, I'm prepared to be arrested!" And so, she was.

Soon after, this moment was captured through the work of artists and posted on various social media outlets. Niall-Julian Watkins, Rebecca Cohen, and Quinn McGowen are among many illustrators who fashioned Newsome's likeness to that of a cartoon. Paying close attention to the different renderings, a pattern emerges. It's as if Newsome defied gravity itself, for she no longer wore climbing gear, a helmet, or a backpack. In my favorite rendering of her illustrated by McGowen, she didn't even bring tools to cut the flag loose, and yet there she stands relaxed on top of the pole holding the confederate flag in her hand. It's as if Newsome arrived at the state capital grounds a human being, but left a superhero.

My immediate interests are to interrogate how and why this happens. Moreover, I am also curious to understand what this all means.

Acting Outside the Realm of Common Sense

One possible explanation can be found in Kara Keeling's The Witch's Flight: The Cinematic, The Black Femme, and the Image of Common Sense. In this text, Keeling seeks to identify the thread that can be used to unravel the tightly wound fabric of American cinema. According to Keeling, American cinema presents a "common sense" notion of reality that is hegemonic. Moreover, images of blackness within this world, stemming all the way back to the beginning of cinema, tend to be stereotypical and limiting of Black potentiality. These stereotypes have been well documented by the works of Ed Guerrero and Donald Bogle in their respective texts, Framing Blackness and Toms, Coons, Mulattoes, Mammies, and Bucks. Digging even deeper, Keeling argues that even some of the most well respected films made by Black directors such as Haile Gerima's, Sankofa (1993), present an image of blackness that is far too conservative as to represent the broad spectrum of blackness that exists outside of the cinematic universe.

Therefore, Keeling's objective is to identify the hidden avenues within these "common sense" realities that lead to alternative ways of sociality. For Keeling, common sense "... refers simultaneously to a shared set of motor contrivances that affect subjective perception and to a collective set of memory images that includes experiences, knowledges, traditions, and so on that are available to memory during perception". She goes on to explain that her view of common sense is most closely aligned with Antonio Gramsci who uses the term to describe, "Man's conception of the world". Keeling further suggests that the most effective way of surveying the field of cinematic reality for these subversive outlets is to focus on those characters that are silenced. These characters are important because they operate as both objects of the greater common sense structure—they are silent because someone else has been privileged to speak—and as potential avenues toward new possibilities (if such a character were to speak, what would they say?).

Keeling argues that the Black lesbian butch femme is so often silenced in mainstream film because the alternative sociality that she represents does not fit into the cinematic vision of the world that has been so carefully constructed over the last century. For this reason, if not carefully examined, the actions taken and words spoken by the Black lesbian butch femme within a cinematic reality will appear irrational or even magical because they do not follow the film's logic. Keeling's text ultimately implies that rather than silence this character, we should allow her to speak, for it is through her that a new vision for the world we live in, may be possible.

Toward the end of her book, Keeling discusses the black femme function: "The black femme function points to a radical Elsewhere that is 'outside homogenous space and time' and that does not belong to the order of the visible." The Black femme function does not refer to Black lesbian characters in film exclusively. As demonstrated in her final chapter, the Black femme function can apply to other characters that occupy similarly subjugated positions within cinematic reality. Keeling continues, "It represents affectivity's capacity to disturb the reproduction of social life by insisting on the existence of alternatives to existing organizations of social life, even if those alternatives are deemed irrational within hegemonic common senses".

In Eve's Bayou, for example, Keeling unravels how the film's main character assumes the Black femme function because she is able to see psychic visions that other people within the film are unable to see. This skill often silences her among other, seemingly more prominent

characters, and makes her appear 'crazy' to others within the film. But ultimately, her ability is what offers to the viewer a hint at a different form of reality. In essence, this character demonstrates how the Black femme is able to "take flight" with our imagination.

That Other Universe

In the age of the first Black president, the respectability politics of blackness has never been more prevalent in American society. There is the pernicious sense that if Black people simply play the game right by staying out of trouble, going to the right schools, getting the right jobs, and speaking in the right tone to the police, one day change will come. The actions of Bree Newsome questions this reality, and in the process points toward a new one. I argue that the rendering of Bree Newsome as a comic book style superhero after her courageous act of removing the confederate flag from the South Carolina state capital solidifies the moment when we, as a nation, saw her assume the Black femme function.

Speaking from the margins, Black people have stated for generations that the flag is indeed a symbol of our racist past, present, and future; so long as it is a state supported piece of property. However, until Newsome took down the flag, "common sense" dictated that the confederate flag was more than a relic of the Civil War, but a symbol of Southern heritage and pride—effectively silencing those in the margins saying otherwise. In the world of "common sense" what Newsome did defies logic: "Why couldn't she wait a few more days until the government steps in?" "What she's doing is illegal!" "There are more effective ways of effecting change."

Its no wonder that immediately following her arrest various artists depicted Newsome 51 as a superhero. As Keeling argues in her book, the Black femme's actions are often seen as irrational or magical because they do not fit the norm. The image of Newsome scaling the flagpole gave the entire country a glimpse of an alternate reality. One where activism prevails over tired social norms and where imagination triumphs over respectability. Newsome bravely showed us a reality we have seen glimpses of before from Ella Baker, Fannie Lou Hamer, Rosa Parks, Martin Luther King Jr., and Malcom X.

In this other reality, those speaking from the margins do not ask permission for their freedom. Instead, they envision the world they want and go make it happen. And even when the purveyors of common sense attempt to weigh these dreamers down to the ground, their unfiltered imagination will give them the strength to take flight.

See: Robles, Frances. "Dylann Roof Photos and a Manifesto Are Posted on Website". New York Times. June 20, 2015. http://www.nytimes.com/2015/06/21/us/dylann-storm-roof-photos-website-charleston-church-shooting.html

Blumberg, Antonia. "Activist Bree Newsome Reveals Staggering Faith During Confederate Flag Action". The Huffington Post: Religion. Jun 29, 2015. http://www.huffingtonpost.com/2015/06/29/bree-newsome-faith_n_7692004.html

See: Goyette, Jared. "Artists Explain Why Bree Newsome Became an Internet Superhero after taking down SC's Confederate flag". PRI: Arts and Culture. Jun 30, 2105. http://www.pri.org/stories/2015-06-30/artists-explain-why-bree-newsome-became-internet-superhero-after-taking-down

See: Keeling, Kara. The Witch's Flight: The Cinematic, The Black Femme, and the Image of Common Sense. Durham: Duke University Press, 2007. pg 14.
 Ibid., 20.

BLACK KIRBY // BLACK NO MORE CHAIR

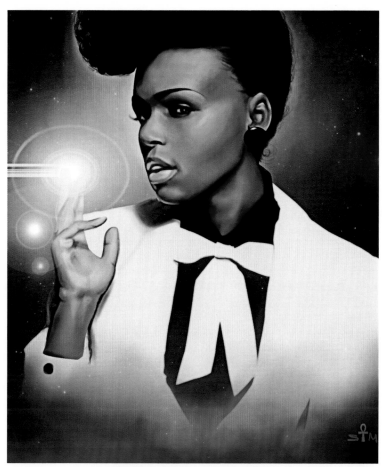

SHEEBA MAYA // JANELLE MONAE - THE ARCHANDROID

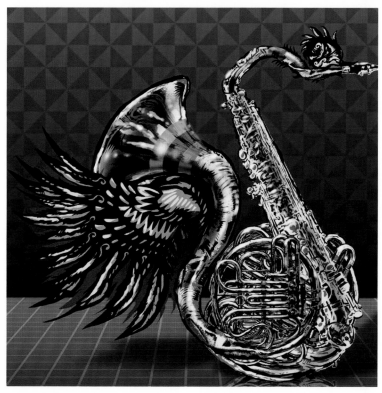

BLACK KIRBY // THE AFRO-HORN

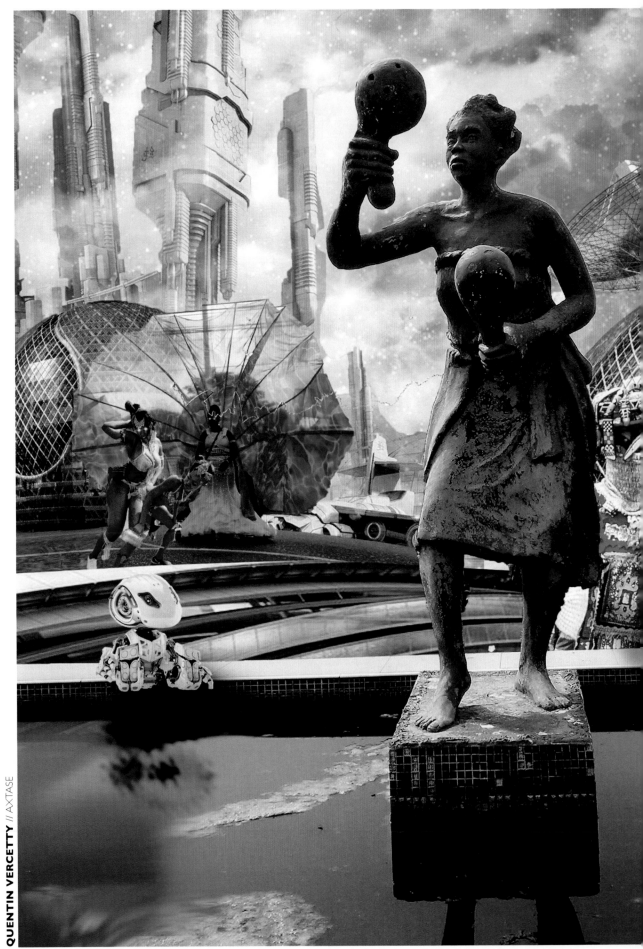

PROVIDENCE

Ajani Brown

His name was Wanyandey, a recently ascended ancestral spirit. His domicile was the Bagua dimension – the afterlife realm of the terrestrial House of Songhai, a tribal group on planet Nubi. The All Mother Goddess, Nalofeta, welcomed his transition to the infinite plane of existence.

"This is our continuum. Here we see all things through time, guide and empower our descendants," she said.

She spoke not with sound from a mouth, but rather, her conciseness vibrated, rippling throughout the universe, emanating from all directions. Wanyandey felt surrounded by her presence and heard her voice, as an unborn child does his mother. Bagua was Nalofeta's womb. Wanyandey's senses were adjusting to his elemental shroud. He could feel sound and communicate to the goddess without speaking – his body functioned like an ear and mouth. He heard through himself and spoke with thought.

"Can I leave this place?" Wanyandey asked. "Only if you are called by a descendant. But those moments are temporary, fleeting, for we are timeless," Nalofeta said.

* * *

In a village, on a rural patch of tendered land, on the high plains of Nubi, youth gathered. They arranged themselves in a semi-circle around a man named Budallu, the spiritual leader of the House of Songhai. It was nighttime on the eve of The Fest for Nalofeta – an annual gathering to worship their All Mother Goddess and those who passed away during the previous year. During a period of eight days tribal members feasted, danced, sung, prayed and told humorous stories of deceased family members. Wood smiths carved Kanaga masks used to call and house the spirits of their ancestors. Each mask was named for the person it represented. The ceremony ended with the choosing of a young tribal member that would lead and protect their homeland while dawning a Kanaga mask.
Budallu, a man small and stout, stood with outstretched arms. His face, neck and chest were coated with multi-colored iridescent paint. His skin illuminated in the twilight with stripes of orange, red, green and yellow. One hand held a walking stick carved from driftwood. Within his other hand he held a meteorite fragment, silvery gray in color.

"Children, why do we gather here tonight?" Budallu asked. In unison the youth responded, "To praise Nalofeta, ask our ancestors for guidance and chose the next Shujaa." In a breathy exhale Budallu said, "Yaaasss!" He continued, "The Shujaa is amongst you my children. A fearless warrior ready to defend the House of Songhai against the Mech Masai."

* * *

The Mech Masai were a rival clan, lead by the rapacious Empress Fujo, who ascended the throne by force after a matrilineal civil war. Centuries ago the clan's alchemists created bionic exo-skeletons to enhance overall strength. Initially the technology was used to build structures faster and harvest food more rapidly. They constructed pyramid temples that towered high into the sky – four sided mountains that shimmered in the brilliance of Nubi's twin suns – white and blue dwarf stars. They built water canals that stretched for miles, transporting millions of gallons a day, and a network of roads all leading to the center of their metropolis.

Pre-civil war they lived in harmony with other tribes, often trading goods and resources. Then Fujo mobilized her people, pushing for planet wide expansion. She had grown tiresome of the physical limits of her territory. She first turned on her weaker, less technologically advanced neighbors; ordered the destruction of their villages, assimilation (or death) of the peoples and hijacked natural resources from claimed lands. The brave tribal warriors tried futilely to defend against them. Empress Fujo's army of Mech Masai warriors pillaged swiftly until they reached the outskirts of the high plains territory of the House of Songhai, where they stood by waiting for orders to attack.

* * *

"The time has come to choose," Badallu said.

He then tapped the top of his driftwood staff on the meteorite fragment repeatedly as he whispered a mantra under his breath. The crowd of youth watched in silence, still standing as the small rock began to glow and spin in his hand. It then rose off of his palm, continuing to spin, arching over the semi-circle of onlookers. Their eyes were transfixed on its apogee, as it began to glide directly over them and descend. The rock ceased movement over a teenage girl named, Sadiah-Jala. The youth saw that she was the chosen one, surrounded her and kneeled.

In unison they said, "Sadiah-Jala is Shujaa!"

Badallu motioned for the girl to come toward him.

"Young child you must now choose a mask," he said and pointed in the direction of the cave on the northern edge of the village.

Alone, Sadiah-Jala walked proudly, knowing this was an honor. She had learned from Songhai griots of the Mech Masai's harassment of her people. They wanted the Songhai's most precious resource - the star that fell from the sky; a fragment of which was held by Badallu during the choosing ceremony. It was the key to the Songhai's connection to Bagua and allowed the masks to open the dimensional portal for the ancestral spirits to travel back to Nubi.

Sadiah-Jala arrived at the cave. It was filled with Kanaga masks. The cave was illuminated by the glow of the larger remaining portion of the meteorite. She looked about the collection of faces, all unique, as different as the people they represented. Thinking back to the stories told by the griots she remembered a great warrior by the name of Wanyandey and how he staved off the Mech Masai for years, single handedly. She searched for his mask found his name carved into one that was freshly painted by Songhai artisans.

"I am Wanyandey," Sadiah-Jala said, as she dawned the Kanaga. Her body tensed with an adrenaline-like jolt that shocked her system. Her senses were amplified; she could feel the Mech Masai's proximity to her village.

* * *

Wanyandey felt a sensation akin to the pull of gravity on Nubi. He became conscious of an alternate location not Bagua, and began to see flashes of the cave familiar to him as a young boy. He was viewing this place through another's eyes.

"Nalofeta what is happening to me?" He asked. Immediately he sensed her thoughts saying, "A descendant has called upon you."

The pull on Wanyandey's shroud continued, for he had no control over the transition. His vision soon cleared and he saw that he stood at the opening of the cave. He felt a heart beating rapidly in his chest, the ground beneath his feet, the air in his lungs and the sweet sound of his people singing loudly.

* * *

Sadiah-Jala walked out of the cave to find her entire village waiting. They sang a proud, joy filled, call to arms. In unison, they chanted, "The House of Songhai is here, and will be for all days, with the blessing of Nalofeta, and the powers of...Wan-yan-dey, Wan-yan-dey, Wan-yan-dey...The House of Songhai is here...."

A distant drum warning sounded, silencing the villagers who rushed back to their homes. Sadiah-Jala ran toward the outskirts of her homelands, each stride covering swaths of ground, impossible under her own power. She felt no fatigue when she arrived and saw, in the distance, an amassing of Mech Masai primed for an attack. Seeing her and realizing the element of surprise was gone, they charged. A boulder sat between Sadiah-Jala and her storming enemy. She ran directly into it, felt no pain and caused it to roll rapidly into their regimental center. Several warriors lay crushed in their exo-skeletons.

Her legs bent and feet pressed down hard on the regolith, she leaped into the sky. Gravity no longer had the same effect on her body - she remained aloft. Her perspective of the battlefield allowed her to see all of the remaining Mech Masai, strewn about, scattered, some still charging toward her village. Focused on those closest to her fleeing people, she flew down and rammed into the advancing column, crushing the frail bodies. Aloft again, she held a Mech Masai warrior's leg in her grasp, strong enough to crush his bone. He flailed about in pain as she effortlessly threw him, creating a missile targeted for his fellow attackers, dismembering them in the process.

"I am Wanyandey!" She screamed then rapidly descended, impacting the ground, causing a thunderous quake that ejected the few remaining Mech Masai off their feet and high into the sky. With one final leap, her speed pierced the sky in a supersonic clap. She flew through the bodies of all the helplessly airborne adversaries, vaporizing them in the process.

Empress Fujo, observed, in agony, from a safe distance, seated on her throne, parched on the shoulders of a quartet of Mech Masai guards. Her army was decimated again the by the superior Songhai force. She knew she'd have to revisit her strategy, yet again, and grow more Mech Masai clones.

TIM FIELDER // *YEMEJA GIVES BIRTH TO THE WORLD (BLACK METROPOLIS SERIES)*

T H E B L A C K
F A N T A S T I

When one thinks of "high fantasy," images of fairies, knights, dragons, and castles fill our heads from years of programming the notion that these stories are an important element of universal mythologies, yet people of African descent are completely absent. Epic tales of mystical journeys, daring adventures, and hidden magical truths do not seem to be for Black people, if you adhere to popular media's presentations of these worlds.

Truth be told, some African Americans are actually descended from kings, queens and warriors. The cultural histories of the African Diaspora and its magicians and sorcerers are just as powerful as any Gandalf or Merlin. Black people have their very own dwarves, goblins, giants and mystical creatures that come directly from their cultural heritage. Stories such as David Anthony Durham's Acacia books, N.K. Jemisin's Inheritance Trilogy, and Charles Saunders' Imaro novels are proof positive that people of the African Diaspora are not limited to a quest to Middle Earth where they find themselves extinct. The Black Fantastic is part of the alchemy of the black imagination. Often referred to as "sword and soul," black bards are weaving truly magical stories from the thrones of fantastically black kingdoms and empires.

63

RIVENIS BLACK

FROM AUDRE LORDE TO AFRICA BAMBAATAA: BLACK GERMANS AND THE POLITICS OF DE_PERCEPTION

Natasha A. Kelly

The attributes Black and German often seem an oxymoron, not only to White German national(ist)s but also to the Black community worldwide. Due to this, the history of Black Germans remains unthinkable, although told time and time again. Hence, this paper aims to promote the Black German narrative and situate it within the context of Afrofuturism. By focusing on two major turning points, it seeks to disclose the politics of de_perception and denote Black German visions of future.

Although they could not be more different, both Africa Bambaataa and the late Audre Lorde have a lot in common. Born and bred in New York City, they both shifted their worldview after spending time in Africa and the Caribbean. Having reconnected with their ancestors, they individually started to promote social change worldwide. Audre Lorde's idea of *global sisterhood* reached Germany in the early 1980s breaking with what Audre Lorde coined the *mythical norm*.

Around the same time, Africa Bambaata's concept of a *Universal Zulu* Nation disembarked in the country and continues to address the alchemy of Blackness. Using poetry and rap, Black German writers and musicians adapt these imported cultural designs of the African Diaspora which challenge euro-centric readings of their realities and experiences and while creating a currency noteworthy of their existence. While Africa Bambaataa functions as the *urban griot* in the underground music scene, Audre Lorde's work operates as the *culture broker* who deals in Black German knowledge production in academia. Audre Lorde, who taught at the Free University in Berlin, inspired her Black students, including the (soon-to-become) famous poetess and political activist May Ayim (formerly known as May Opitz), to address and document their own *herstories*. She especially encouraged Black women to look behind the veil at Germany's colonial past and take an active role in the deconstruction of binary oppositions and hierarchies.

"When we view living in the European mode only as a problem to be solved, we rely solely upon our ideas to make us free, for these were what the white fathers told us were precious. But as we come more into touch with our own ancient, non-European consciousness of living as a situation to be experienced and interacted with, we learn more and more to cherish our feelings, and to respect those hidden sources of our power from where true knowledge and, therefore, lasting action comes."

By transforming silence into language and action the unspeakable becomes spoken. The re-articulation of a hyphenated identity is worded in the term *Afro-German* and thus the unthought-of becomes thinkable. In the context of the second wave of the German Women's Movement, at a time when topics on sexism and homophobia were no longer taboo, Audre Lorde succeeded in importing questions on racism into the German feminist discourse. For the first time in German academia, White women who held the power of voice were forced to rethink their dominant positions. Consequently, a separation between whiteness, including all its social privileges and Blackness as a marginalized position, became visible on the basis of gender categorizations. Black German women published the first German-language anthology *Farbe bekennen* was in 1986 that led to the organisation of the ISD and ADERFA . Participation in this Germany-wide network of politically active Afro-Germans sharpened the political consciousness of the first generation of Black German MCs and directed Black German youths to the social realities of scarcity, and rap music, break dancing and graffiti art. The vanguard generation in Germany included the group *Advanced Chemistry* that made hip hop a national phenomenon.

As one of only a few German groups, *Advanced Chemistry* became part of the *Zulu Nation*. In 1985 Zulu Nation founder, Africa Bambaataa appointed Torch the first German Zulu King. As co-founder of *Advanced Chemistry*, Torch contributed to the emergence of German-language rap. From the announcements between songs during concerts, he developed German-speaking freestyles, which finally resulted in German lyrics.

During the late 1980s and early 1990s however, it was not cool to rap in German. At the time, too little of the native language could express a positive attitude towards Black life in Germany, which was tainted by continuities of colonialism and national socialism. There was no vocabulary to support or describe Black positivity and therefore no palpable acknowledgement of positive Black life as a German. Black Germans were compelled to look to the United States for role models who they found in KRS One and other hip hoppers of the time. Their final break-through nonetheless was achieved with their 1992 anthem *Fremd im eigenen Land*. Describing the social reality of Black Germans and other ethnic minorities as that of *aliens in their own country*, *Advanced Chemistry* stood in line with the authors of Farbe bekennen, which is presently hailed as a milestone in the canon of Black German knowledge production. By audio-visualizing the concept *Afro-German*, the group also adapted the afrofuturistic idea of alienation in their textual representation. However, the music video did not contain science fiction or comic elements but, for the first time, showed a majority of migrants embracing their subjectivity, which was a novelty in the German music industry. For the first time, German rap forwent spoof depictions and transported a deep political message to a non-academic audience. Since then Torch has continued to carry the light of hip hop culture as Dj Haitian Star throughout Germany and globally.

Farbe bekennen and *Fremd im eigenen Land* are two of many moments in time that mark contemporary Black German history. Not only are visions of Black social realities unveiled, but also the racial politics of de_perception are evident of how Germany upholds its white supremacist power structure.

Targeted forms of inaction (not speaking, not seeing or not thinking about racism), alongside the act of colour-blindness had hitherto distorted African German truth and situated Black Germans in cultural rootlessness. Perceptions of the white German majority considered *objective* or *neutral* had a central impact on social-political decision-making processes while that which lies beyond the standard was de_perceived. Accordingly, reflexive observations show the extent to which colonial practices are transported into present time and lead to the distortion of social political movements. Both Audre Lorde and Africa Bambaataa facilitated the development of resistance strategies and cognitive attributions of meaning (sense). Therein Black Germans gained the ability to produce independent and self-determined knowledge, which they shared with each other and thus enabled socialization in the form of community building. Black German visions of future, however, are yet to unfold.

The underscore in de_perception opens space to the reflexivity of the word. Within the blind spot of every perception a deperception takes places. Thus perception and deperception always occur simultaneously.

Audre Lorde describes the white, male, heterosexual, standardized norm as mythical, as it creates a false hierarchy. In: Audre Lorde (2009): Difference and Survival. An Address at Hunter College, I am Your Sister. Oxford University Press, 203

Audre Lorde (1984, 2007): Poetry Is Not a Luxury, Sister Outsider. Berkley, 37

"Farbe bekennen. Afro-deutsche Frauen auf den Spuren ihrer Geschichte" was the first anthology published by Black German Women in Berlin in 1986. The English translation was published in 1992 under the title: "Showing Our Colors. Afro-German Women Speak Out".

Initiative Schwarze Deutsche (The Initiative of Blacks in Germany) is a political organization that represents the interests of Black people in Germany, promotes Black consciousness and publicly opposes racism etc. http://isdonline.de/

ADEFRA is the sister organization of the ISD with focus on women's issues http://adefra.de

Translated: An Alien in Your Own Country

For more information on the early days of Black German rap artists see the interview with Kofi Yakpo, member of Advanced Chemistry under: Morhttp://www.bpb.de/gesellschaft/migration/afrikanische-diaspora/59580/afro-deutsche-rapkuenstler?p=all

69

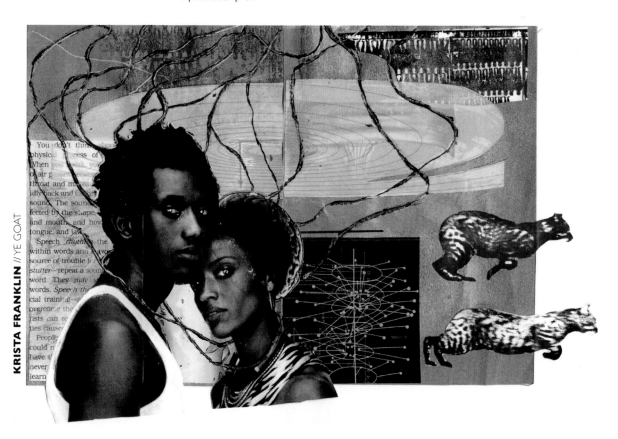

KRISTA FRANKLIN // YE GOAT

ODERA IGBOKWE // SHANGO

JASON REEVES & LUIS GUERRERO // TAUSI AND NUNDI

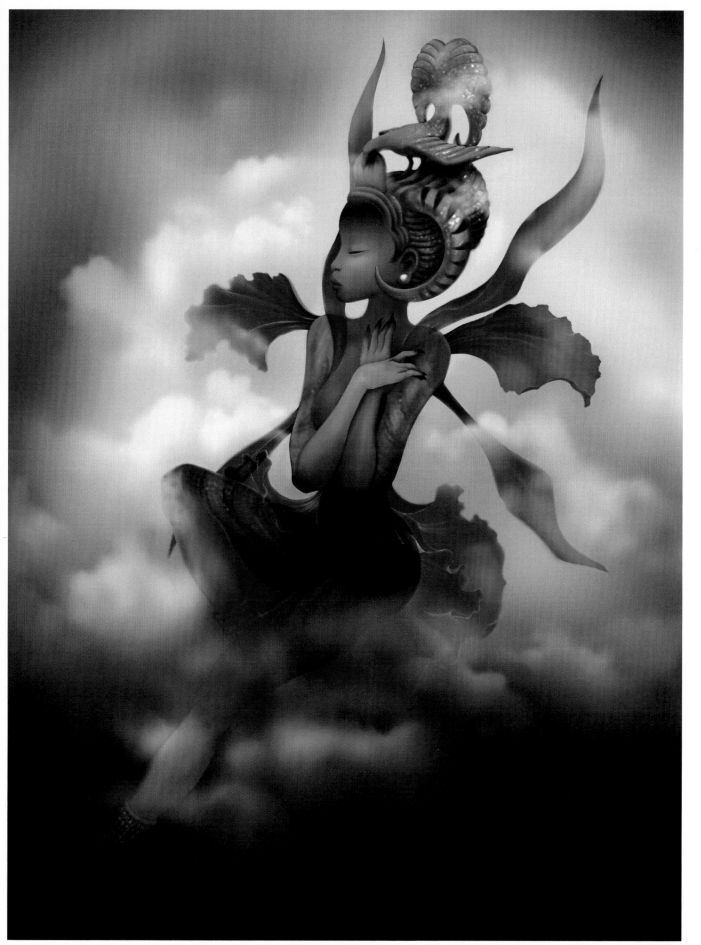

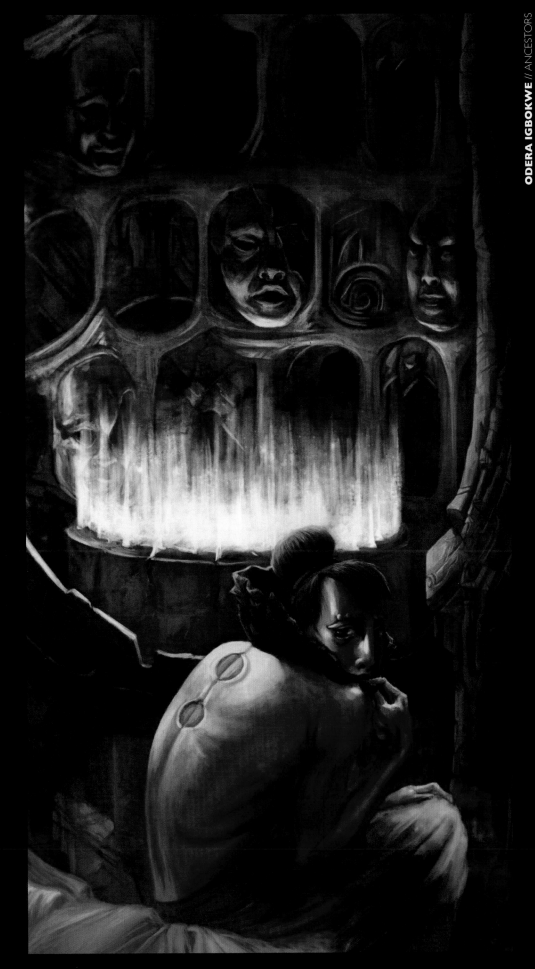

BLACK STAR LINE

Moor Mother Goddess

On an altar in New Orleans there is a
shrine dedicated to Marcus Mosiah Garvey
a time capsule of this moment
Eternity be our measurement
Success, success
We chanted
Success, success
Over and over again
We couldn't believe our hearts
Couldn't believe the sounds coming out of brother Garvey's mouth
His mighty voice, fire
his eyes, a billion earths
He came to speak in New Orleans
but before he could even speak,
He was arrested
We gathered every gun, every weapon, every hand we could find
gathered around the jail
Determined and fearless
We needed to hear him
We was going to outer space
We was gonna have an outer body experience
We was gonna be the first ones
The guardians on the black star line
Soon as them White boys saw us, they let him right out
Some of them even followed us to the lodge and we chased them right back to where they came from

Not afraid to die
'Cause even in death we are just beginning to fight returning from wherever they want to send us;
heaven or hell
The plantation or exile
returning
Death is not a factor in the liberation of African people
We will return
revolutionary spirits from the Americas the Caribbean, Africa
Always returning
'Cause Marcus Mosiah Garvey has built us a spaceship
that we can activate right now
The black star line
They think we about to sail
back to Africa
Code words
You know Africa is a planet off the coast of Tanzania
Under a moon called Ghana
Garvey said "let Africa be a bright star against the constellations of nations
So that we may always be illuminated in any dimension so we may find our way home." He said
"We have a beautiful history and we shall create another in the future that will astonish the world"
We chanted
Success, success
We had the coordinates
Past relic
Present shrine
New future
New world

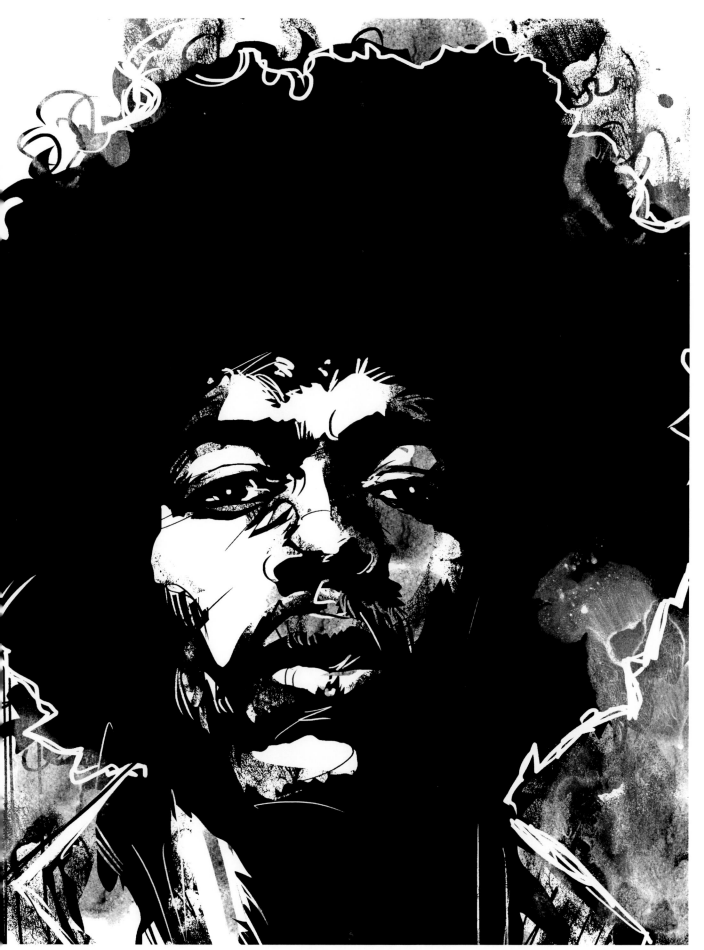

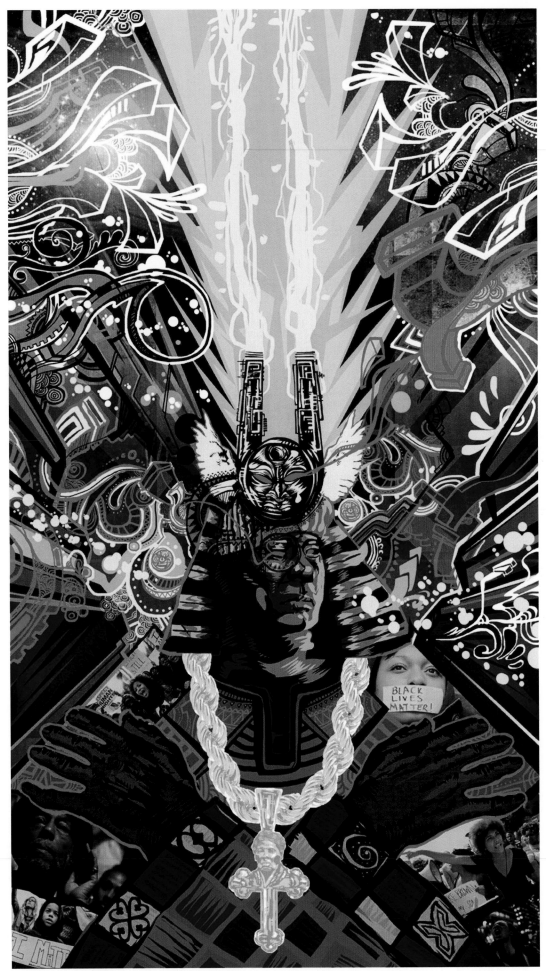

STACEY ROBINSON // SUN-RA WITH A HARRIET TUBMAN JESUS CHAIN

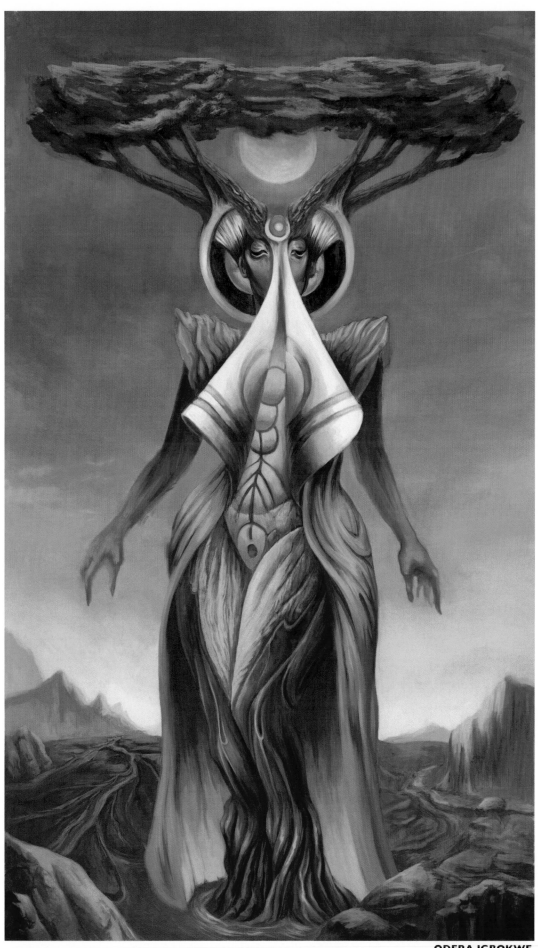

ODERA IGBOKWE

DARK MATTERS

James Weldon Johnson's lyrics in "The Negro National Anthem" speak of singing a song "full of the faith that the dark past has taught us." Dark Matters signifies the ways in which this "dark past" can manifest when left unexamined. The generational traumas of slavery metaphorically haunt our nation and create spectres that can only be dealt with by staring them in the eye and naming them. It is this power of the word that gives black people the light to dispel the dark and move into a productive future.

Storytellers Toni Morrison, Malorie Blackman, Tananarive Due, Brandon Massey and Linda Addison are not afraid to play in the dark. These writers' words exhibit the bravery needed to face the gothic horrors of the collective American history. Primarily speculative cultural narratives that actively engage with negatively affective racialized psychological traumas via the traditions of Gothic tropes, and deal with the complex disruptive tensions between the constructions of memory, history, the present, and the self, could very well be called the ethnogothic. These cultural narratives are generated to cope with the things that we hide away from the world and even from ourselves. With this intention, stories and images can exorcise the spirit of this history, seek the light, and dispel these ancient terrors.

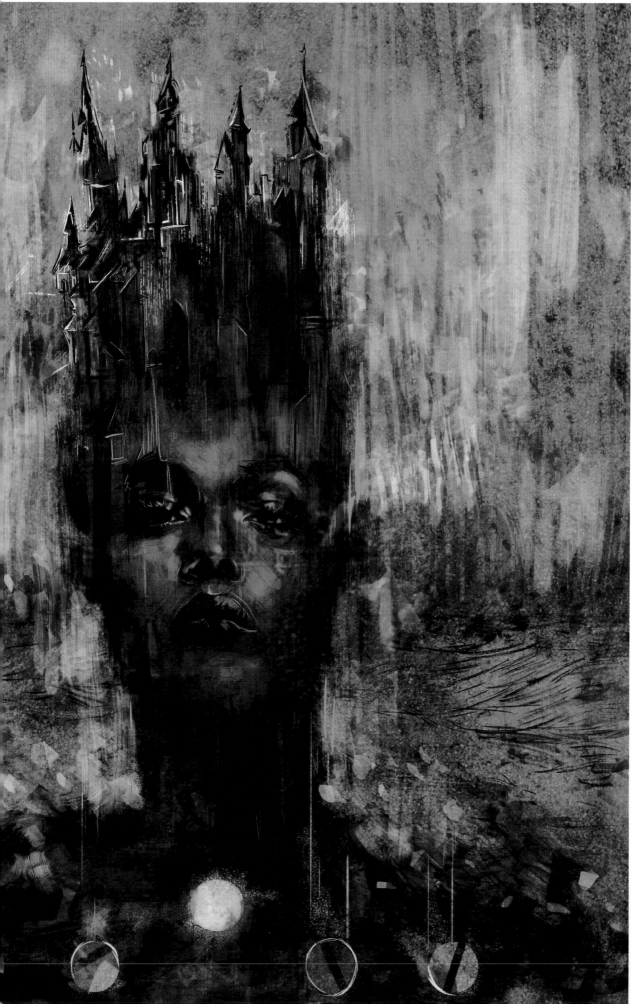

ODEDERA IGBOKWE

THE ELECTRICAL SCENT OF DAMAS: NEGRITUDE, THE HARLEM RENAISSANCE, AND THE AFROSURREAL

D. Scot Miller

"Yet above all, the Earth being for me the specificity of Africa, as revealed by Diop, and Jackson, and Van Sertima, and its electrical scent in the writing of Damas. Because of this purview I have never drawn to provincial description, or to quiescent chemistry of condensed domestic horizon" —Will Alexander, My Interior Vita

As a poet, I feel the tension in these lines from Afrosurrealist Will Alexander's poem, My Interior Vita, from his 2011 collection, Compression & Purity (City Lights). This tension is both a challenge and a declaration residing from the first line, "Above all," to the last "condensed domestic horizon," but where does it come from? It is not the "specificity of Africa," so much as that line's distance from "its electrical scent in the writing of Damas." One must reach across a great chasm of specificity, where scholars like Diop and Van Sertima dwell, to get to the Guyanese artist/poet Léon-Gontran Damas, and even then, all that is there is his "electrical scent."

The chasm Alexander addresses is one between the essentialist scholar's notions of specificity and the more nuanced, nebulous "scent" of Black arts and culture. Regarding Black Radical Imagination and Black speculative manifestations, this tension has made itself known when considering how one should mine the past, present, and future in both scholarly and artistic practice.

As The AfroSurreal Manifesto and Afrofuturism come to the fore in artistic, commercial and academic circles, the struggle between the specific and "the scent" has come with it, posing interesting challenges to both movements. For Afrofuturists, this challenge has been met by inserting Afrocentric elements into its growing pantheon, the intention being to centralize Afrofuturist focus back on the continent of Africa to enhance its specificity. For the Afrosurrealists, the focus has been set at the "here and now" of contemporary Black arts and situations in the Americas, Antilles, and beyond, searching for the nuanced "scent" of those current manifestations. This speaks to a long-standing disconnection between the histories of Black radical artistic movements, exemplified by the supposed chasm between Damas' Negritude, the Harlem Renaissance, and the contemporary Afrosurreal movement.

What Alexander posits in his poem is what Peter Lamborne Wilson termed in his book Sacred Drift: Essays On The Margins Of Islam (City Lights, 1993) as a "poetic fact," an insurrectionary image that punctures history, one that both troubles and stimulates, one that asks more questions than it answers. The question I am interested in for this essay is: What is Damas' "electrical scent," and how can it inform us about the connected histories of contemporary Black cultural movements?

In the seminal AfroSurreal anthology Black, Brown and Beige: Surrealist Writings From Africa And The Diaspora (UT Press, 2009), editor and UCLA historian, Robin D.G. Kelley, calls Damas a member of, "The Triumvirate Of Negritude And L'Etudiant Noir": "It was this remarkable trio— (Aimé) Césaire, (Léon -Gontran) Damas, and (Léopold Sédar) Senghor —who in March 1936 started the paper L'Etudiant Noir, long renowned as one of the monuments of Negritude. Indeed, it was in the pages of L'etudiant Noir that the word 'Negritude' (coined by Cesaire) first appeared in print."

Negritude, being one of the first international Black cultural movements, has been defined in vastly broad ways. Wikipedia includes in its definition, "The problem with assimilation was that one assimilated into a culture that considered African culture to be barbaric and unworthy of being seen as 'civilized.' The assimilation into this culture would have been seen as an implicit acceptance of this view." This commentary would lead one to believe that Afrocentrism and the scholarly specificity of Africa were the driving engines of Negritude, and thus Damas' "electrical scent." However, in Black, Brown and Beige, Professor Kelley includes an excerpt from Damas' 1974 collection, Continuities. Nineteen seventy-four (1974), the very year Amiri Baraka coined the term, "Afrosurreal Expressionism:"

"Startlingly, the Negritude was not conceived by Africans in the Motherland, but by those influenced by the spirituals, blues and jazz of the United States of America; the sound and dance of Cubans; the batucada, samba, frevo, and capoeira of Brazil; the merengue and petro of Haiti; the mereque of the Dominicans and Puerto Ricans' the calypso of Trinidad and Jamaica the casse-cou of Guyana, not to mention the beguine of Martinique and Guadeloupe - all of which had their origins in Africa.
Here Negritude was born—not in Africa, but the West Indies.

It was not until the 1920s and 30s that there arose a generation of writers who, instead of voicing cries of complaint and hope, demanded justice, and of Blackness its entitlement to civil and cultural rights, as W.E.B.Du Boise defended so eloquently.

It was the birth of the Harlem Renaissance and the New Negro in whose name Langston Hughes proclaimed a manifesto:
'We younger Negro artists who create intend to express our individual dark-skinned selves without fear or shame. If the white folks seem pleased, we are glad. If not, it doesn't matter. We know we are beautiful. Ugly too. The tom-tom cries and the tom-tom laughs. If colored people are pleased, we are glad. If they are not, their pleasure doesn't matter. We build our temples for tomorrow, strong as we know them, and we stand on top of the mountain free within ourselves.'

"The profound sense of this manifesto was realized by Negritude: Césaire, Maugée, Achille, Gratian, Senghor, Diop, myself and others. We were determined to follow in the footsteps of Langston Hughes, Countee Cullen, Jean Toomer, Sterling Brown, and Claude McKay, the author of Banjo, who realized in 1930 (a date to remember), a much-deserved success. Césaire, Senghor and I helped as much as we could to make all of their works well known."
— Léon-Gontran Damas, Negritude and Surrealism, 1974

In one paragraph, Damas makes the connection between Negritude, unequivocally showing that its impetus is deeply grounded in the contemporary Black American and Antillean cultural production of the Harlem Renaissance, and ends with a prescient declaration to the power of Black American manifestos, a document both he and Césaire employed in forming the contours of Negritude. This passage, taken as a whole, tells us that Damas' "electrical scent" is clearly an AfroSurreal one.

As Black speculative practice evolves into the new millennium, it would behoove artists and scholars alike to remember both the ancestor veneration and analytic rigor of those who came before us, and attempt to approach our practices with a "both/and" mentality over an "either/or" one. From Robin D.G. Kelly's Black Radical Imagination to the Afrosurreal Manifesto, to move away from these terms and functions is to widen the chasm between the specific and the "scent."

As an AstroBlackness organizer, Adilifu Nama, said at their conference in 2015, "I think Afrosurrealism— that is Afro, Afro-American, Afro-Latino—Afro communicates what in fact we are looking for. It gives us an orientation. It locates us in a historical discourse. When we move away from Afrosurrealism, we move away from [Amiri] Baraka [and] notions of Black Dadaism that's lost this general notion of Ethnicity. I need to know who is saying what to understand what is being said."

ALEX BATCHELOR // THE BETWEEN

" ODDITIES OF NATURE"

THE ODDITIES OF NATURE: BISHOP CHARLES H. MASON AND THE REALM OF THE SUPERNATURAL

Rev. Andrew Rollins

There are several photographs of Bishop Charles H. Mason, the Chief Apostle and Founder of the Church of God in Christ, sitting behind a desk with various "oddities of nature" on display. Just what were these strange looking items? Physically they were weird shaped branches, stumps, roots, vegetables and rocks but spiritually they were more than that for they were used by Bishop Mason as sources of discernment and revelation. These pictures repulse some people. To them the scene of Mason with these objects looks grotesque. Others consider it demonic reasoning that the artifacts are instruments of witchcraft and there are those who see the photographs of Bishop Mason with these objects as representative of his spiritual depth and acuity. This latter group surely has a better understanding and appreciation of spiritual matters and cultural differences.

Certainly these pictures exemplify Bishop Manson's faithful walk with God and his allegiance to his African heritage. According to Bishop Ithiel C. Clemmons, author of *Bishop C.H. Mason and the Roots of the Church of God in Christ*, "Mason was firmly committed to preserving the African spirit cosmology." Anthropologist and Afro-Pentecostal scholar Craig Scandrett-Leatherman describes Mason as a man who had Slave Religion in his heart and roots on his desk. To grasp how Bishop Mason used physical objects to receive spiritual messages it is necessary to have a working knowledge of his social and spiritual background. Therefore we will review his social background, and then we will review his spiritual life as a prerequisite for interpreting his use of the oddities of nature.

Bishop Charles H. Mason was born September 8, 1866 in Shelby County, Tennessee. He lived a long life that nearly stretched into a century, dying on November 17, 1961 at 95 years old. Mason began life one year after the close of the Civil War, which brought slavery to an end. His parents, Jerry and Eliza Mason, were former slaves. Even though Mason lived in a time when Black people in America were treated as "second class citizens" and subjected to racist terror by government institutions, commercial enterprises and secret societies, he still achieved a great deal in his life. Beating the odds, he overcame enormous obstacles that the world placed in his path. Despite being born a Black man in the brutally racist southern part of the United States in the nineteenth century, Mason became one of the founders of the Pentecostal Movement and he also founded the Church of God in Christ, which is now the largest Pentecostal Church in the United States.

Although the Church of God in Christ was officially founded in 1907 in Memphis, Tennessee the movement, which gave birth to this church began in the 1895 in Mississippi, taking root in the Tri-State area of Mississippi, Arkansas and Tennessee before spreading throughout the United States. In the early years of this movement, Mason travelled all over the Tri-State region sowing the seeds of the Holiness/Pentecostal message. Upon examining Mason's origin and primary venue of ministry it would be appropriate to say he was a Southern preacher. However he was not provincial, rather he was a deep thinker with a vision big enough to have universal appeal. Mason's roots ran deep into southern soil. He was licensed and ordained to preach in 1891 in the Baptist Church in Preston, Arkansas and in 1893 he entered Arkansas Baptist College in Little Rock, Arkansas where he studied for a while. In 1895 he met Charles Price Jones a Baptist pastor in Jackson, Mississippi who was also a writer and hymnologist. Discovering that they shared an affinity to the Holiness/Sanctification doctrine led them to form a partnership to do ministry. Eventually both Mason and Jones would be expelled from their local Baptist Association for preaching the Holiness message of entire sanctification as a second work of grace because this belief ran counter to Baptist doctrine.

Mason began his ministerial career when race relations were at a very low point in America: a period historian Rayford Logan called the nadir. These were very dangerous times for Black people, especially in the South. Yet Mason was committed to ministering in the South where he maintained his base of operation all his life. Biographer Eugenia Green, author of *Mason: The Profile of a Saint*, said this about Bishop Mason and the times he ministered in the South:

"Bishop Mason had the courage to stand still in the times of adversity. He did not flee from the dangers of the segregated and racist South. He remained fearless in the face of eminent danger. It was a time when thousands of Black men, women, boys and girls were lynched, burned at the stakes, shot, drowned, tied to tracks, beaten, threatened, and ridiculed. It was a time when justice for Blacks was literally non-existent. Whites could openly brag about atrocities against Blacks. If they were arrested, courts and juries would find them innocent. It was the time of Jim Crow."

Mason was a man of valor and integrity in the face of all this horror. Green says that Mason preached boldly though he was "persecuted for his stance against segregation and injustice;" though "he was beaten, shot at, jailed" and had to stand before "local and state magistrates falsely accused." He was even accused by the F.B.I. of espionage during World War I and his stance against war as a conscientious objector also caused him trouble with the F.B.I. According to Green, "He objected to killing other human beings and strongly objected to Black men and Black women losing their lives for a country where they were not totally free." It was in this time that Pentecostalism came into being.

Pentecostalism emerged amid Black Codes, terror and the pervasive injustices of the South. During this time a Black man could be arrested for vagrancy and then sold for free labor for a financial fee paid by a company to the county or state government, until the duration of his sentence. Douglas A. Blackmon calls this convict lease system "slavery by another name." So when Mason went from town to town preaching, he could have fallen victim to this system. Yet Mason dauntlessly continued to travel preaching his Pentecostal form of Christianity - giving encouragement, comfort and direction to thousands of marginalized Black people. I t has been said that Pentecostalism enabled many African-Americans to endure hardships in a world that brutalized and dehumanized them and where their

traditions were being ridiculed, demonized and in many cases obliterated. The founders of the Black Pentecostal Movement linked the spiritual and the physical in an African cosmological fashion in which the spiritual and the physical world are a unified field where the temporal and eternal interact. This world view empowered them with a "prophetic social consciousness" and "a sense that the Holy Spirit not only transforms persons but rearranges relationships and structures." They would find this perspective helpful in navigating an environment that relegated them to a subjugated position as members of an oppressed, stigmatized race. Possessing a deep communion with God gave them the fortitude to face racism, segregation, peonage, poverty and the Klu Klux Klan. They could carry on in abject conditions knowing that there was a God who super-ruled over human rulers and that the Spirit of God intervened in the affairs of this world.

In order to gain a good understanding of Bishop Mason's life, it is important to realize that he was primarily a spiritual man. Even in the midst of a terribly racist environment he lived the life of a "Man of God." Therefore, to truly know Mason one must explore his spiritual life. Comprehension of his interpretation and relationship with Slave Religion, Pentecostalism and the Realm of the Supernatural are necessary in understanding the spirituality and theology that informed and guided his ministry. Moreover, having knowledge in these areas is critical in getting to the basis for his viewpoint on the oddities of nature.

First, in understanding Bishop Mason's spiritual journey it is necessary to recognized the importance of Slave Religion in his life. Mason was birthed out of Slave Religion and was an advocate of Slave Religion throughout his ministry. As a boy Mason prayed, asking "above all things for God to give him a religion like the one he heard about from the old slaves and saw demonstrated in their lives." Just what is Slave Religion? Bishop Ithiel C. Clemmons historian of the Church of God in Christ said, "The most durable and adaptable constituents of the slave's culture, linking the African past and the American presence, was his or her religion. The slaves' unique biblical and theological reflection gave rise to a remarkably indestructible, autonomous institution: the black church." According to Clemmons Slave Religion was an institution peculiar to the African diaspora in the United States. It espoused a Christianity that refused to "uncritically accept the Eurocentric interpretation of biblical and theological thought" but developed a biblical, theological tradition that reflected Black people's feelings and thinking "in light of their ordeal as slaves." W.E.B. Dubois at the opening of the twentieth century stated that the Black Church in America was the only social institution started in the African forest "that survived slavery; under the leadership of the priest or medicine man, afterward the Christian pastor" and that being "the sole surviving institution of the African Fatherland accounts for its extraordinary growth and vitality." Charles H. Mason was a powerful and influential Black religious leader in that tradition. Clemmons said, "Mason especially insisted upon the centrality of personal inner transformation without shedding distinctive African cultural expressions." In the 1920,s anthropologist and folklorist Zora Neal Hurston made this fforward thinking statement:

"The Saints or the Sanctified Church is a revitalizing element in Negro music and religion. It is putting back into Negro religion those elements which were brought over from Africa and grafted on to Christianity as soon as the Negro came in contact with it,"

In that spirit Mason embraced the African worldview and religious folk culture of Slave Religion as a positive spiritual path. He militantly defended the "ecstatic practices" of exuberant worship services, shouting, dancing, trances and the use of instruments such as the tambourine, drums, guitar, trumpet and other instruments often associated with jazz and blues. He was also open to other folklore modes of ministry that were a function of

Slave Religion such as the use of the "oddities of nature" as means of discernment.

The crowning event expanding Bishop Mason's spirituality was his experience at the Azusa Street Revival where he received the baptism of the Holy Spirit. It was this experience that triggered his transition from being Holiness to being Pentecostal. This change in his doctrine would cause a split from his friend and ministry partner Charles Price Jones who rejected Pentecostalism. The Azusa Street Revival took place in Los Angeles, California between 1906 and 1909. This revival, which birthed the Pentecostal Movement, was led by a Black Holiness preacher named William J. Seymour. Seymour was born in 1870 in Louisiana to parents who were former slaves.

Like Mason, Seymour was steeped in Slave Religion and had become a Holiness preacher. At Azusa Street, Seymour preached that the gifts of the spirit that were operable in the early church were available to modern day believers and he beckoned people to be baptized in the Holy Spirit like the believers were on the Day of Pentecost. Thousands of people were receiving the baptism of the Holy Spirit at the Azusa Street Revival. Prophecy, miracles, signs and wonders were taking place at this meeting. The Holy Spirit was operating at the Azusa Street Revival much like in the early church as recorded in the Book of Acts and prophesied in the Book of Joel, which said the Spirit of God would descend on all flesh in the last days. When word reached Mason about the amazing move of God in California he immediately wanted to go there to witness it for himself. In March and April of 1907 Mason traveled to Los Angeles to attend the Azusa Street Revival. There, he had a powerful encounter with God where he "received the Holy Spirit." While in Los Angeles his life went through a dynamic transformation. Mason wrote:

"After five weeks I left Los Angeles, California, for Memphis Tennessee, my home... I was full of power and when I reached home the Spirit had taken full control of me and everything was new to me."

According to Clemmons:

"Mason received a new vison for the church and a sense of new anointing for ministry. The gift of tongues accompanied other gifts such as interpretation, healing, word of knowledge and wisdom, and exorcism of demons."

This spiritual encounter at Azusa Street delivered Mason "from spiritual and social limitations." This experience brought about "a psychological liberation that led to personal growth possibilities for himself and for the poor to whom he was called as a leader. Clemmons says he experienced an emotional and psychological healing, growth and wholeness. Immediately, Mason started using his spiritual gifts in ministry. As he did, he drew large gatherings of people, at times up to ten thousand people, because this new dimension in his ministry made it all the more powerful and charismatic.

Bishop Mason lived in the realm of the supernatural. It was like he walked with God similar to the way Enoch walked with God. "Enoch walked faithfully with God, then he was no more, because God took him away." (Genesis 5:24) Enoch walked so perfectly with God that he stepped into another realm. Mason was in this world but he was part of the supernatural world at the same time. Mason ministered in miracles and prophecies. He possessed a great healing and deliverance ministry casting, out demons and raising the dead through the anointing of the Holy Spirit. He was able to do these "mighty acts" because he honored God's call to him by living a strict consecrated life of fasting, prayer, Bible Study and Praise

of God. Eugenia Green says that, "At an early age, C.H. Mason was endowed by God with supernatural characteristics which were manifested in dreams and visions..." Yet he did not minister solely in the power of his gifts but lead a spiritually disciplined life relying more on the power of God than upon himself. Though he operated in all the gifts of the Spirit (I Corinthians 12: 8 - 10) he also sought the cultivation of the fruit of the Spirit (Galatians 5:22 - 23) in his life so he would have a balanced, wholesome and greater Holy Spirit anointed ministry.

Bishop Mason had an awesome presence. His presence exuded magnetisms, commanded respect from those he came in contact with and above all radiated an "anointing" from God. There were several occasions when he entered Mason Temple during service that he would simply kneel down and thousands of people would follow his example by also kneeling down. Then as he prayed miracles would break out around the room. The blind would receive their sight, the cripple would walk, the sick would be restored to health and those in emotional and/or spiritual bondage would be set free. The powerful presence Mason possessed was a result of a spiritually disciplined life style that comprised regular prayer and fasting. His biographer, Eugenia Green said, he loved prayer and that he prayed always and that his constant communication with God enabled him to remain in the will and favor of God. He would pray three or four hours a day in a single session. Sometimes he would pray for nine hours straight. Mason was also committed to fasting. Once he fasted and prayed for 40 days and nights. Green says "The Saints ministering to Bishop Mason near the end of the fast -- had to wrap Dad Mason's body in a wet towel to hydrate his body because he was so dehydrated."

Mason's life was remarkable. He operated in the realm of the supernatural and flowed in the miraculous. The old saints of the Church of God in Christ say that God placed a protective supernatural shield around their founder. They often declare, "How else could he have survived the numerous vicious attacks by his enemies?" Green related a story in her biography of Bishop Mason about how he was protected through divine intervention. She says:

"In Lexington, Mississippi, Bishop Mason was arrested and placed in a 'sweat box.' The police, prosecuting attorney, and judge that were involved mysteriously died. As a result, they said, 'Turn that nigger loose or else we will all die'."

Many people also believe that God sent an Angel to rescue Mason in a Mississippi jail where he was confined by southern White racists. It is believed that his experience was similar to the way God sent an Angel to rescue the Apostle Peter out of Jail in Jerusalem, when King Herod Agrippa placed him in detention (Acts 12:1 - 11). According to Green, "there is a photo from the Mississippi jail where Bishop Mason was held, that portrays an Angel standing in the back of Bishop Mason."

Having studied the life of Charles H. Mason let us take a deeper look at his views on the "oddities of nature." We are now equipped to approach the topic with the enriched perspective that comes from having knowledge of Mason's background. Cecil M. Robeck, Jr., Professor of Church History and Ecumenics at Fuller Theological Seminary, went in depth on the "oddities of nature" in his seminal book, *The Azusa Street Mission and Revival: The Birth of the Global Pentecostal Movement*. Robeck said, "Charles Mason, in particular, dealt with the subject of "special revelation" throughout his long career as Chief Apostle and Bishop of the Church of God in Christ." Special revelation is a belief that knowledge of God and of spiritual matters can be discovered through supernatural means and God's truth can be revealed through means other than human reason. Theologically speaking, Mason's dealings with the oddities of nature is a form of special revelation.

Robeck adds, an outsider viewing photographs of Mason with these weird looking artifacts on display might conclude Mason is a shaman or 'conjure' man practicing some form of voodoo. However, Mason "claimed that by the means of the Holy Spirit he could discern messages that God had placed in them when they were created," and that they could yield words of knowledge and words of wisdom. A word of knowledge is knowledge transmitted by the Holy Spirit to a person that they do not have the means to know with their own natural ability. Generally a word of knowledge gives insight into the present and past. A word of wisdom is wisdom from the Holy Spirit that grants understanding of problems and direction on how to handle problems. Generally a word of wisdom gives insight into the future. Robeck further states that, "What Mason believed he was doing was giving voice to the wordless speech of God's creation ..." To prove this Mason referred to Psalm 19: 1- 4b to explain what he was doing.

> The heavens declare the glory of God;
> and the firmament sheweth His handiwork.
> Day unto day uttereth speech,
> and night unto night sheweth knowledge.
> There is no speech nor language,
> where their voice is not heard.
> Their line is gone out through all the earth,
> and their words to the end of the world.

As a social/spiritual interpretation of Mason's ministry of special revelation using the oddities of nature Robeck definitively stated:

"There is a sense in which Mason baptized into Pentecostal practice something he had seen in the surrounding African American conjure culture. He stood in the place of the medium or shaman, in the place of the 'conjure' doctor or root worker, and using the same signs as they would use, he gave them complete new meaning. He filled them with 'Christian' meaning. Charles Mason thereby preserved something from an historic African cultural basis, a non-Christian 'conjuring culture' while transforming it into a Christian means of communications."

Indeed Bishop Mason was a unique individual. He was the kind of special person humanity rarely produces. He was Prelate and Prophet, Apostle and Sanctified Preacher. He was a compassionate shepherd of his flock and a Seer who willingly shared the vision God gave him to all who would hear the message. Bishop Mason was a spiritual giant who was faithful to his Savior Jesus Christ and faithful to his African heritage and Slave Religion. He set an example of how to be a Black Christian in the matrix of Black culture, worship style and African cosmology. It is up to this generation and future generations to build on the foundation Mason laid and for them to refine and develop the theology, hermeneutics and ministry methods he forged in the heat of the day, shortly after the end of slavery in the United States.

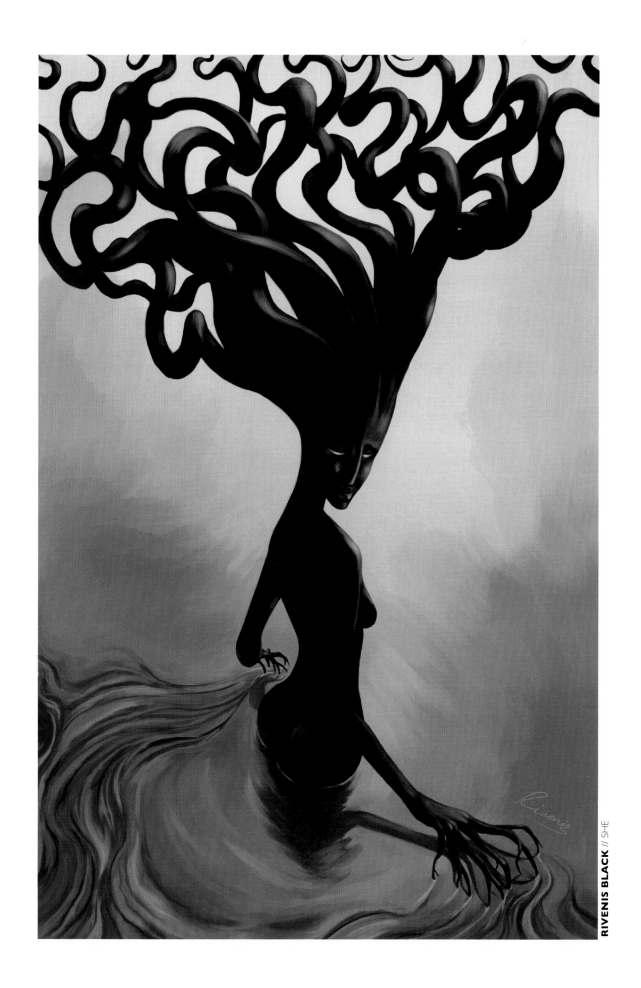

Something To Add To Your Funk

STANFORD CARPENTER // INVISIBLE BROTHER

FERGUSON FUTURE SHOCK AND THE RETURN OF THE REAL

Reynaldo Anderson

All worldly figures
Playing on niggers
Oh, seeing them passing
See how they're dancing
To the Superfly
— Curtis Mayfield

The candid lyrics uttered by Curtis Mayfield in the song Future Shock in his 1973 album Back to The World nudged into my memory on my way to the site of the Ferguson rebellion last week. The song Future Shock was a sensitive artistic response to the emerging conditions of postindustrial and postmodern American society to which Black Vietnam veterans were returning. These conditions weere coldly described by the writer Alvin Toffler in a 1970 book about the future with the same name, and socio-politically illustrated in Saint Louis with the destruction of the Pruitt-Igoe housing complex in 1972. The song was appropriate in my mind as we drove through the intersection of Lucas and Hunt Avenues and noticed the paradox between the corporate types and wannabe one percenters, playing golf behind the country club's manicured hedges of greenery to our left and a massive police presence at the intersection controlling entry and exit into Ferguson like a postmodern American version of the Gaza strip. Passing by the corporate types I could not help but think the protestors were missing the target. The phrase "No problem can be solved at the level of consciousness that created it," attributed to the scientist Albert Einstein, seems most appropriate in relation to the Ferguson rebellion. Problem: So why is Black life so cheap in America? I pondered this question as I walked and marched and hunkered down into the night on West Florissant. After spending some time either walking, marching, or in conversation with other protesters and driving around the municipality of Ferguson, I tentatively came to the conclusion the rebellion was struggling against the legacy of the power elite and institutional racism, the fight for control of the Black imagination, and the symbolic attempt by an ineffective and marginalized African American leadership class to re-assert moral authority through a politics of respectability.

Historically, Black life in America has always been cheap. However, only two generations ago there was a possibility the equity and disparity gap in America would be closed. There were roughly three choices facing America following the rebellions of the 1960s. First, maintain the status quo and it would eventually lead to re-segregation and a heavily policed society to reinforce that political choice. Second, adopt a policy of racial geographic enrichment and abandon the goal of integration. Third, combine elements of the first two with policies that encouraged cross-cultural engagement. The concern was the nation was moving towards two separate societies. However, America has always

been separate and unequal and in the following decades the American power elite, increasingly more global in consumption and cultural outlook, largely embraced an approach of benign neglect that would maintain institutional racism at the expense of most Americans. The empirical data is in, and the nation is moving in the direction of the first choice and creating a permanent Black and brown underclass that will be watched and governed by a prison industrial complex, organized on the basis of institutional white supremacy, with a patina or finishing coat of colored people to defend its policies to the American popular imagination. Moreover, the rebellion will have to swiftly recognize the relationship between the interests of the Power Elite and how American foreign policy is intimately linked to its domestic policy. It is no accident the citizens of parts of Ferguson were controlled by a militarized presence, bombed and tear-gassed in much the same fashion that Palestinians on the West Bank and the Gaza Strip are treated with collective punishment. According to local A.M.E. Zion Pastor Reverend Ken McKoy, the situation for black youth can be characterized as "They are literally fighting for the right to breathe." Therefore, to the surprise of many Americans, militarized repression of the rebellion impacted the popular imagination, and brought to the surface existing tension and struggle over autonomy and corporate control over the Black Radical Imagination.

Two generations ago, a year after Curtis Mayfield's call of Future Shock, the Black Modern Jazz musician Sun Ra responded with Space is the Place. Space is the Place is a creative musical and media project that recognized people of African descent in an emerging, technologically sophisticated society would have to solve the problem of global white supremacy on a different level than it was created. More specifically, the African diaspora would be required to create intellectual space that provided the basis for reimagining alternative possibilities. Now that Black youth have repossessed the cultural political microphone during the Ferguson rebellion, federal and local agents, provocateurs, organizations, and corporations have flooded the (S)pace of West Florissant seeking to influence the direction of the rebellion. Strolling down the avenue it was interesting to see the juxtaposition of CNN across the street from MSNBC and the different crowds they would attract as some participants would dutifully wait during a commercial break before breaking into chants after a word from a sponsor. There is a clear distinction between the radicalized youth and their allies who want justice for Michael Brown with the larger goal of fighting White supremacy, and who are prepared to agitate for as long as it takes, and individuals, either through family, political nepotism, or the lure of fame, who seek the microphone to amplify their own marginal voices or archaic organizations at the expense of the interests of the Black grassroots.

Finally, the fact remains the angry Black grassroots have wakened from their slumber and caught off guard an aging, decrepit, and marginalized local African American leadership class that has suddenly stirred and called for new leadership. However, this brings to mind an important essay Martin Luther King Jr. developed before his assassination where he warned against the manufacturing of black leadership. For the last two generations, a revisionist history of the civil rights movement and the Black power movement has been promoted locally and nationally in the interest of obtaining privilege and access for many Black bourgeoisie elites. In his book, We Have no Leaders, Dr. Robert Smith pointed out the dilemma twenty years ago with the observation of how African Americans with promising ability were incorporated into institutionally racist organizations that protected White privilege at the expense of the community or broader society. For example, the current president is symbolic of this phenomenon, although he is in office; he is not in power, as he must bend to the dictates of the elite one percent against the interest of most Americans.

Yet, for the first time in a long time the old social contract of accommodating local institutional white supremacy is openly being challenged and is spreading beyond Ferguson to other urban spaces like Dallas with the formation of the Huey P. Newton Gun Club. , Additionally, protests surrounding the police killing of Black youth in New York and Los Angeles find the youth and their allies are mobilizing. Therefore, despite the initial gummy bear soft rhetoric of the president, youth have resisted craven

requests for understanding and peace until justice has been satisfied. However, it bears watching how colored tokens of the establishment are being used to re-establish legitimacy for institutions. For example, the Mayor of Berkley, Missouri, Ted Hoskins, was correct in his recent analysis, along with another MSNBC contributor, that the lone black highway trooper, Ron Johnson, and a black brigadier general were trotted out in front of the media as tools used to defuse and betray elements of the rebellion, with other minority promotions to come, despite police abuse. This tactic was used in the sixties in states like Mississippi when activists would be fingered by officers and civil rights workers or perceived radicals would be arrested and or reported to the State Sovereignty Commission for registering Blacks to vote or identified as trouble makers. Furthermore, the whining about outside agitators by some of the local and state African American leadership class sounds similar to former Southern governors who complained of activists stirring up their niggras. It remains to be seen what the radicalized Black youth of this generation, born after the Cold War, and having never known defeat or the humiliation of their grandparents, will do in the face of what on the surface may seem stiff odds to establish and promote a more autonomous leadership. Like another generation of African American youth before them, they may be preparing to seize the time and make their own mark in history, while forgoing the 30 pieces of silver for accommodating reactionary colored leadership or worshiping at the golden calf of White supremacy.

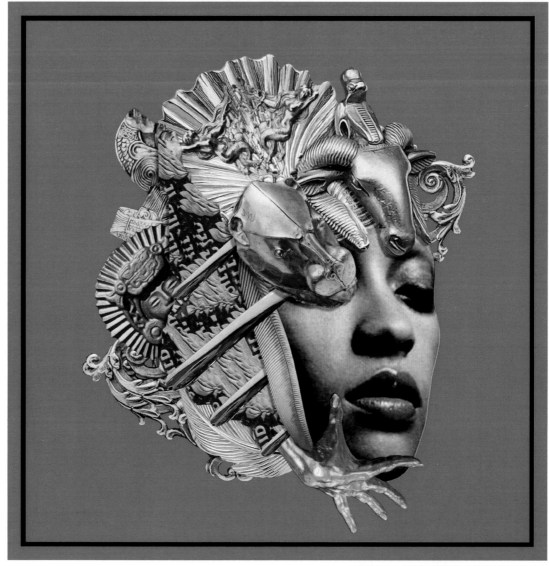

MANZEL BOWMAN // GOLDEN CHILD

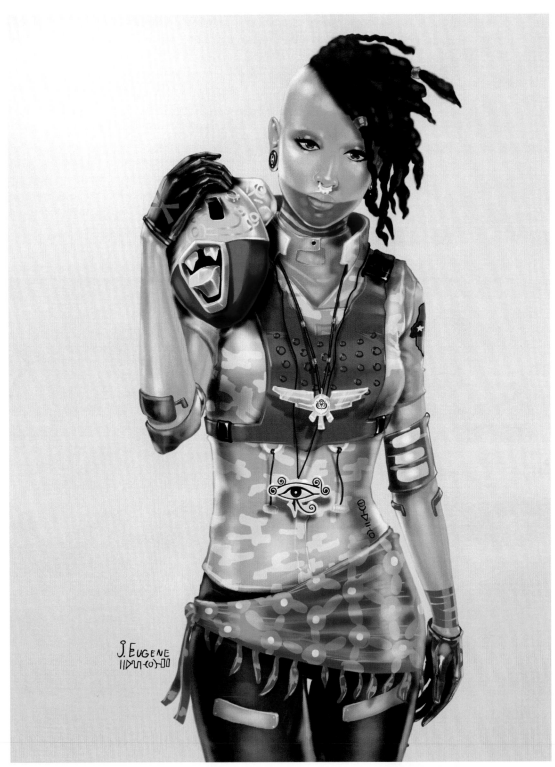

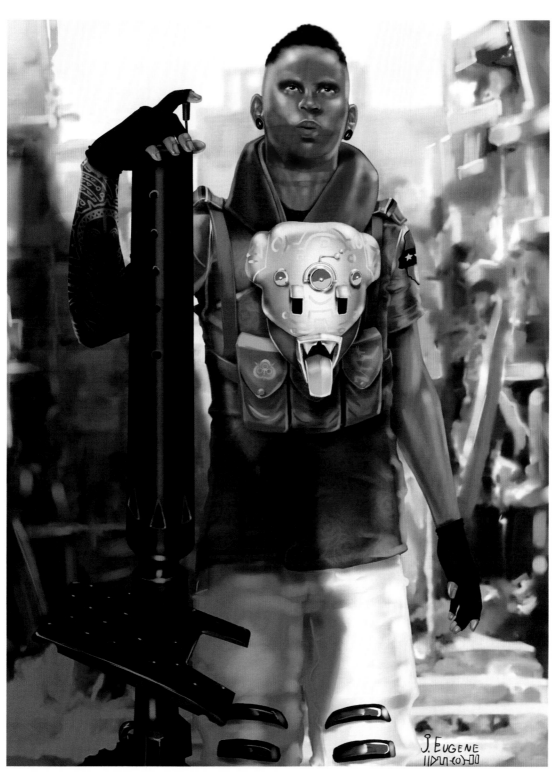

JAMES EUGENE // WAR GLASS GOJEE

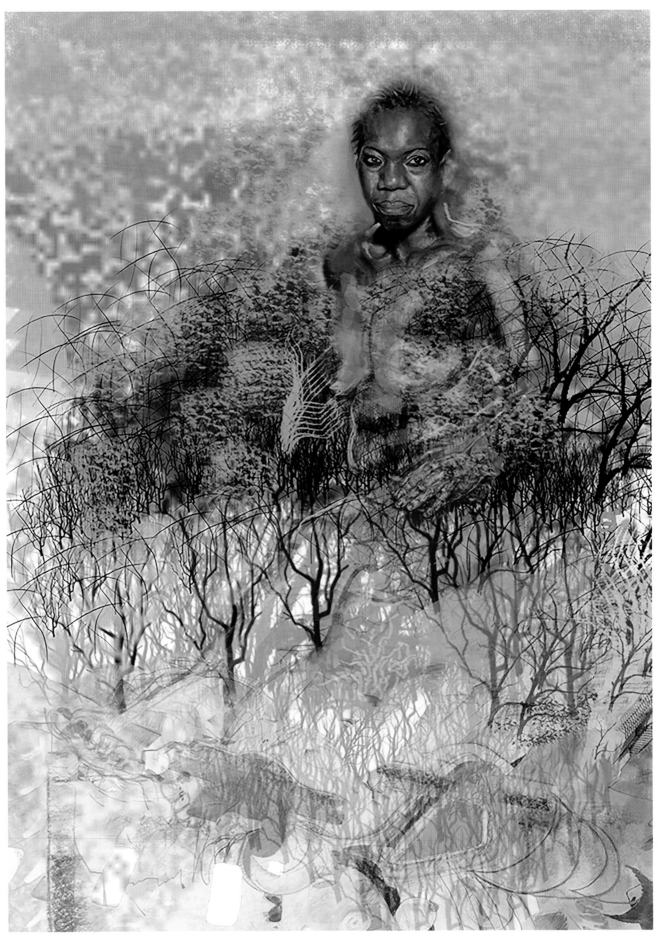

GIL ASHBY // TREE QUEEN

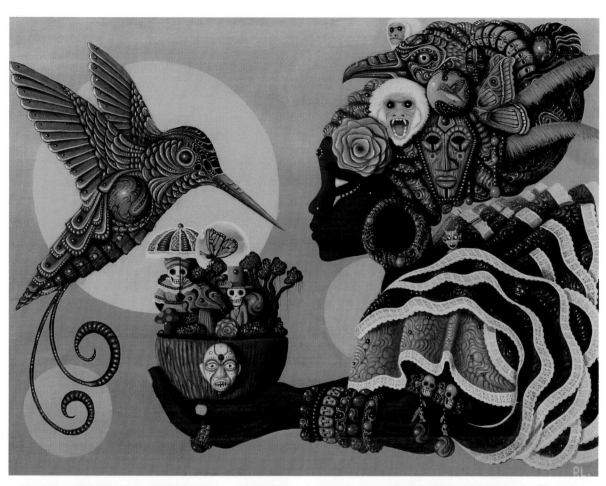

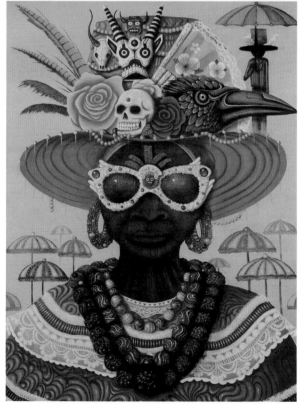

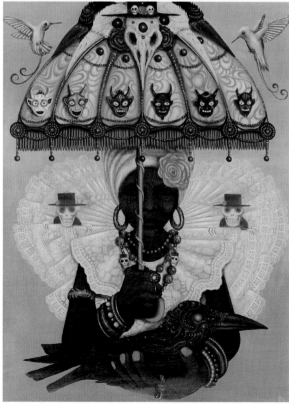

PAUL LEWIN // THE OFFERING, ZYLA, & THE CROWN AND THE CARNIVAL QUEEN

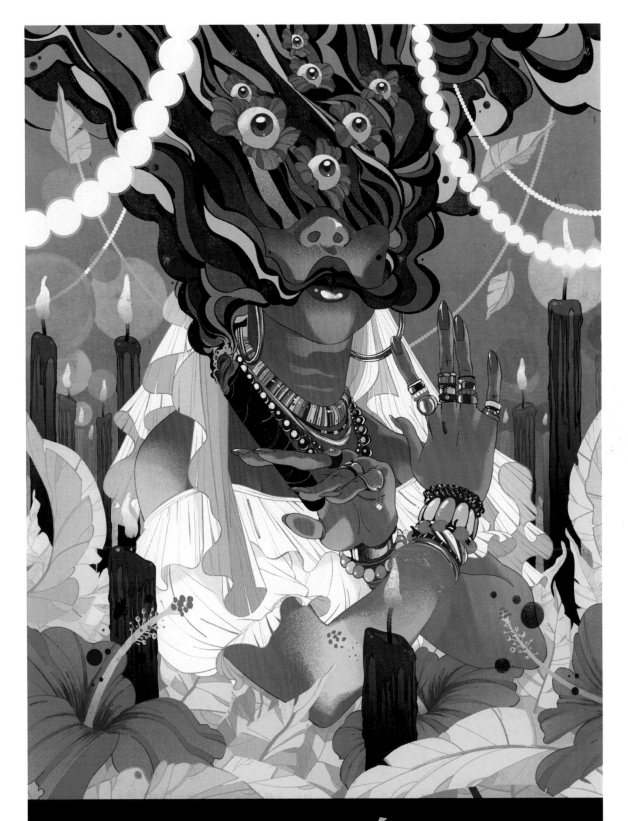

DANIEL JOSÉ OLDER

KIA AND GIO

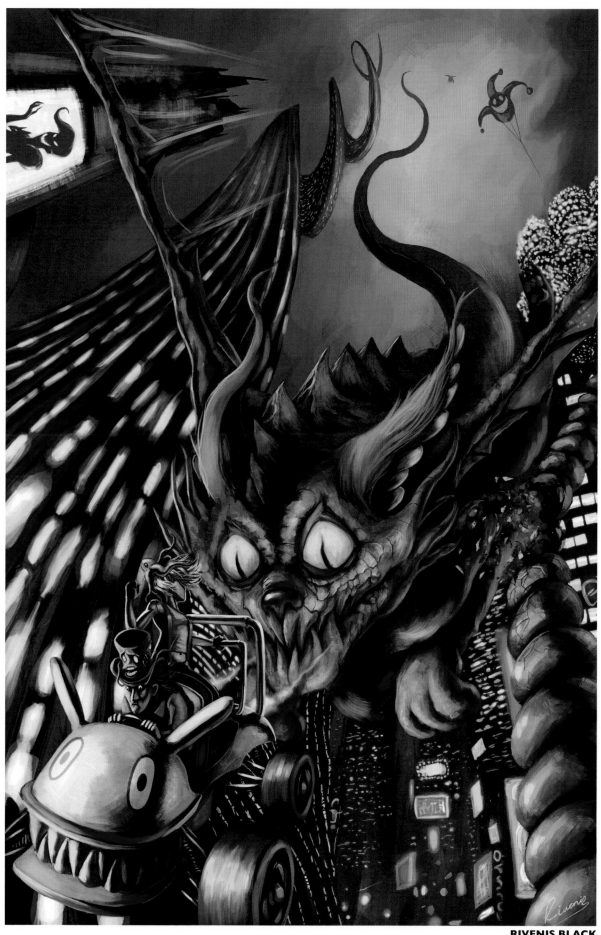

RIVENIS BLACK

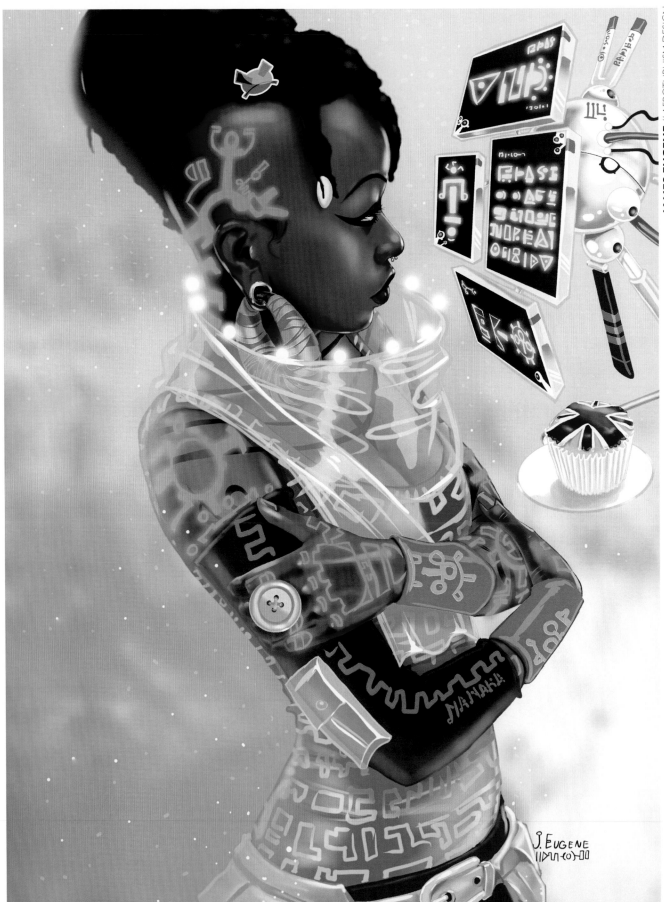

uploading

CHUCK COLLINS // FERAL CORP

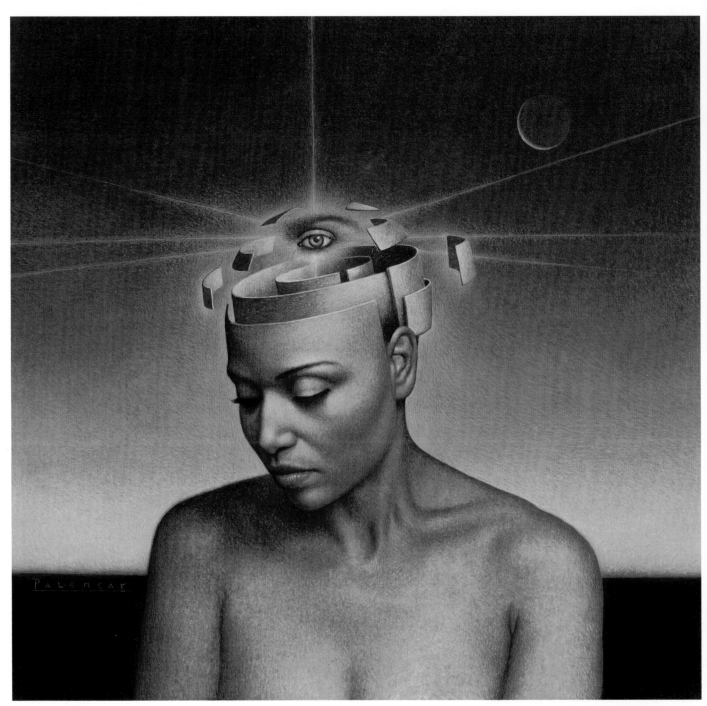

BINTI

Nnedi Okorafor

"There's more vivid imagination in a page of Nnedi Okorafor's work than in whole volumes of ordinary fantasy epics." — Ursula K. Le Guin

ARE ANGELS ROCKETS? A SUITE FROM THE SEQUENCE

Scott Heath

012
behold the shiny
blacks, electric africans
in just-come fashion.

020
brown at night, we are
whiskey people; our bellies
fire fly when they rub.

034
anticipate this:
an haute couture soundsystem
broadcast from her womb.

D I A S P O R I C
D R E A M S

Blackness is vast, containing an expansive range of cultures throughout the Continent and Diaspora. Within each of these cultures is the possibility of myriad futures. The creators who make work about a Black future have not been truly compromised by a split-self. A veil has always just been a piece of clothing to shield them from the sun. What stories unfold from a unified sense of belonging, culture, and self? What does the future look like from a perspective of humanity unfettered by division but common goals centered in relationships? These creators provide us with a roadmap through the twisting sands of the uncertain future.

These narratives are driven by indigenous cultural practices, localized languages, and landscapes that may be "alien" to black Americans, but speak of a different kind of home for so many other unheard voices. Writers and artists like Nalo Hopkinson, Matthew Clarke, Dilman Dila, and Nnedi Okorafor are leading the charge in changing how speculative narratives function in our society. These politically-centered and engaging stories transcend the notions of doubled mind and utilize the author's connection to a definite heritage to move the reader into spaces they would never have dreamed.

These narrative styles and aesthetics are driven by fusing the fantastic with the familiar, the cultural with the cosmic, and the indigenous with the infinite. From the future shores of Lagos to the mystical streets of an alternative Barbados, these stories expound upon the notion that not only do black people dream of these rich fantastic vistas; they thrive there.

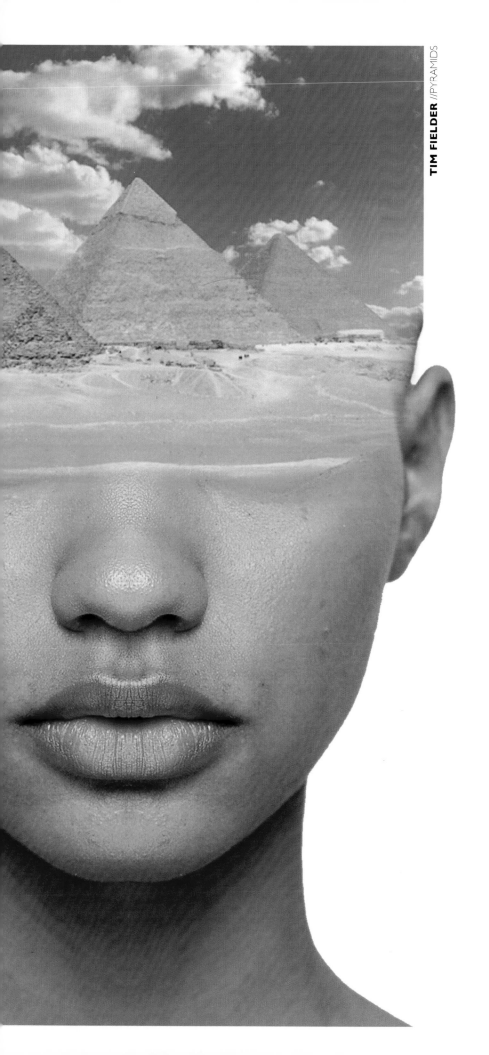

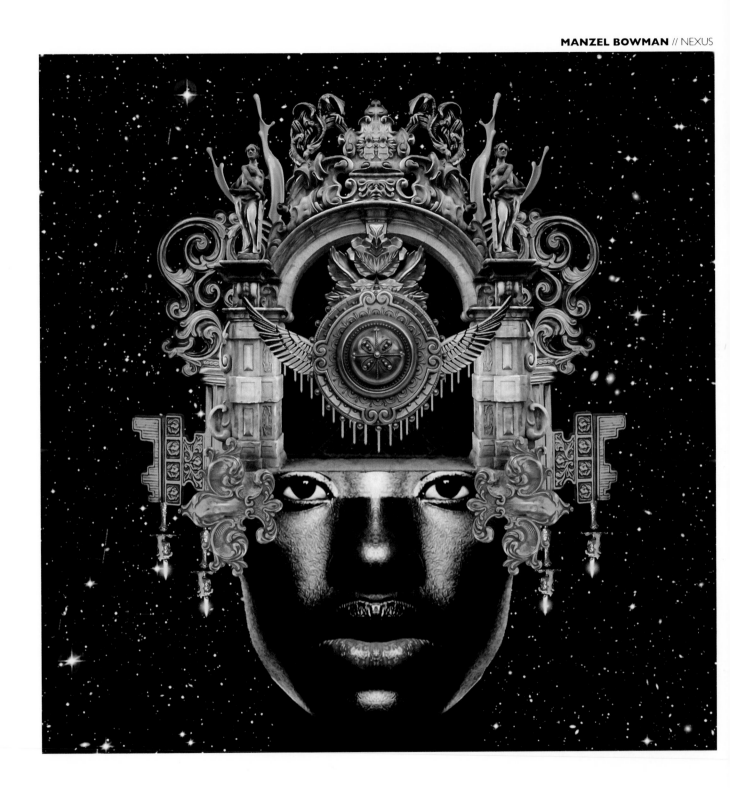

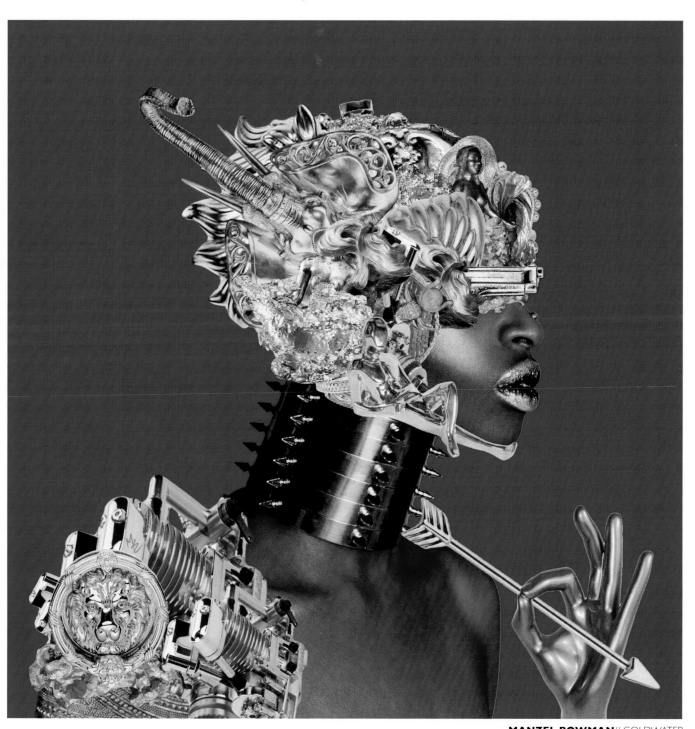

MANZEL BOWMAN// GOLDWATER

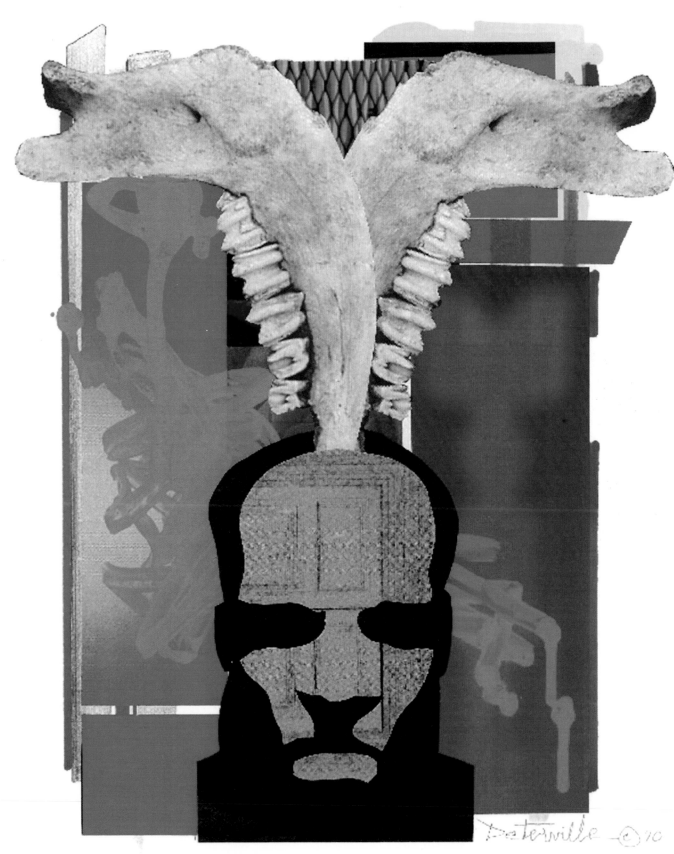

DUANE DETERVILLE // SHANGO

CADILLACS IN SPACE?

Jason Vasser

Of course there are Cadillacs in space,
how else would brotha bots get around
to collect that bounty? Flying by on 20 inches,
flakes in the paint so when the sun shines
they appear as comets or shooting stars
on their way to Venus. The gravity of five moons
keep their Afros in place, mistook for helmets
shinin like new money, blood cuz
nickel plated, tall tees cover brotha bots
and their ebony – chests and no matter
where they find themselves, there is a sun
and every so often one dreams of grasslands
and drums, and the other hums a Negro Spiritual
he has never heard, but they fly –
they be flying as blue birds blending in an infinite sky
and stars blink as they ride high in a 'Lac
with diamonds in the back, sunroof top, digging
the scene with a gansta lean. Once, near Sirius B
brother bot # 411 east, found a gold stone amidst
some rubble and with some wire, he made himself
a pendant and carved a glyph in the center,
from memory; another time brotha bot #1620V.J.
found one cowry along the Milky Way and it lives
in the pocket near his mechanical heart that rusts
sometimes and only palm oil makes it tick,
makes it tock – Kateee!, Kateee!, Kateee!, looking
for love. They find themselves in the middle
of space, in the center of the vastness,
the heart of an ocean of stars
rooted by a figment of their imaginations,
a shadow of some surface, a feeling that they
have been here and have done this all before
and there is the faintest image of a cone like structure
always in the back, always behind
always in the back, always behind.

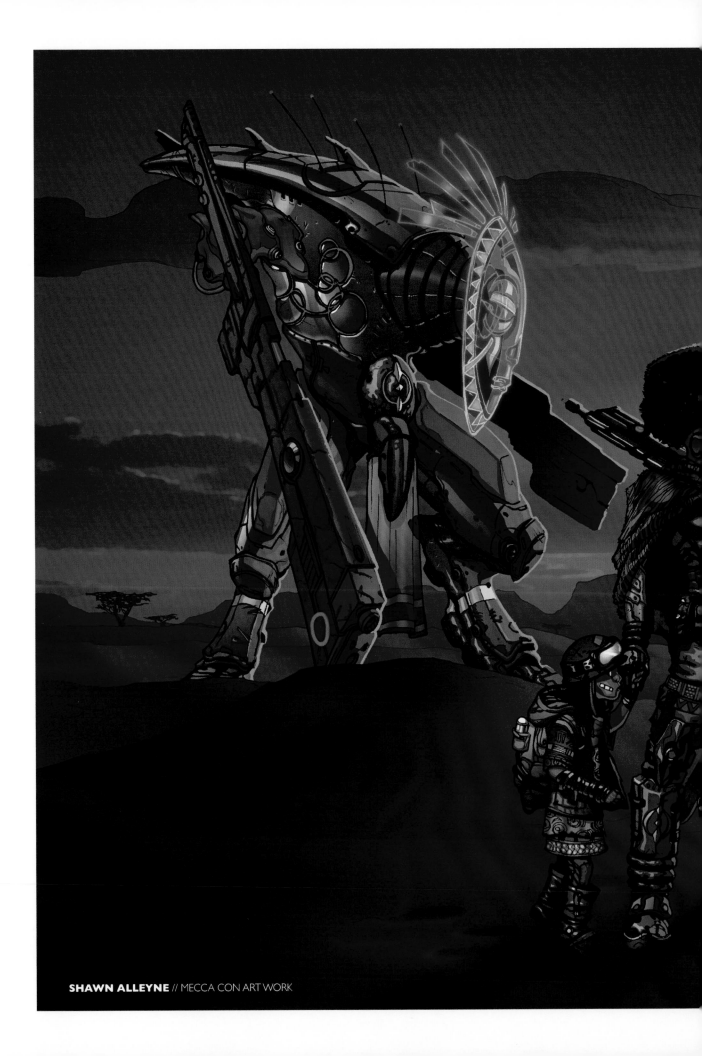

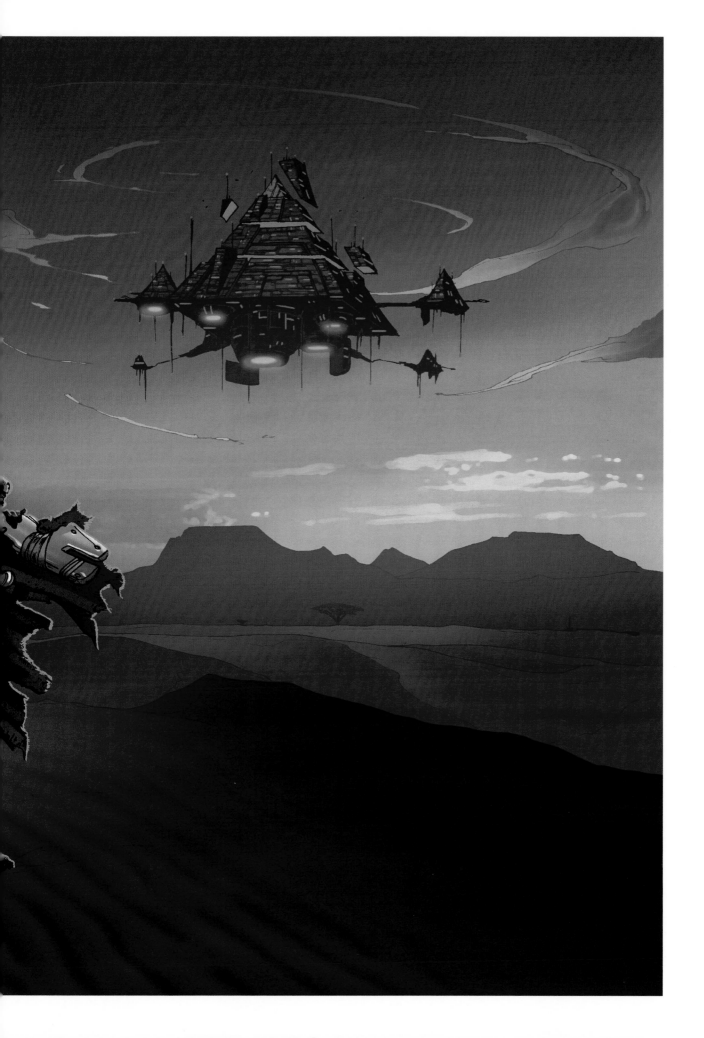

OLALKEN JEYIFOUS // VICTORIA ISLAND 2081

Outpost Shangri-La, Journal Entry #1274:

"Journeyed beyond the pods today, just after high noon, when the risk of an incursion is unlikely...
It's been many cycles since I last did so. My viewer confirms no external breach, so an exhaustive survey awaits."
Also, the birds have returned (though of a different hue), I'll have to parse that later..."

OLALKEN JEYIFOUS // Z-5

JASON REEVES // JUJU BABU

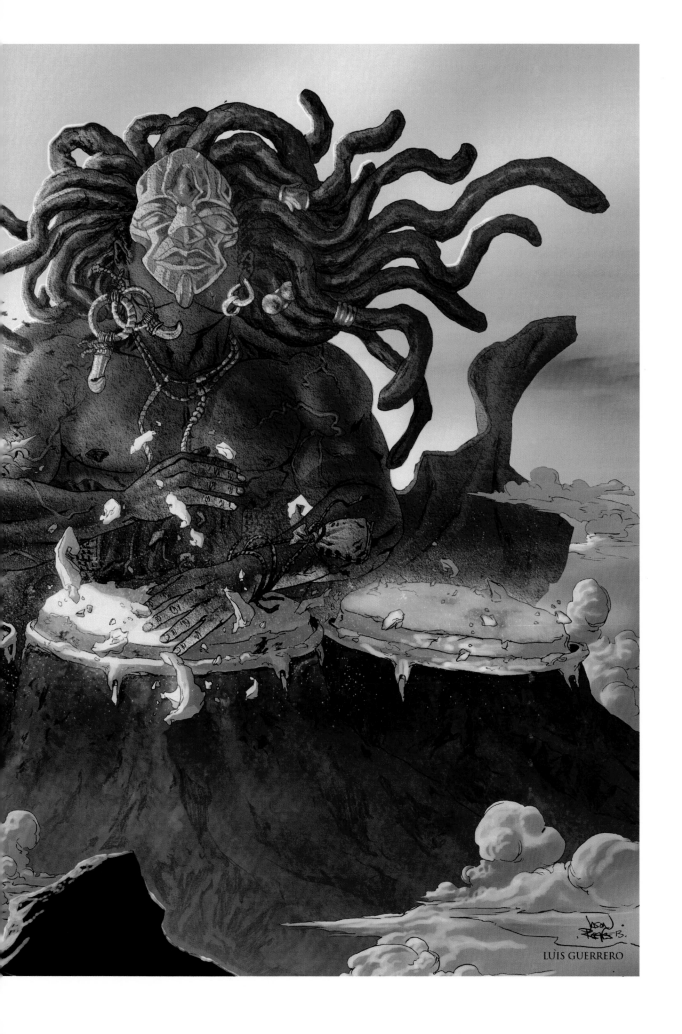

125

LUIS GUERRERO

GIL ASHBY // NATURAL ABSTRACT

MICHELINE HESS // BEASTS OF THE SOUTHERN WILD

WILL FOCUS

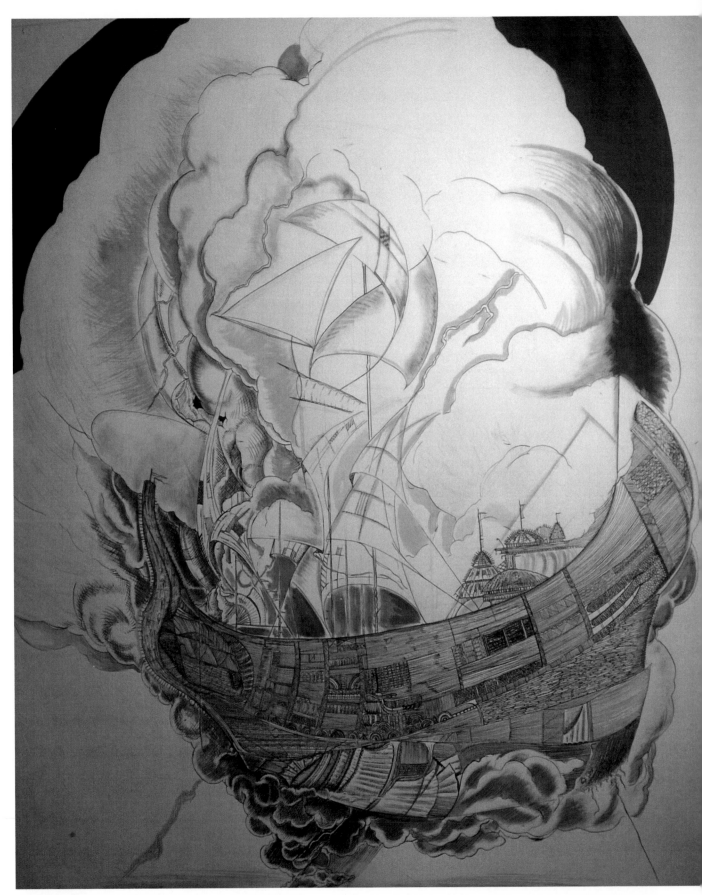

KEVIN SIPP // ARK OF BONES

OBSIDIAN / THE BALLAD OF BAD BRAINS

Kevin Sipp

ob-sid-i-an/ ebsidie.en
1. n. dark volcanic rock that is generally black in color.

Intro
I. Awakening
 Like a fever mad black dreams it comes,
 this hard-nosed black noise that comes,
 screaming like a love in the full embrace of life,
 jumpstarting dream machines of superhuman joy,
 Like a fever mad black dream it comes,
 writing metaphysical graphitti on the surface of the sun,
 announcing the arrival of ever living awareness,
 awakening electric memories
 that were waiting to tell their utopian tales.

II. Arrival.
 From distant celestial motherlands,
 soul ships descend and begin to thrive,
 begin to survive,
 begin to seek vessels of fearless black expression,
 begin to seek possession,
 soul ships carrying,
 the hypersonic energy
 of ancestors searching for faster freedom,
 ancestors traveling at light speed across lightyears,
 full of fire and manic holy madness,
 full of infinity,
 repossessing children of kemetic light,
 jumpstarting sleeping souls slipping into limbo,
 down here inna Babylon, down here
 where rhythmic gifts of cosmic love are given,
 to the prisoners of this urban jungle.
 this spiritual ghetto,
 this public circus of soulless cycles,
 and deep within the mix,
 of this unstable carnal carnival
 rainbow black souls are born singing Osirian love songs
 and we embrace their sound and dance insane, BadBrained.
 Amid soulsadshadows we search for sunlight,

Amid the dread and bloodshed
 we shake and shatter, close our ears to the chatter
of Babylonian streets,
our spirits feeding on the fat, black, feedback
of solar souls making stellar rhythms hum
as our eardrums tune us in
and pull us into ecstatic spiritual spaces of abandon.

III. War
Barriers begin to break down around me
as sounds assault me,
manic and movingly,
smoothly moving me
from one metamorphic meaning to another
as I close my eyes to discover
primal interior worlds,
and there deep inside
I unlock
and return to hard rock my reality
with all the fury and fire of a soul set free.
My tattooed brain aflame with hermetic desire,
I find myself dancing like a dervish
on the razor's edge,
between saints and sinners
baptised in electric streams of consciousness,
I and I, a sonic soul apprentice,
sentenced to serve freedom,
I and I, a black soul ranger
standing strong among strangers
in a strange and loveless land,
I and I, a supernatural warrior
walking this desert of the heart and soul,
and for so long I've been told that my D.N.A.
has been marked D.O.A.
that the dark, ghostly, trip of the slave ship
has let my mind slip into never ending shadow,
and yet I stand here living
giving the breaths that's left in me
to the spirits of eternity,
I-ternally,
my ancestors keep burning me
with dreams of raw fusion,
worldly illusions become smoke
when I invoke their presence,
their essence becomes my shield,
my mystic seal against American addiction
against the friction of living in this dimension,
within this demented American culture that cultivates
its cults of hate,
that is a civilized ape that burns and rapes,
that was born to erase our visionary mindstates
with its blind hate,

America, the civil war without end,
has seemed to be a sin without judgement,
forcing me to continuously scream
behind my divine dress of black flesh,
My emotional walls keep shaking,
keep breaking
down within the soundproofed booths
of our cellblocked soulrock.
and we who were called niggers,
we are now electric spirits,
we are now purified and without limits,
we are now boundless in our powers,
we make our prayers now to unseen saints
traveling the spaceways bold as love,
electric like us in their potency,
electric like us with their prophecies,
and we who were stigmatized, crucified, and burned,
we now rise,
we now return,
untainted by the rank and file
of a defiled earth,
where spirits of truth live
bound, gagged, and bodybagged from birth.
From eternal journeys we return,
as sacred lovers drifting over the seas of the blind,
our holy visions moving sublime
thru this rage we call America,
our holy wisdom burning for a heart
to hear its soulful Sothic song,
And we who are electric spirits
live under constant attack down here,
our enemies live in constant fear,
that we will "DESTROY BABYLON"
and engineer our "RE-IGNITION"
our readmission,
into Godhood,
into Godheads,
into Supersonicdreads,
yes, "THESE ARE COPTIC TIMES,"
and the beast of crimes eats innocent minds
in the ghettoes of the world,
and if "as above, so below,"
we have a long way to go before we reach
" on earth as it is in heaven,"
And we who are electric spirits
must constantly be at war down here,
as we walk these shattered city streets
singing rainbow blues,
singing like holy fools,
for those who live with tongues tied,
living for those who, too soon, have died.
The suppression of our expressions

have made our very souls the battleground,
and we welcome you
with love
to come inside this sound,
into this black rage underground,
we invite you,
to come and march with us on stage,
within this razor blade of visions,
into anti-hellish, hyperpolyrhythms
of black vinyl velocity
turning us into firebirds of ferocity
searching for Pharoanic cities to cruise,
we cyberblues lovers of black metal mysticism,
and yes we've had visions
of our heartcore spirits
spilling out like black sperms,
like tadpoles of soul
swimming thru the uterus of the Yoni-verse,
thru the cosmic fire of live wires and bent frequencies,
to fertilize our dreams with Nyabinghi drumbeats
gone ballistic and berserk,
to purge the hurt we feel
as we rock and reel reality.
Can't you hear the universal buzz,
the buzz that was, is, and always will be,
that flames and flowers forever thru the ether of our
fuzzed-boxed Afro-psychedelica,
where hardcore grunts of liquid steel harmonies
merge with cosmic Kuntis of "SACRED LOVE"
my version of JAH is a black goddess
coming down from above,
and we are all now Her menstrual singers,
JAH-love is the secret song of Soul-Ammon,
the soul in man who hungers for heaven,
whose galactic black garden will always be our resting
place,
whose mothership memories linger in us
like echoes enclosed within blackholes of dub,
the spirit of JAH enters us
and we begin to seek ecstasies,
begin to speak in the secret tongue
of esoteric philosophies,
our third-eye-d's
becoming our tickets to Electric Africa,
Zion's atomic train pulls into our brainstations
as our positive mental vibrations triple
then ripple
into subterranean rivers of soul,
hidden rivers where the NETERU dwell,
waiting for evocation,
a pantheon of particles waiting for release,
they stare at us across times' chasm,
we who are the children of Black Madonna orgasms,
our melanin skins becoming universal nerve endings,
our souls sending messages back

to the black wombs of our beginnings,
we touch
and the universe feels,
we look
and the universe sees,
we make love,
and the universe gives birth
to itself
its celestial wealth sparking its own ignition,
and as we fruitfully multiply
on super high frequencies of faith
Babylonian leaders play like Herod
over our newborn heads,
wanting us dead and diluted,
and spiritually polluted,
wanting us wasted and confused,
wanting us used,
and most definitely not,
nappy soul happy metalheads,
with afros like haloes
and electric dreads,
most definitely not like Sun Ra's rising
but more like living coloreds
collared by a slave mentality.

IV. The Psychedelic Ghetto
Soon the black census will be taken in negative numbers
if we remain slumming in slumber land,
dead to our dying,
deaf to our crying,
begging for dignity
in this cold soul-less city,
following urban contemporary souls without inner sight,
walking numb thru the night,
among bondaged bones and ghetto disasters,
as colonial pimps flash ghostly smiles of victory
and wipe their asses with our history,
while we are reduced to black skeletons
chasing crystal dreams of death
imploding in on ourselves,
leaving empty wells
where once we used to stand,
yes, indeed, "These are Coptic Times"
when cosmic signs
sail across a blood red sky,
when the lost and beautiful young
drown themselves under the neon suns
buzzing over infinite streets of soul,
when whiplash musical wizards
conjure up galactic noise
from deep tribal transmissions,
when rastapunk radiofires
fuel frenzied dreams of majestic ambition
in double-conscioused double time,

and we who would rather be colorful than colorblind
begin to shine
begin to climb
begin to ride our minds
thru all our incarnations
we who are inherently
suns, moons, earths, winds, fires, and holy waters
inherently sons and holy daughters of light
inherently
GODS OF LOVE,
inherently free,
we often dream of the days
when we were conscious deities
living in societies
without need of resurrection
singing songspells
that once swelled with hope eternal,
these ancient visions rush us
as the black light of heaven enters us
centers us
then splinters us
into a thousand I and I's
and we who were many become one
within this web of light, within this web of life we live.
and like black fevers on amphetamine we screams,
trying to shake this dead scene from sleep,
living hungry as hell for heaven here
here in this psychedelic ghetto
where human nightmares creep
where humanities mentally weak
speak in dim-witted whispers and ciphers
about illuminati vipers and devils,
we live starving for the millinium here
here in this psychotic metropolis
where paranoid black mystics
speak in twisted tongues
about blacklisted black knowledge,
and howl out about holographic revolutions
as they beg for contributions
on corners of desolation,
and from the heart of this D.C. ghetto we come
JAH drunk junglepunks
humming truth at lightspeed
killing demonic greed
with well placed dub bombs,
our musical message
inciting soulriots
as we piss in the gene pool
of cool white rock,
as shocktroopers for JAH
we practice rasta terrorism,
ska-jacking violators of our sacred airwaves
downpressors dig their graves in our presence,
we shapeshift from fast-forward to slow fluid,

we are conduits of divine contradiction
floating tropical thru North American soul winters,
guess who's coming to dinner,
Natty Dread Rock,
in our world
rainbows dance with the ghost of heavy metal Africa,
in our world
blackpearls
speak live from Atlantis,
in our world
live wired rooms
give birth to Dubhumans
clubhumans
in constant communion with JAH.
The underground is our womb,
and we enter its den to be born again,
and within this turbulent temple of tenderness
we close our eyes
and dance with high urban angels
into evergreen dreamlands of chaos and passion,
baptized by sweat
we submerge and breathe
and rock inside seas of intense emotion
where every wave of flesh reaches high
into an endless sky
like hands raised in prayer,
Every night we rise from the sleep of sin
and shed the dead skin of downpression
every night we sneak away from the pain we've seen
into the secret chambers of our scene,
as supercharged currents of energy
we enter mysterious stellar gardens,
kick-drumming our kabalistic coming into being
our hearts like open books of splendor,
we are tender in our divine love
as we climb our trees of life from kingdom to crown,
becoming intoxicated souldreamers,
becoming Solomonic song singers,
becoming Phoenix-winged buffalo soldiers
riding barebacked
thru the four worlds of creation,
over ambered waves of grain
and the embered graves
of our granite ghetto realities.

V. Shekina's Coming
We kiss Shekina in our hardcore dreams,
She who is heaven's whore,
she who is heaven's door,
she who is a hidden Hathor
dancing in our souls,
dancing thru seven veils of khemetic dub,
she who sings love duets in the DUAT,
she who sings a funky mother's message from Mu to
you

whose musical kiss is our hallucinogenic drug,
We kiss the Magdalene in our astral dreams,
the undetected bride of the resurrected
Mari, the sacred beloved, the one perfected,
the mamasonic mystery and muse,
whose fuse ignites us all,
We kiss Shekina in our dreams,
becoming her electric lovers loving all life,
becoming, like her, whores of heaven, open doors to
positive holy ghost possession,
mingling on the shores of eternity,
where our spirits and flesh mesh and thrash
to Gnostic, crossroad soundclashes,
creating a renegade cyber-rasta race of punkish grace
and glory,
and in heaven's holy name Shekina comes,
stepping like a razor thru her crescent gates of life,
opening her book of concealment
for all blue souls to see,
and we,
lost in her Queen Omega love,
begin to read ourselves,
begin to see the world
thru burning brand new eyes,
and as we stand here
on this Mother Earth,
on this terrestrial turf,
we begin to surf
this wave of humanity,
as hyper-dimensional nubian hippies
cyberpunking JAH's message across
space-time continuums,
and Shekina comes,
comes calling all blue Hebrew rockers to come
with cosmic waves vibrating she comes,
reanimating the black magicians
of a Sirius black tradition
into sonic missions of mysticism.

VI. Love Apocalypse
From the higher heights of heaven
Obsidian souls have emerged
rushing to the rescue of the restless youth,
soulmining for sunshine
in the basement of our minds,
raging and glowing
they have entered our time,
beautiful in their quickness,
in their shining speed,
in their spiritual need,
to overcome evil,
"Fearless Vampire Killers"
making music move like mercury,
forcing unrestrained drainage

of Babylonian brain damage,
forcing out media-minded scum
payed to cum
unglued from themselves,
and from the depths of my soul
I've heard the words
burn from H.R.'s flamescarred, soulstarred,
throat,
singing
never again,
never again,
heard the chainsaw churning
of Dr. Know's celestial guitar
burning rainbow holes into the club's night air,
heard thirdrail basslines
from Darryl's fluid fingers outracing the pressure
of downpression,
as Earl 'The Pearl'
beat down the wicked of the world
with his drums,
leaving our spirits stunned,
our bodies numbed,
and our hungers filled,
obsidian bombs of love
have exploded over America,
have expanded
their sphere of influence,
have pollinated the wind
with their words, sounds, and powers,
indeed, "These Are Coptic Times"
and Latino angels are writing of loves apocalypse
on urban bricks,
don't mistake it for anything other than cryptic
twilight prophesies,
"These Are Coptic Times"
and African angels are speaking thru apocalyptic
lips
of freestyle holy verse,
repossessed, they now expressed
their souls uncensored.
Obsidian serenades have seduced America,
and slowly America opens wide,
and slowly new souls come inside
to ride America into orgasmic liberty,
planting black seeds of freedom
helping America deliver her overdue promise to
the world,
and from this union
there will come a new heaven and a new earth,
a new model Nubian,
and never again will we be brain dead.

OUTRO

133

BIZHAN KHODABANDEH // PUMZI

ARIE MONROE //SPACE GIRL

RHYTHM
TECH

Poet Amiri Baraka's story "Rhythm Travel" declares the power of music, as he describes a fictional device that would allow one to transport to where any song ever made has been or ever will be played. Black music's beat and expression is one of our most powerful tools for justice and liberation. That's probably why John Akomfrah's "Data Thief" called the blues a "black technology" in his 1995 film The Last Angel of History. He knew the key to the future was to understand its music. Black music resonates from some other world. It takes you places you have never imagined. Black music unifies, heals, and mobilizes the spirit when it is necessary.

The venerable experimental jazz musician Sun Ra famously said that "space is the place" for freedom, and he would take his audiences there with his "Arkestra." Jamaican "dub" music pioneer Lee Scratch Perry's studio "The Black Ark" constructed abstract jams to beam listeners into the atmosphere. The funk band Parliament, along with their front man George Clinton, used cosmic vibes and complex audio mythologies as a method of critique of late capitalism while moving people's feet on the dance-floor. Deltron 3030's (aka Del the Funky Homosapien) used far out sci-fi motifs to show not only the versatility of the hip hop culture, but its longevity into the future. Outkast described themselves as ATLiens, living on the cusp of an ever-morphing urban south. Today, our heads nod to the wondrous mixes of Flying Lotus, the whispering darkness of FKA Twigs, and the energetic and unwavering voice of Janelle Monae. They all flow through this continuum of using music a tool for aesthetic freedom, justice and liberation. They each, in their own way, want the same thing: the freedom to be who they are and to share that freedom with us all. Music is tool and it's been in our bag for centuries. We just have to learn how to listen and follow the tune.

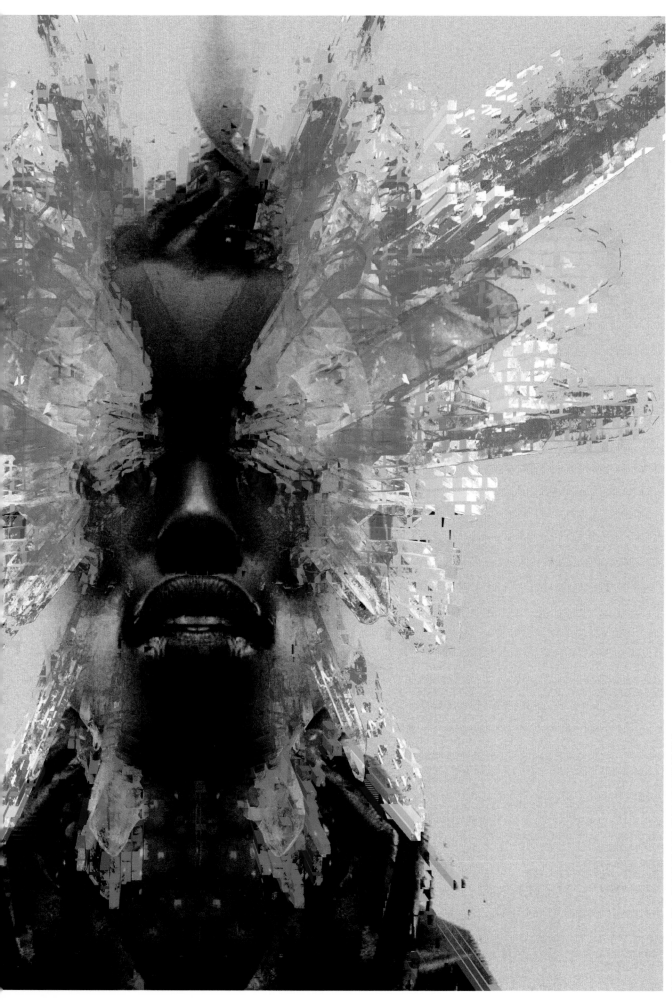

MANZEL BOWMAN // MIND BLOWN

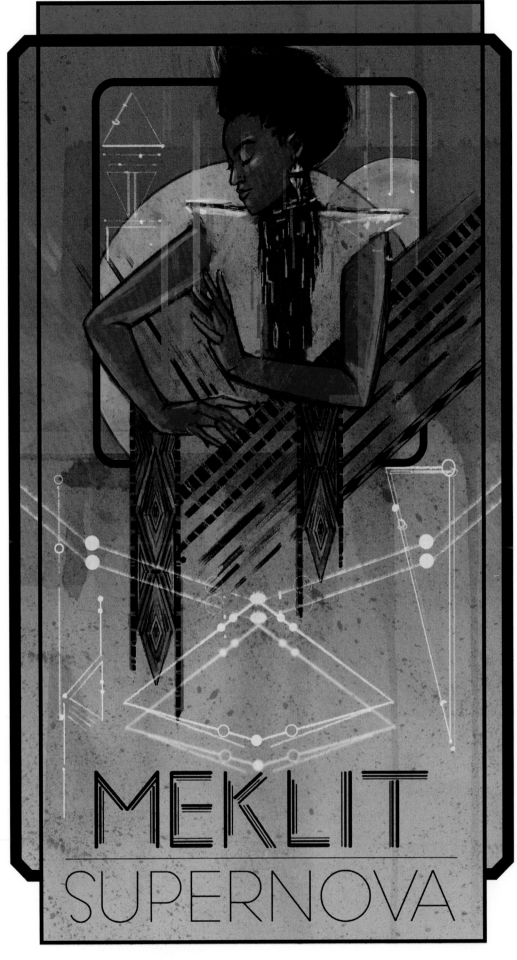

MEKLIT

SUPERNOVA

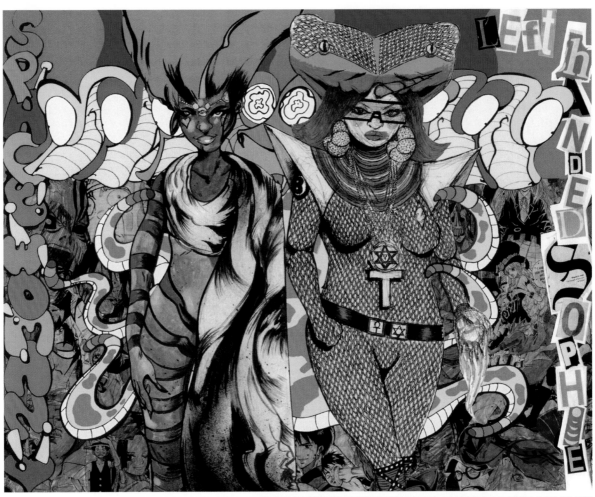

BRYAN CHRISTOPHER MOSS AND PHONZIE DAVIS // SPACE GIRL

C FLUX SINGLETON // 3000

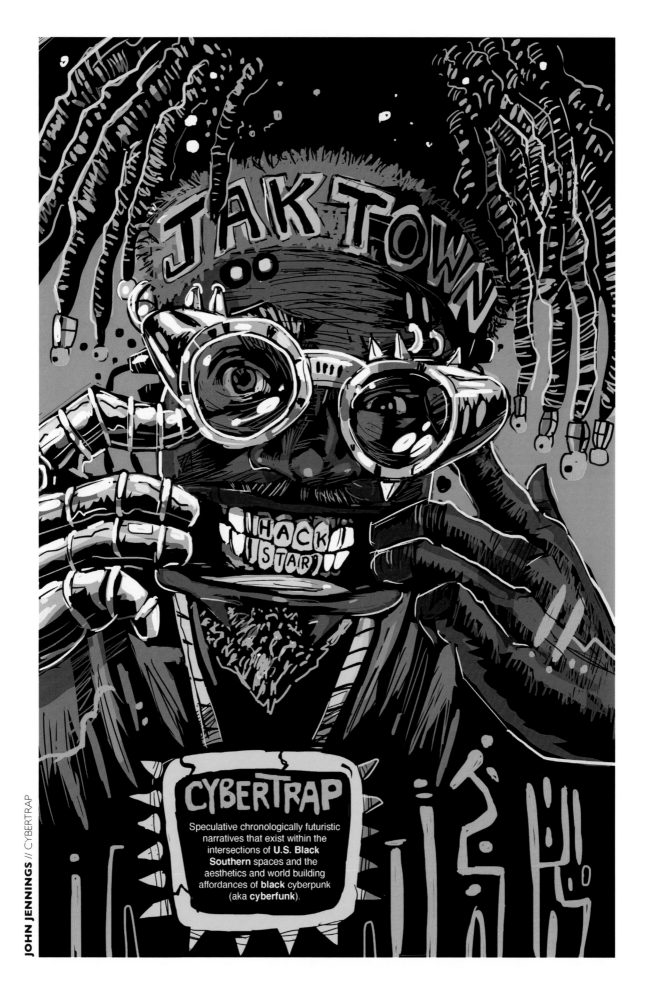

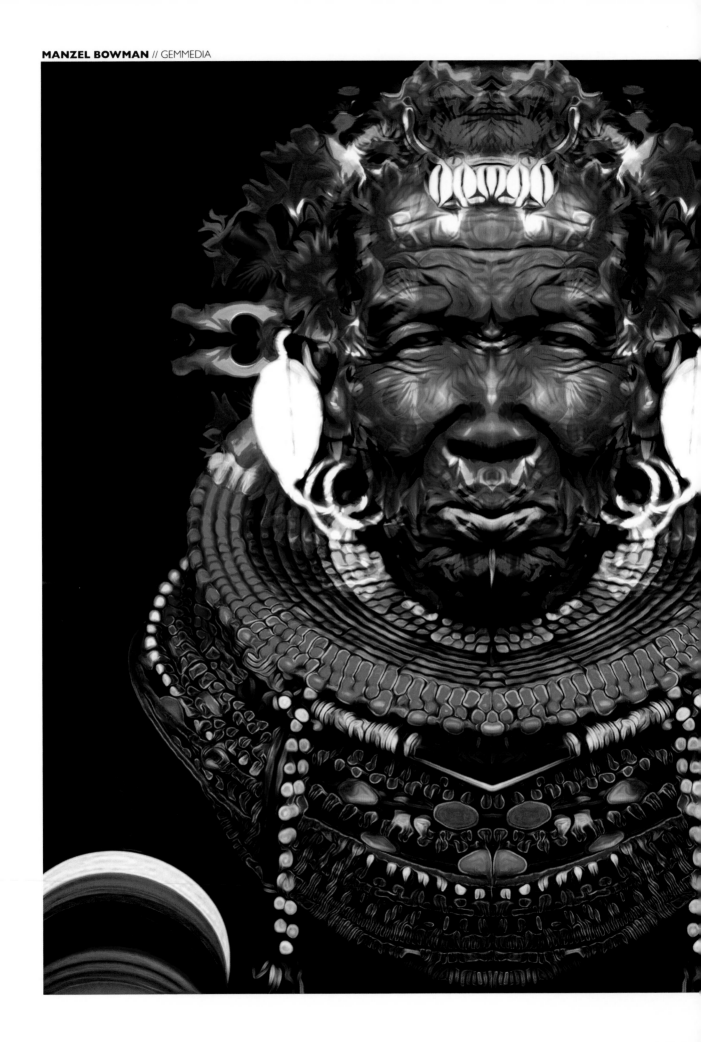

THE HARMONICS AND MODALITIES OF METAPHYSICAL BLACKNESS

Rev. Andrew Rollins

The Modern Jazz Movement of the 1940s, 50s, 60s and 70s signaled a major cultural shift for African Americans. During this period African Americans opened the flood gates within them letting the psychological waters of the African Unconscious flow freely as they turned to Afro-Asiatic thought and culture. To comprehend its meaning modern jazz must be recognized as more than musical technique. It is a social process. Amira Baraka in his classic book "Blues People," says that you can trace the history and social evolution of African American people through their music. Thus an inquiry into the substance and development of modern jazz can provide valuable knowledge about the African American community in the middle of the twentieth century.

During and immediately after World War II there was a restless atmosphere in the Black American community generated by the rising expectation for improvement in the conditions for black people. This surge of energy eventually triggered an explosion. By the mid-1950s Black Americans were engaged in a social/political movement historically known as the Civil Rights/Black Power Movement, which lasted until the mid-1970s. The music of the Modern Jazz Movement was also a part of that Movement. Modern jazz and the Civil Rights/Black Power Movement in fact had a dialectic effect on one another: each reflecting and inspiring the other. This was a time when Black Americans turned to the Eastern World: the world of Africa and Asia. African American realization was that truth, civilization and things of value did not exclusively reside in Europe or were not solely created by Ancient Greece and Rome. It was a time when Martin Luther King sought inspiration and guidance from the life and ideas of Mahatma Gandhi, Malcolm X went to Mecca and Africa for inspiration and support and the Black Panther Party studied the revolutionary theories of Mao Zedong and the liberation lessons of the Algerian Revolution in the writings of Frantz Fanon. Modern Jazz embraced Eastern culture and the sentiment of the Third World Liberation Struggle. In fact modern jazz is an artistic expression of Afro-Orientalism and the African Unconscious linking Africa America to a united movement of Pan-Asia and Pan-Africa.

Afro-Orientalism and the African Unconscious are respectively the ideological and psychological bridges connecting African Americans to the Eastern world. Thus an understanding of these concepts is necessary to be able to grasp the theoretical frame of modern jazz. So let's briefly examine these ideas for grounding in the cultural origin of this musical style.

In April of 1955, twenty-three Asian and six African nations – all of them sovereign – convened in Indonesia for the first Afro-Asian summit meeting of heads of state. This gathering was a product of the anti-colonial struggle that had been rising for a decade after World War II. The meeting was named the Bandung Conference. At the opening ceremonies President Sukarno declared to those assembled, "We are united ... by a common detestation of colonialism in whatever form it appears. We are united by a common detestation of racialism." The African American writer Richard Wright who attended the Bandung Conference, said the meeting "smacked of something new, something beyond Left and Right ... There was something extra-political, extra-social, almost extra-human about it, it smacked of tidal waves, of nature forces." The Spirit of Bandung birthed modern Jazz. This new kind of music was a modulation of the nineteenth century melancholy sorrow songs of slavery times into the mid-twentieth century vibrant jazz fantasias that gave voice to what historian Dr. Regennia N. Williams says is the binding of "Black Americans to African and Asian-descended participants in global struggles for change in cultural, political and economic affairs."

Africa America's binding with the Afro-Asian world came about naturally because the psychological roots of every black person are planted deep within a subterranean Africana soul collective known as the African Unconscious. The African Unconscious is a set of instincts and archetypes that animate Black people through symbols, mythologies, dreams and fantasies. Etched in the DNA of every Black person are memories of the scents, vibrations, sounds and images of Africa flowing from blood ties to the Motherland. The trauma of the slave castles, the middle passage and the American slave system, as brutal and devastating as they were, did not completely sever the link African Americans have with Africa.

To illustrate modern jazz as an expression of Afro-Orientalism and the African Unconscious, let's look at some individuals who orchestrated this new sound. In the 1940s bebop, the first phase of modern jazz came on the scene. Bebop differed from swing in that it was "characterized by a fast tempo" and it was "non-danceable music that demanded listening." Swing was representative of America before the great social paradigm shift caused by World War II. Now this new era birthed its own music to communicate its feelings and way of looking at the world. Though Dizzy Gillespie, Thelonious Monk and Charlie Parker emerged as major figures in the initial development of modern jazz, historian Gary Giddings believes that Charlie Parker was the primary figure in bringing bebop into being. Giddings says that Charlie Parker had done his laboratory work in Kansas City while Dizzy Gillespie and Thelonious Monk exchanged ideas in New York. So when he arrived in New York he already had the finished product. It should be noted that Kansas City in the 1930s was a jazz mecca. All the great musicians of that time were periodically located in Kansas City or regularly performed there. So Parker's hometown was an ideal place to nurture his gift in the early stages of his development. According to Dizzy Gillespie, "Charlie Parker was the architect of the new sound. He knew how to get from one note to another." Because he already molded the template, other musicians modeled themselves after him. Parker was a virtuoso whose performances as a saxophonist were astounding. His extraordinary talent made him a hero and later a patron saint of the hip and beatnik communities. "A Night in Tunisia," a piece which both Gillespie and Parker performed, marked the dawning of this style of music. Gillespie wrote the composition in 1942. It became one of the signature pieces of his bebop group. Later Parker recoded his own version of "A Night in Tunisia" in 1946. This song symbolized a view of the world that was beyond Jim Crow America and it was a melodic embrace of the cultural richness of the Dark World. Bebop was a musical revolution in jazz forged from the passion, pain and vision of African Americans. According to music ethnologist Gerhard Kubik, the harmonic development of bebop sprang from the blues and other African related tonal sensibilities. It was different from the music based on Western diatonic chord categories. Kubik also said, explorations in modern jazz during the 1940s brought African-American music back to "principles and techniques rooted in African tradition." Bebop also had a phenomenal universal appeal to people with various cultural backgrounds in Europe, Africa and Asia as it echoed the spirit of the times by

painting a vivid musical picture of the advent of post modernity. And just think how remarkable it was for an oppressed, exploited and marginalized people to produce such exquisite music. This sensational music was a dazzling demonstration of Black creativity. Certainly that creative capacity was personified in Charlie Parker, a young Black man born and nurtured in the depths of Jim Crow America, who was pivotal in launching a musical movement that captured the world with its splendid aesthetic quality.

The legendary trumpeter Miles Davis is another giant in modern jazz. His rise in the modern jazz world was meteoric. Immediately after graduating from high school in 1944 he moved from Alton, Illinois to New York City to study at the Julliard School of Music. However, upon his arrival in New York City he spent most of the time trying to locate his idol Charlie Parker. After finally locating Parker, Davis joined a group of musicians who became leaders in the bebop revolution. By this time he became thoroughly disappointed with Julliard because it focused too much on Eurocentric and white repertoire. So he decided to drop out in his first year, trading studying music in the conservatory for learning in jam sessions with his bebop friends. This experience substantially contributed to his growth as a musician. Davis was not only musically influential but he also possessed an influential persona. Because of his dynamism he has been called the greatest star in modern jazz. He was charismatic and mysterious. He was cool and stylish in an era when people, and more specifically, Black men were being lynched. And the crowning point that made him so spectacular was that the necessary talent and discipline were intertwined in this complex personality enabling him to become one of the most accomplished jazz musicians of all time. Davis became a model for others; setting standards, establishing principles and charting new courses in the field. His range of technique and methodology ran the gamut, including Kind of Blue (released in 1959) one of the best-selling jazz albums of all time and the trail-blazing album Bitches Brew (released in 1969). "All Blues" is one of the most popular pieces on the album Kind of Blue. This smooth, sophisticated modal frame worked piece is an example of transformation of the blues from the low down rough and ready "Mississippi delta blues" to the urban "cool jazz blues." By 1969 Davis metamorphosed to the futuristic sound in Bitches Brew created by fusing electronic music, funk, rock and jazz. It was a haunting, primeval cry erupting from a Black soul stretched beyond the outer reaches by the impact of future shock. The electrified driving melody and beat of Bitches Brew, propelled by the rhythms and tones reverberating from the African Unconscious were exhibited in works like "Miles Runs the Voodoo Down" and "Pharaoh Dance." This eerie cosmic rhapsody explored the multidimensional universe through the prism of music preparing the way for the present day of Astro-Blackness and Black Quantum Futurism.

The musical genius John Coltrane was instrumental in taking modern jazz to another level. During his life journey he evolved from the hard bop to the cool jazz of his Blue Train days to a transcendental sound. The latter was an enchanting sound of the blues modulated into the melodic, guttural and growling Afrocentric blues heard in the 1963 rendition of "Afro Blue Live at Birdland." Expanding musically and culturally, "John Coltrane immersed himself into Asian, African and Middle Eastern music and mixed it with rhythm and blues, jazz and Black Church music." He also studied the Eastern Science of Sound. All of this contributed to his development of a new kind of music that had the ability to possess both him and the listeners and transport them somewhere beyond their present state of being. His music became meditative. It is not surprising that Coltrane's life became very spiritually oriented when you look at his background. Coltrane was raised in a church environment in North Carolina before he moved north as a teenager. Both his grandfathers were ministers in the African Methodist Episcopal Zion Church and he was introduced to music in the church where his mother sang and played piano for her father's gospel choir. Coltrane was on a spiritual quest in his final years. He adopted a Sanskrit spiritual name --- Ohnedaruth, which means compassion. Ultimately he turned to music as a path to enlightenment. As a result his music acquired a mystical power that gave it a magnetic force to pull listeners in and then take listeners to another dimension. That power exudes in

his later works in the 1960s especially the masterpiece A Love Supreme recorded in December 1964 and released in February 1965. This four-movement suite is a spiritual composition about the human struggle for purity and Coltrane's gratitude to a God who loves him and his recognition that his talent and instrument belonged to God. The entire album is a hymn of praise. Coltrane proclaimed in the poetry liner for the album that "God breathes through us so completely... So gently we hardly feel it... yet, it is our everything." A Love Supreme is considered an avant-garde classic; combining clanging gongs and sizzling cymbals with abstract piano and Coltrane's "majestic violent blowing" on the saxophone that is "famously described as sheets of sound." John Coltrane was a charismatic individual. His life had a profound impact on his time and the future similar to his contemporaries Malcolm X and Martin Luther King. It is noteworthy that the Black mystic "Sun Ra felt that Coltrane was truly remarkable, both as a man and a musician, and that he even had messianic qualities." After Coltrane's death the Afro-Oriental spiritual music message would continue to be spread by others; specifically by Coltrane's wife, Alice Coltrane, an accomplished musician in her own right and Free Jazz Artist Pharaoh Sanders.

Certainly the keyboardist, composer, philosopher and shaman Sun Ra was one the most unique figures in modern jazz. He is recognized as laying the ground-work for the Afrofuturist Movement. Sun Ra, along with being a great musician, constructed a comprehensive philosophy of metaphysics, social science and music. This system of philosophy was a synthesis of Black Nationalism, Egyptology, Futurism, the occult and science. Sun Ra's point of origin was within black mysticism. His mother was attracted to black mysticism because she named her son Herman after the African American magician, voodoo priest, root doctor and occultist Black Herman. Early in life Sun Ra had a vision when he was a college student at Alabama A&M in 1936. While he was in deep religious concentration, Sun Ra claims he was transported to the planet Saturn. There he was given the mission to speak through music to a world of chaos. The effect of this visionary experience eventually led him to abandon his birth name and to take on the name of Sun Ra (Ra being the Egyptian God of the Sun). To accomplish his mission he organized a Band named --- Intergalactic Infinity Arkestra. This band became known for their exotic costumes that were a mixture of Ancient Egyptian and futuristic clothing and for their avant-garde music or what Sun Ra called --- "space music." Sun Ra was as committed to the study of the occult and philosophy as he was committed to music. In his way of looking at things music, the occult and philosophy intertwined forming a grand system of cosmic sound and eternal truth. To pursue this area of interest, Sun Ra with his close friend and collaborator Alton Abraham founded Thmei Research in 1951. Thmei Research was a secret society dedicated to the study of the occult, Egyptology, philosophy, the Bible, new technology and scientific ideas. There are two works, both titled Space is the Place, which epitomize Su Ra's genre. One was a musical composition and the other a musical screenplay. The album Space is the Place was recorded in 1972 and released in 1973. This music blended bebop and Free Jazz. It engendered an extraterrestrial atmosphere as it was 'both dissonant and catchy." The musical screenplay, Space is the Place, was made in 1972 and released in 1974 as a sci-fi movie. In it, Sun Ra plays the role of a space age prophet. This role gives him a platform to present his Intergalactic philosophy proposing that Black people go beyond fighting to acquire Black power and self-determination on earth to leaving an exploding disintegrating earth in order to survive in a safe haven somewhere in outer space. To truly appreciate Sun Ra one must realize that this was more than role-playing for him. Sun Ra was a prophet whose mediums were poetry, philosophy, mysticism and music. His Afrofuturist message was a call for redemption and liberation. He was a composer-mystic who envisioned a place where Black people would be at peace and in harmony with the Black Sacred Cosmos.

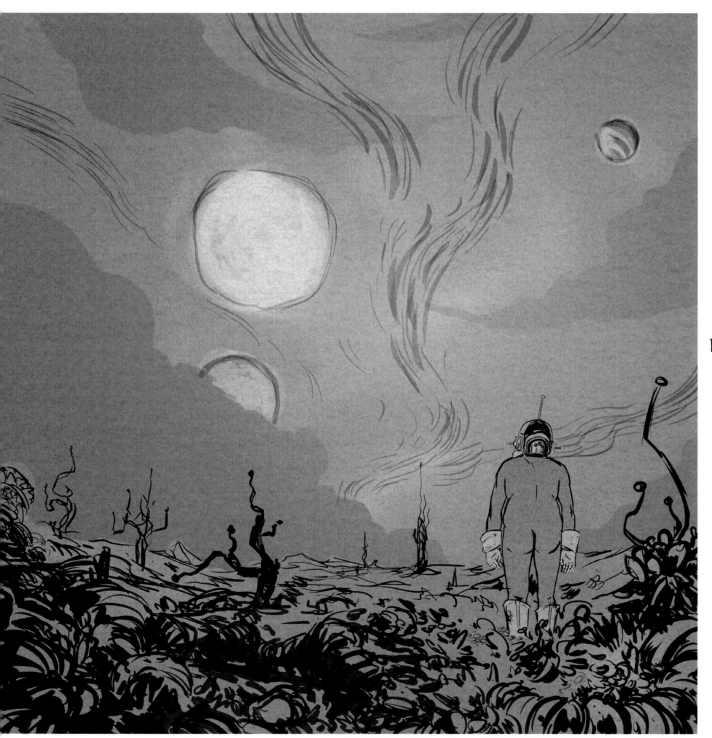

147

DAVID BRAME // THESE CLOUDS AREN'T UNICORNS (DUSTY FUNK SERIES)

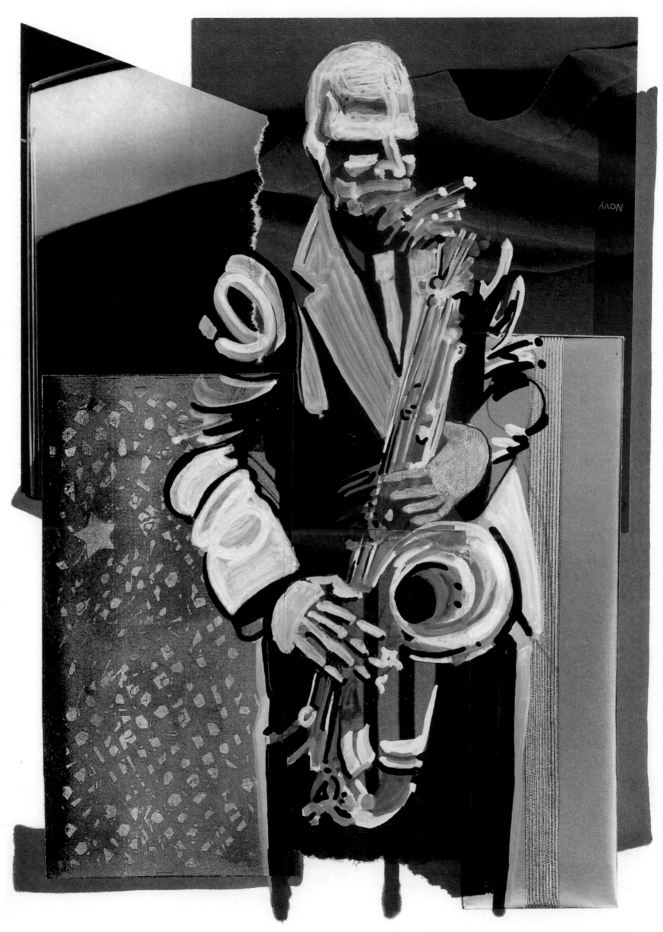

DUANE DETERVILLE // ARCHIE SHEPP

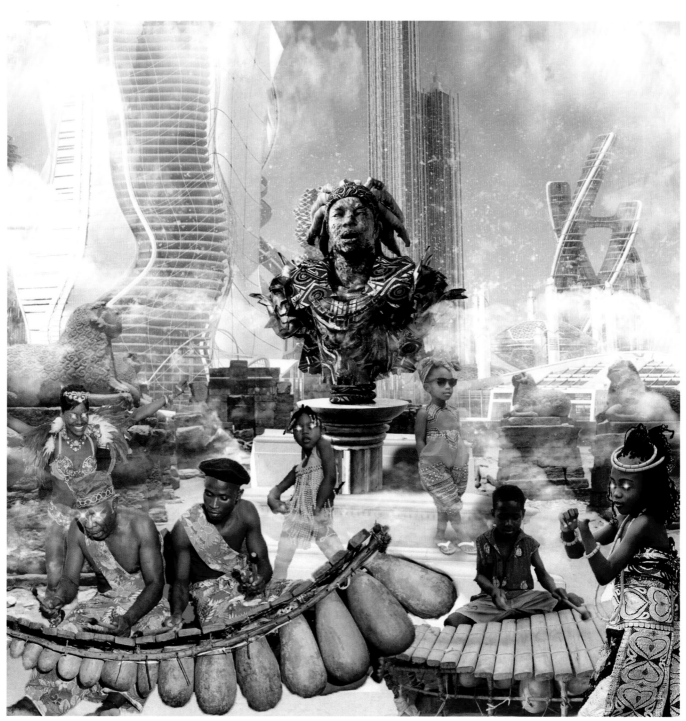

QUENTIN VERCETTY // BALAFON-DUBE

READ
DUSTYFUNK
:AFRO
SPACE
OPERA

DAVID BRAME // DUSTY FUNK SERIES

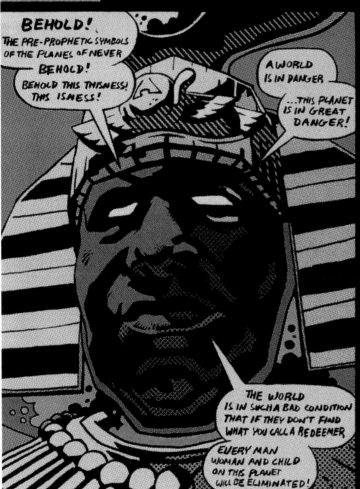

PLANET DEEP SOUTH

BLACK KIRBY

153

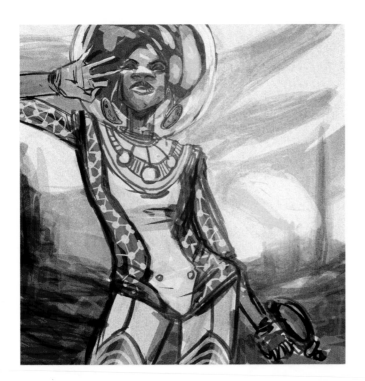

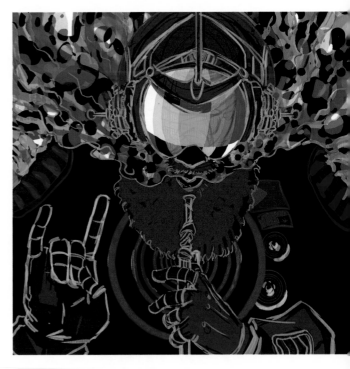

DAVID BRAME // DUSTY FUNK

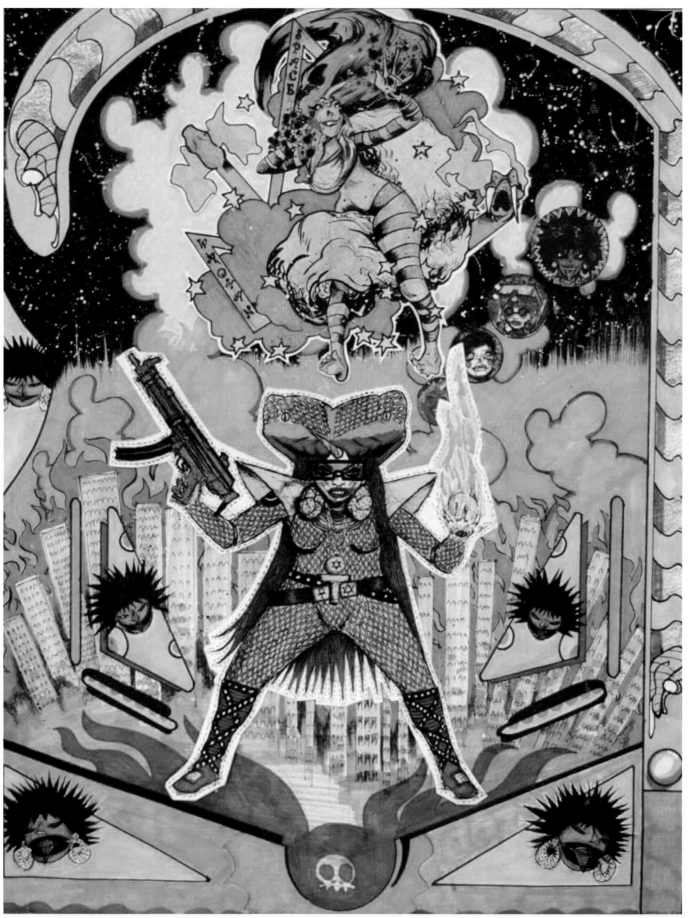

BRYAN CHRISTOPHER MOSS // SPACE WOMAN

DAVID WHITE // ELECTRO BOOGIE

DISMANTLING THE MASTER'S CLOCK: BLACK QUANTUM FUTURISM AS A NEW AFRO-DIASPORIC TIME CONSCIOUSNESS

Rasheedah Phillips (founder of The AfroFuturist Affair/Black Quantum Futurism)

Most people take our everyday experiences of time as a factual, unalterable facet of reality. There are clocks that chart the hours, minutes, and seconds; calendars that chart the march of days, months, and years; suns, planets, and stars that chart the ages, mapping out cosmic time. More subtle, however, are the ways in which time governs our social interactions, regulates our motions and movements, frames our worldviews, informs our politics, and leaks into our very consciousness. The ways in which we are situated in time is reflected in how we talk about, think about, and conceptualize the world around us.

The construction of modern day, American society can be viewed through a temporal lens, where time is organized discretely and causally into a linear past, present, and future. Under this temporal regime, the thermodynamic arrow moves unilaterally and indiscriminately forward into the future, one second by one second. Natural time has all but been overthrown by Western linear time, where temporal orientation is facilitated by clocks, schedules, cell phones, and digital calendars.

The inscription of the Western linear time consciousness found its early legitimacy through advances and events in science and technology; through Darwinism and thermodynamics, the Industrial Revolution, the development of the railroad, and innovations to the telegraph, to highlight a few turning points. Many of these milestones in the history of Western temporal consciousness intersect with, or are simultaneous to significant events of the Maafa. One could sketch out a timeline of events such as the Civil War (1861-65), the Emancipation Proclamation (1863), or the last voyage of the TransAtlantic slave trade (1887) for instance, and find them in close succession to, or overlapping, sociohistorical and temporo-historical events such as the first long-distance railroads (1830), development of the second law of thermodynamics (approx. 1854), and the establishment of the four continental US standard time zones by the railroads (1883).

The inscription of linear space-time could even be discerned in the notion of slave ownership itself. 36°30' north is the parallel of latitude that divides where slavery was allowed and prohibited in America under the Missouri Compromise, and the line that separated the United States from the Confederate States. In Mastered by the Clock: Time Slavery, and Freedom in the American South, Mark M. Smith describes the process by which White southern slave masters adopted mechanical clock time and a linear time construct as the dominant temporal consciousness over that of nature-based timekeeping methods, noting that the transition fulfilled simultaneous motivations of social order, discipline, economic gain, efficiency, and modernity.

Modern-day mechanical clock time and its ancillary linear, temporal consciousness were encoded into the enslaved Black African by means of the whip, and other forms of torture and violence. Masters further encoded a temporal order by use of sound; bells, horns, public clocks, chants, songs, andspeech patterns, were used to regulate slave labor on the plantation. Temporal literacy and ownership of timepieces, was also for the most part forbidden for enslaved Africans, lest it be used as a tool to gain their freedom.

To some extent, enslaved Africans retained their connections to natural time constructs and their own traditions of observing space-time. One potent example is the use of the North Star to point North on the Underground Railroad. However, for survival purposes alone, enslaved Africans came to internalize some form of a linear time construct, and in turn obeyed and resisted clock time as an extension of the slave master.

The emancipation of enslaved Africans from slavery did not automatically free them of the Master's clock time, however. At the point of emancipation, the Western, linear construct of space and time was already encoded into every aspect of the American way of life, social order, economy, transportation, and communication. Time continued to be used as another form of social control against oppressed communities. There would be no practical way to totally eschew linear temporal consciousness while remaining in this society. If seeking to integrate into it, or to at least peacefully co-exist (though that ultimately proved to be unsuccessful), compromises had to be made. A split spatiotemporal consciousness - one parallel to that of the Dubosian double consciousness, was thereby developed in the emancipated Africans, referred to as CP Time.

One can only speculate on the mental state of an emancipated African seeking to reconcile their own innate time consciousness with the American, linear time construct. In general, an indigenous African time consciousness has a backwards linearity in that when events occur, they immediately move backward towards Zamani, or macrotime. In many Indigenous African cultures and spiritual traditions, time can be created, is independent of events, and is not real until experienced. From this time perspective, time is composed of events, so days, months, and years are just a graphic or numerical representation of its events. A linear, Western time consciousness in direct opposition, stresses fixed events along a forward moving timeline, while events are seen as irreversible. The linear timeline is embedded within cyclical time, in that hours, minutes, and seconds in their abstract, numerical form, repeat. Events themselves, however, will never repeat on a progressive, linear timescale.

Black Americans today are the stark embodiment of temporal tensions: a disunity between cultural notions of time, many of us occupying what Jeremy Rifkin calls "temporal ghettos" as well as physical ones. How we negotiate time and space in relation to the event(s) that forced upon these shores - the TransAtlantic Slave trade - provides context for the struggles that we continue to endure in the present. CP Time has been both a defense mechanism against Black communal trauma and post-trauma under the conditions of class warfare and racial oppression, and a harkening back to a more natural, ancestral temporal-spatial consciousness.

CP Time is often seen and studied as temporal orientation of presentism in the Black community. Use of the presentism time orientation can be class, and by extension, race-based, yet, it is recently appropriated by New Age philosophy and meditation mantras. However, when a presentism time orientation is applied to Black people, it is usually seen as a negative trait: considered as lacking a sense of future and only concerned with present pleasure, concerns, associated with laziness, indolence, and lateness. These traits are in turn, used to justify the Black community's disproportionate rates of poverty, joblessness, homelessness, and disease. Less analyzed is the ways in which this temporal orientation is connected to class oppression, racism, white supremacy, and the legacy of slavery. Slavery was where time was inculcated into our very skin, where the ring of the bell or the tick of the clock regulated our fate, labor, birth and death, taking over the natural rhythms and spirits, spatio-temporal orientation and consciousness (and I only speak here of temporal disorientation, but a spatial disorientation should be implied, to the extent that the fabric of the two are co-associated in an Einstein universe). In the present day, we continue to be punished for not being "on time." For being a mere fifteen minutes late to court or to work, you could lose your livelihood, children, home, or freedom.

There is a necessity to dismantle the master's clock and reinscribe a CP Time, or, perhaps more affirmatively, to construct a new diasporic African spatiotemporal consciousness. It is unrealistic to expect that we can ever return to the time consciousness of our more distant ancestors, enacting a complete reversal to a pre-TransAtlantic slave trade spatiotemporal construct. It is much more realistic to reconcile our bifurcated time consciousness by creating or adapting a time consciousness consistent with our experiences as diasporic, displaced Africans, living in communities that have by and large adopted a linear time construct. There is a meaningful way to embrace the paradox and allow these two opposing temporal modes to co-exist, in the way that light co-exists both as wave and particle on the quantum level. This is by crafting a unique time construct that takes account of a Western time mode and our own natural time tendencies, as inscribed in our DNA through biology, ancestry, culture, spirit, and natural rhythms. Such a time construct inevitably requires a new language, a way to speak of the past, present, and future without resorting to time hierarchies.

159

Black Quantum Futurism (BQF) is in the process of developing and enacting a new spatiotemporal consciousness. BQF theory, vision, and practice explores the intersections of quantum physics, futurism, and Black/African cultural space-time traditions. Under a BQF intersectional time orientation, the past and future are not cut off from the present - both dimensions have influence over the whole of our lives, who we are and who we become at any particular point in space-time. Our position from the present creates what that past and future looks like and what it means at every moment. We determine the meaning and relationships both dimensions of time have to our present moment.

BQF also seeks to unravel the processes of how communal memory is seeded, how the collective memory spreads across time and space - reaching backward in time and forward in time simultaneously to include everything that has and will happen. This dynamic process, which BQF has termed a "retrocurrence," takes on features and characteristics reminiscent of quantum matter, where time is naturally reversible and information can flow in both directions. A retrocurrence is a backwards happening, an event whose influence is not discrete and timebound - it extends in all possible directions and encompasses all possible time modes. Retrocurrences provide pathways of opportunity for seeding new schemes of spatiotemporal consciousness.

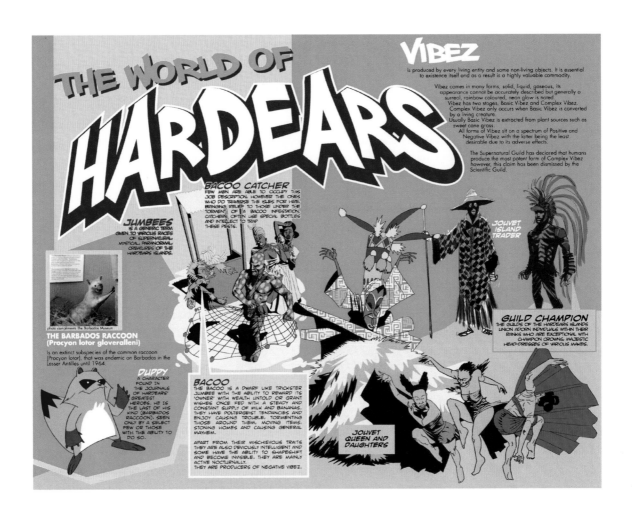

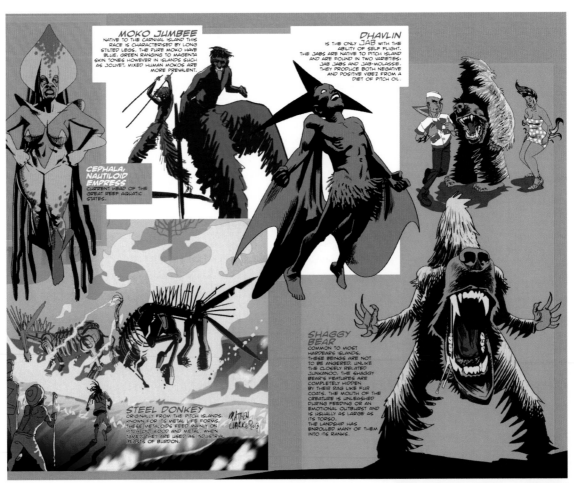

MATTHEW CLARKE // HARD EARS

LANDSHIP

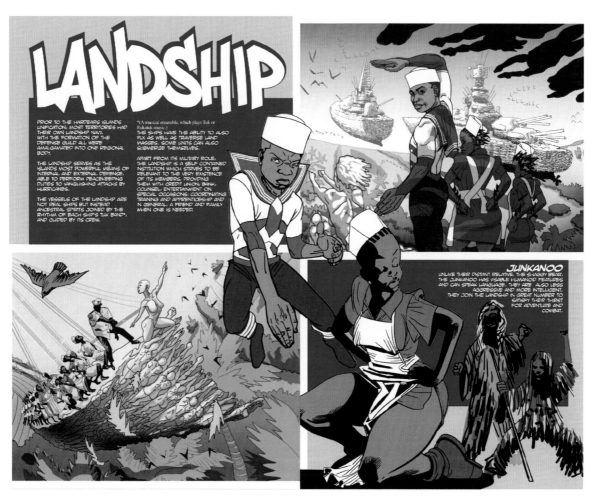

PRIOR TO THE HARDEARS ISLANDS UNIFICATION, MOST TERRITORIES HAD THEIR OWN LANDSHIP NAVY. WITH THE FORMATION OF THE DEFENSE GUILD ALL WERE AMALGAMATED INTO ONE REGIONAL BODY.

THE LANDSHIP SERVES AS THE ISLANDS MOST POWERFUL MEANS OF INTERNAL AND EXTERNAL DEFENSE, ABLE TO PERFORM PEACEKEEPING DUTIES TO VANQUISHING ATTACKS BY HURRICANES.

THE VESSELS OF THE LANDSHIP ARE NOT REAL SHIPS BUT INSTEAD ANCESTRAL SPIRITS JOINED BY THE RHYTHM OF EACH SHIP'S TUK BAND*, AND GUIDED BY ITS CREW.

*(A musical ensemble, which plays Tuk or Rukatuk music.)

THE SHIPS HAVE THE ABILITY TO ALSO FLY, AS WELL AS TRAVERSE LAND MASSES. SOME UNITS CAN ALSO SUBMERSE THEMSELVES.

APART FROM ITS MILITARY ROLE, THE LANDSHIP IS A SELF CONTAINED INSTITUTION WHICH STRIVES TO BE RELEVANT TO THE VERY EXISTENCE OF ITS MEMBERS, PROVIDING THEM WITH CREDIT UNION, BANK, COUNSEL, ENTERTAINMENT ON SPECIAL OCCASIONS, COORDINATING TRAINING AND APPRENTICES-HIP AND IN GENERAL, A FRIEND AND FAMILY WHEN ONE IS NEEDED.

JUNKANOO

UNLIKE THEIR DISTANT RELATIVE, THE SHAGGY BEAR, THE JUNKANOO HAS VISABLE HUMANOID FEATURES AND CAN SPEAK LANGUAGE. THEY ARE ALSO LESS AGGRESSIVE AND MORE INTELLIGENT. THEY JOIN THE LANDSHIP IN GREAT NUMBER TO SATISFY THEIR THIRST FOR ADVENTURE AND COMBAT.

161

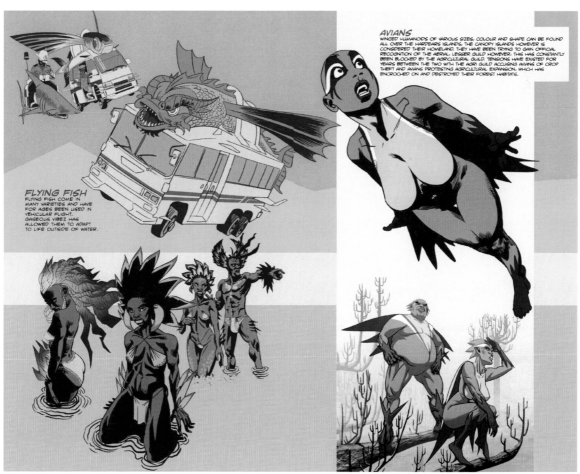

AVIANS

WINGED HUMANOIDS OF VARIOUS SIZES, COLOUR AND SHAPE CAN BE FOUND ALL OVER THE HARDEARS ISLANDS. THE CANOPY ISLANDS HOWEVER IS CONSIDERED THEIR HOMELAND. THEY HAVE BEEN TRYING TO GAIN OFFICIAL RECOGNITION OF THE AERIAL, LESSER GUILD HOWEVER, THIS HAS CONSTANTLY BEEN BLOCKED BY THE AGRICULTURAL GUILD. TENSIONS HAVE EXISTED FOR YEARS BETWEEN THE TWO WITH THE AGRI GUILD ACCUSING AVIANS OF CROP THEFT AND AVIANS PROTESTING AGRICULTURAL EXPANSION, WHICH HAS ENCROACHED ON AND DESTROYED THEIR FOREST HABITATS.

FLYING FISH

FLYING FISH COME IN MANY VARIETIES AND HAVE FOR AGES BEEN USED IN VEHICULAR FLIGHT. GASEOUS VIBEZ HAS ALLOWED THEM TO ADAPT TO LIFE OUTSIDE OF WATER.

MATTHEW CLARKE // HARD EARS

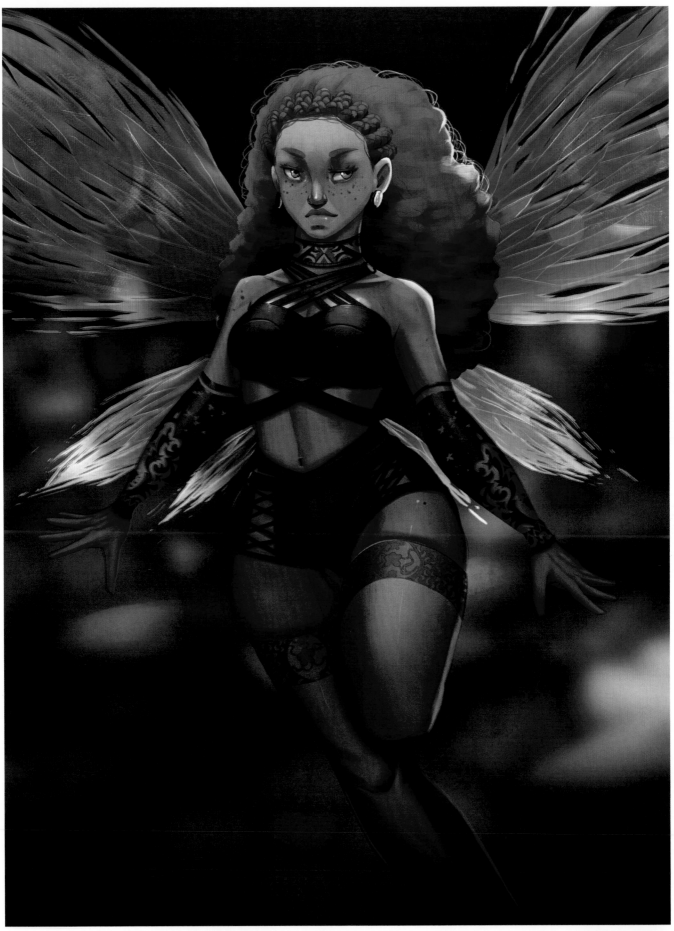

VENUS BAMBISA

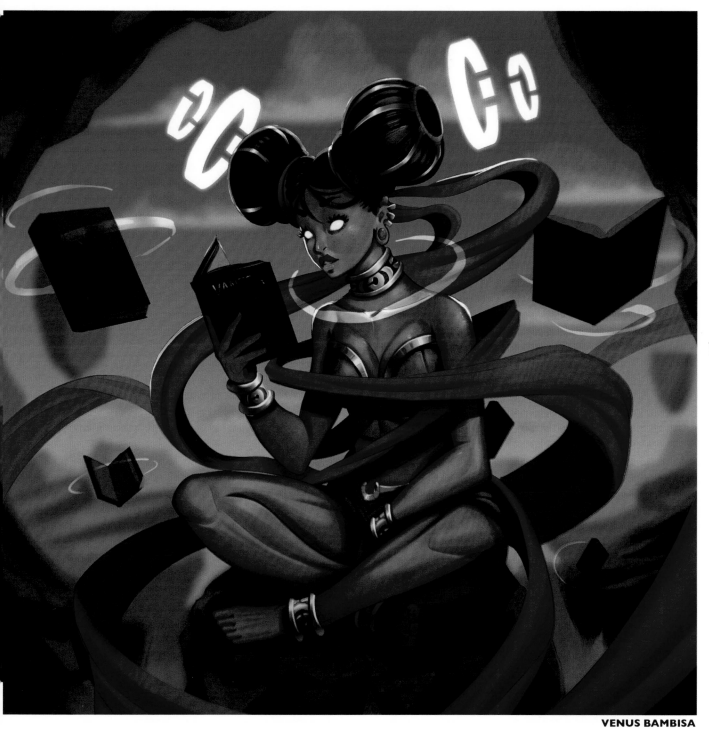

163

VENUS BAMBISA

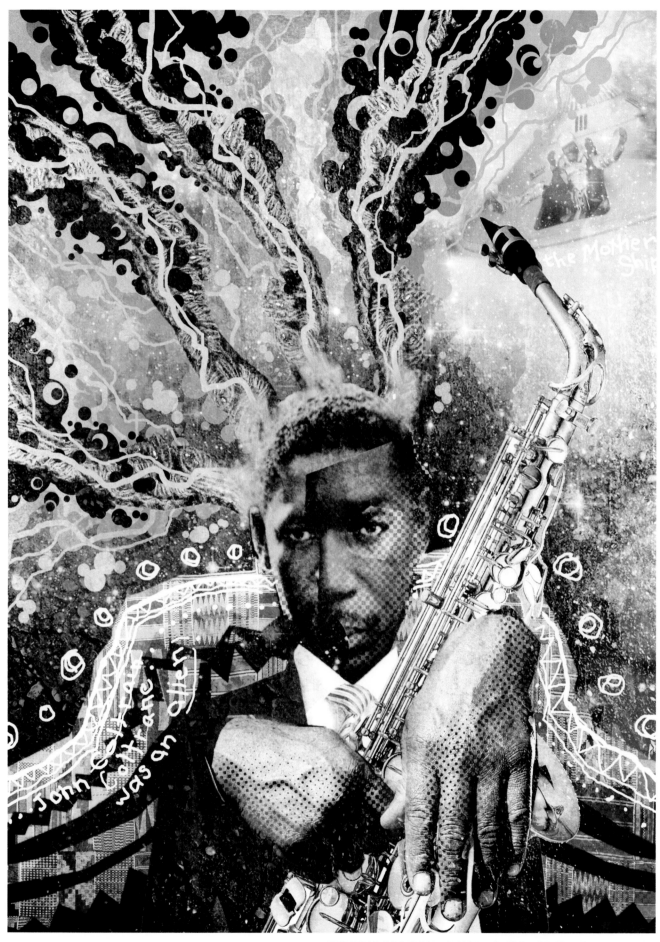

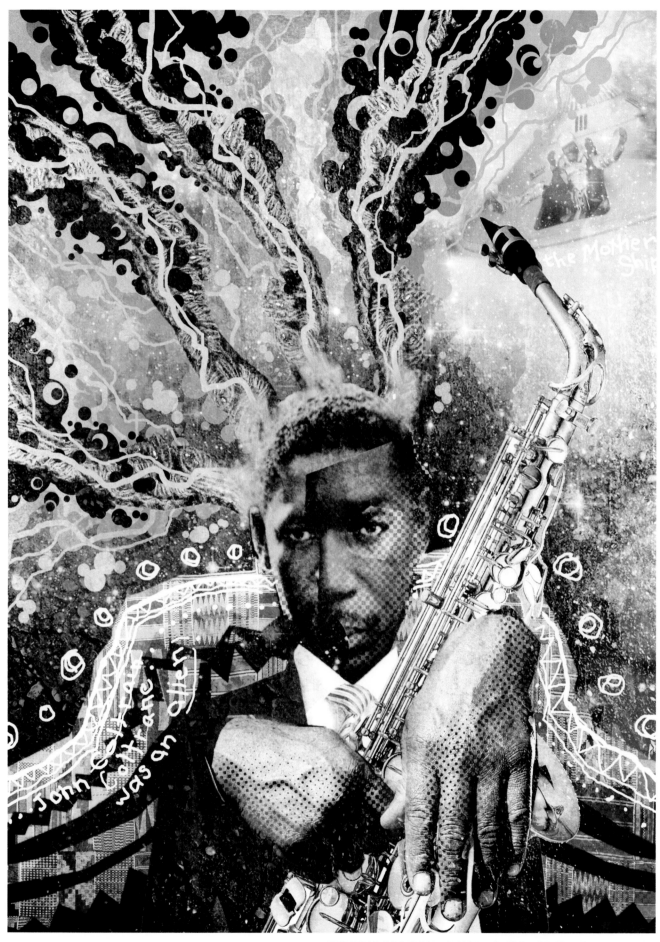165

STACEY ROBINSON // SAMO WAS HERE & COLTRANE WAS AN ALIEN

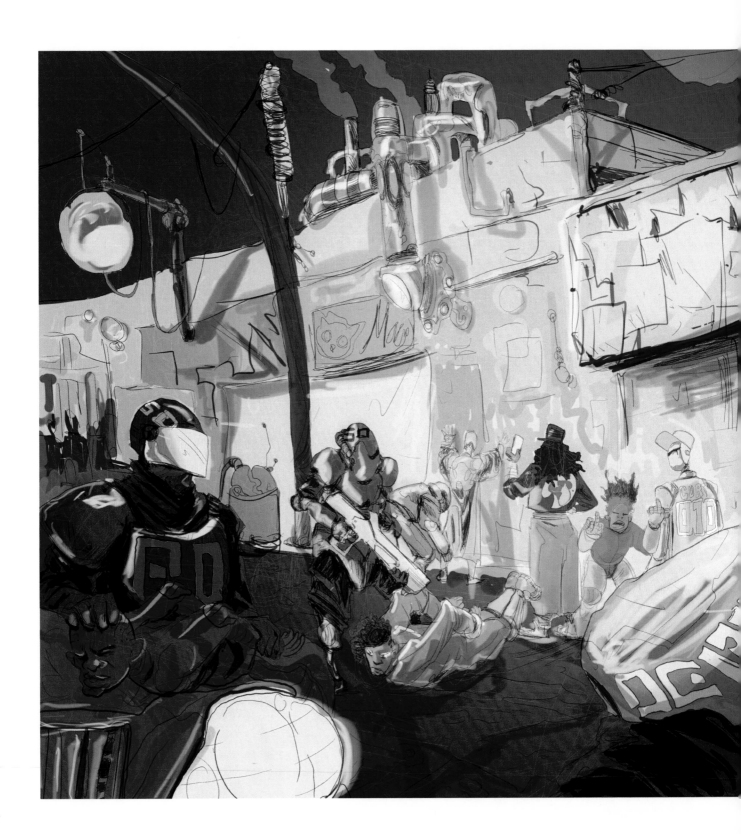

Watch Night
A TEN MINUTE PLAY

Gregory S. Carr

CHARACTERS

Calligrapha – A member of the Influentials. Her super power is the ability to write and send messages telepathically.

Firebrand – A member of the Influentials. His super power is to change the words he speaks into radioactive kinetic energy.

Dr. Duality – The leader of the Influentials. His super power is to adapt his consciousness into whatever environment he is in.

SETTING

Atlanta, Georgia, December 31, 2062, the Adebowale Building. Although it appeared to be a once stately edifice, it appears to be in disrepair. CALLIGRAPHA, walks into the meeting room. She looks around the room, mentally recalling its memories.

Couldn't use edit so I did it this way-

> #### CALLIGRAPHA
>
> Hello? Is anyone here? Hello? (Moments later, FIREBRAND, enters the room. He is tall and wears a bespectacled mask. He pauses momentarily when he sees CALLIGRAPHA. FIREBRAND begins to make a hasty retreat for the door, when CALLIGRAPHA calls to him.) Firebrand, what are you doing here?

> #### FIREBRAND
>
> Well, I could ask you the same thing, but with a less of the third degree in my voice.

> #### CALLIGRAPHA
>
> Is this some kind of joke? I received an urgent message to meet here in Adebowale Building before midnight to discuss the Neotecons takeover of the government.

> #### FIREBRAND
>
> I got the same message, but Coxswain sent it to me.

> #### CALLIGRAPHA
>
> Madam Clandestine relayed the message to me through the helioporter.

> #### FIREBRAND
>
> (Laughing) This is too funny.

> #### CALLIGRAPHA
>
> What's so funny?

.VID BRAME //TROUBLE ON MLK AVE.

FIREBRAND

We both fell for the old end around play.

CALLIGRAPHA

So you mean someone is setting us up?

FIREBRAND

Without a doubt.

CALLIGRAPHA

What makes you so sure?

FIREBRAND

Did you confirm that it was actually Madam Clandestine that sent you the message?

CALLIGRAPHA

I just assumed that it was Madam Clandestine. She and I have kept in touch over the years; unlike *some* people.

FIREBRAND

That supposed to be a subtle hint about me?

CALLIGRAPHA

(Sarcastically) Does it sound subtle Frederick?

FIREBRAND

Here we go. As soon as you start calling me by first name, I know I'm in trouble.

CALLIGRAPHA

That is your legal name, isn't it?

FIREBRAND

(Unamused) I know that, but I don't go by that name anymore. The name is *Firebrand*.

CALLIGRAPHA

So, Mr. Calm, Cool and Collect does have a temper. I can still read your heart. (CALLIGRAPHA reaches out her hands towards FIREBRAND's heart.) And you heart is still broken. So sad...(FIREBRAND momentarily succumbs to CALLIGRAPHA's powers.)

FIREBRAND

Don't play games with me, Calligrapha! I don't need your little tricks to get me in contact with my emotions. I've been through hell and back. (FIREBRAND recoils and pulls away from her.) The last thing I need is you putting your feelers on me. Save it for someone else.

CALLIGRAPHA

Don't dish it out if you can't take it.

FIREBRAND

I didn't come here to argue with you Calligrapha.

CALLIGRAPHA

Maybe if we would have had more arguments you wouldn't have left the Influentials to strike out on your own like some lone vigilante! You walked out on us Firebrand! Especially when we needed you most!

FIREBRAND

Do you mean when I walked out on you, or when I walked out on the group? Which one is it Calligrapha? You can't have it both ways.

CALLIGRAPHA

Why do you keep going back to that...

FIREBRAND

...Because we never resolved what we had between you and me. So much anger... you need to release some that anger...it's always better to say what's on your mind...(FIREBRAND walks closer to her. CALLIGRAPHA turns her back on him. FIREBRAND puts his arms around her.)

CALLIGRAPHA

(Pulling away) Anger? Yes I'm angry! Firebrand, it is not that simple! You can't just pick up where we left off. (CALLIGRAPHA stops when she realizes what is happening.) And stop trying to use your powers on me!

FIREBRAND

All right. (He stops) Now you know how it feels.

CALLIGRAPHA

I've moved on without you. You made your choice; you left.

FIREBRAND

And you don't think that you pushed me away? You were no saint either, sister.

CALLIGRAPHA

So what are we doing here Firebrand? Some mysterious person, who we think is our friend, invites us to our old headquarters. This could be a trap by the Neotecons to destroy us both.

FIREBRAND

It could be. But don't you think that they would have moved in by now? Those cyborgs would give anything to round us up and put us away forever. This is someone with an agenda. (DR. DUALITY walks through the door and smiles at the two of his protégés.) Well, well, it's the good doctor. Why did I not see that coming?

DR. DUALITY

That is because you still have not mastered the art of reigning in your own emotions, Firebrand. I tried to work with you, but you resisted.

FIREBRAND

That's because I don't like to be controlled Doc. You of all people should know that about me. I spent enough time in the Prison Industrial Sentinel System to figure out that I never want anybody to try and control me.

DR. DUALITY

Hello Calligrapha.

CALLIGRAPHA

Dr. Duality, I never thought that I would agree with Firebrand, but you could have done this differently.

DR. DUALITY

And if I would have told you that Firebrand was going to be here, would you have come? (CALLIGRAPHA looks away.) The two of you needed to come here and put your pasts behind you. There is a greater danger we all must face.

FIREBRAND

The Neotecons.

DR. DUALITY

That is correct. At midnight tonight, the Neotecons will pass a bill called the Institutional Reclamation Edict.

CALLIGRAPHA

Isn't that an urban legend, like alligators in the sewers of New York?

DR. DUALITY

No my dear, I only wish it were fiction. The Neotecons have successfully disenfranchised every major voting region through redistricting. They have also rolled back every piece of Affirmative Action legislation, and the Voting Rights Act of 1965 will not be renewed in 2085. In essence, the Industrial Reclamation Edict, also known as I.R.E Bill 666 will nullify the Thirteenth, Fourteenth an Fifteenth Amendments. It is the antithesis of the Emancipation Proclamation. Our old friend Ronald Andrew Bedford Davis and his Invisible Army is up to his old tricks.

FIREBRAND

How can they be stopped?

DR. DUALITY

There is one group that stands in their way; the Influentials.

CALLIGRAPHA

But the Influentials don't exist anymore. We're just a bunch of solo projects. There's no unity among us. Everybody's doing their own thing.

DR. DUALITY

That is precisely why we are here. We must band together to stop them.

FIREBRAND

You know Doc, that's all well and good, but I've had some success on my own. Coxswain and I flew the Black Star to Africa, and we've been helping African countries rid themselves of these "dictators for life" and the cut the strings of the governments who have been their puppeteers. I do my best work solo, or if I work with someone, we have an understanding that we part ways at the end of the mission. Doc, I know you're into all that double consciousness philosophy, but the only thing those Neotecons are going understand is brute force. This is 2062, and all out war is the only answer!

DR. DUALITY

Calligrapha, can I appeal to the better angels of your nature? If we don't band together now, all of the freedom that our ancestors secured for us will vanish in one night?

CALLIGRAPHA
Dr. Duality, you are asking a lot from us in such a short amount of time. Firebrand has his methods, I have mine, and the others have their own way of fighting the Neotecons. Who's to say by us joining our powers together again that we won't have the same problems we had before?

DR. DUALITY
That's the chance we have to take, Calligrapha. If we fight them as individuals, we face the risk of total annihilation. Together we can form a plan of action that utilizes the best of all of the Influentials.

FIREBRAND
Doc, as soon as we get going, you're going to pull the "wise father" card, and nobody will have a say so in the battle strategy. I just don't want to go back down that road again.

CALLIGRAPHA
What about the others? Why aren't they here? How do we know that they are onboard?

DR. DUALITY
If you must know, you two are the last to sign on.

FIREBRAND
We're the last?

DR. DUALITY
Yes. Coxswain, Madam Clandestine, Major Justice and Sage have all agreed to unite for the cause. You two are the lone holdouts.

CALLIGRAPHA
Could you explain why we were contacted last?

DR. DUALITY
Because the two of you, shall we say, have history?

FIREBRAND
There you go again Doc! Stop with the arm chair psychology! That's one of the reasons I left the Influentials!

DR. DUALITY
When will you stop thinking about yourself and start thinking about the future! You've had plenty of time to lick your wounds. Now is the time to set egos aside for the greater good of the people. The people need the Influentials. This country needs the Influentials. The Influentials need the Influentials. Time is not on our side. I.R.E) goes into effect at midnight if we don't get on the Black Star, fly to Washington and stop it from happening. Can I depend on you Firebrand? (DR. DUALITY reaches out his hand to FIREBRAND. FIREBRAND stares at DR. DUALITY's open hand for what seems to be an eternity.

Suddenly, CALLIGRAPHA gentle wraps her hand around FIREBRAND's hand and the three join hands together.)

FIREBRAND
I always hate it when you make those kinds of arguments Doc.

DR. DUALITY

What kind of arguments Firebrand?

FIREBRAND

Rational arguments. You know I want to let my emotions run free when it comes to these issues.

DR. DUALITY

And maybe I can learn to let my emotions out a bit more this time around.

CALLIGRAPHA

And make sure you listen to us Dr. Duality. We recognize that you are the leader of the Influentials, but you have to listen to our ideas. It's not your responsibility to come up with all of the plans. That's the responsibility of the team. We are a team, aren't we?

DR. DUALITY

We are a team.

CALLIGRAPHA

And if that is the case, after we get back from Washington, this place needs a little fixing up. Definitely needs a woman's touch. If we're going to be working together again we are going to need some serious updates.

DR. DUALITY

This mission is life or death. The Neotecons are very powerful and they have infiltrated the community. They have undercover agents in every segment of the Beloved Community. Judge, doctors, teachers, lawyers, politicians…

CALLIGRAPHA

(Knowingly) And super heroes.

DR. DUALITY

Yes, especially when they are from among us.

FIREBRAND

You mean there are "house" Neotecons?

DR. DUALITY

They are the most dangerous of the Neotecons. They appear to promote unity within our ranks, but at the same time are reporting our movements back to the power behind the Neotecons.

CALLIGRAPHA

Ronald Andrew Bedford Davis.

FIREBRAND

Mr. R.A.B.I.D. himself.

CALLIGRAPHA

What is R.A.B.I.D?

FIREBRAND

Radical Advocates Building Institutional Decency

DR. DUALITY

Davis will go to any length to reverse every policy that secures the freedoms of Afrocentrists and their allies. In fact, he will not be satisfied until he places all of us in chains.

FIREBRAND

Tell Ronnie to bring it on. I'm ready to fire it up!

CALLIGRAPHA

I'm in Dr. Duality. What about you Firebrand?

FIREBRAND

The Good Doctor once again has convinced me to be a team player. I'm in. But I'm not sitting next to Major Justice. I don't want to be bored with his "rhetoric of brotherhood."

DR. DUALITY

And let us not forget that there are some Eurocentrists that are sympathetic to our cause. We can depend on them for resources, information and sometimes for protection. Madam Clandestine runs a series of information through the Enantiomorph Network Cyber Labyrinth Automated Verification Electronic System, also known as E.N.C.L.A.V.E.S., which will protect our comings and goings, as well as erase our electronic footprints.

CALLIGRAPHA

What's our next move, Doc?

DR. DUALITY

We're flying to Washington D.C., before midnight. Madam Clandestine has information that Davis will be sending an electronic neural signal via satellite that will temporarily hypnotize the lawmakers in to voting unanimously for I.R.E. Bill 666. The Black Star is waiting outside along with the other members of the team. Do you remember the Influentials' motto, or has it been that long?

ALL

One faith, one aim, one destiny.

DR. DUALITY

As our ancestors waited for a dream to come true at midnight in 1862, we are determined to keep that dream from becoming a nightmare 200 years later. Influentials, let's go change history! This is our Watch Night!

CURTAIN

NALO
HOPKINSON

WINNER OF THE JOHN W. CAMPBELL AWARD FOR BEST NEW WRITER

MIDNIGHT ROBBER

"An
impressive
debut."
— *Washington Post
Book World* on
*Brown Girl
in the Ring*

MIDNIGHT ROBBBER COVER

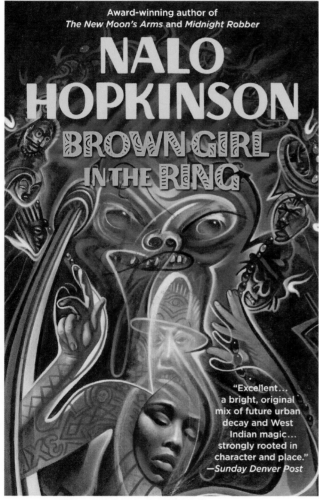

BROWN GIRL IN THE RING COVERS

MANZEL BOWMAH // PATEVANS

ROOT WORKING'S RECURSIONS IN THE BLACK IMAGINATION

Tiffany E. Barber

In 1964, Romare Bearden produced Prevalence of Ritual: Conjur Woman, the first of a series of three collages and the first appearance of the conjur woman figure in the artist's signature medium. Conjuring the root woman connects Bearden's collage practice to Black folk life and ancestral ritual practices retained in the Americas after enslavement. Bearden tells us, in reference to another 1964 piece, Conjur Woman as an Angel,

A conjur woman was an important figure in a number of Southern Negro rural communities. She was called on to prepare love potions; to provide herbs to cure various illnesses; and to be consulted regarding vexing personal and family problems. Much of her knowledge had been passed on through the generations from an African past, although a great deal was learned from the American Indians. A conjur woman was greatly feared and it was believed that she could change her appearance.

Once Bearden switched from social realist paintings and copying Dutch masters to exclusively working in collage in 1963, viewers and other characters in Bearden's oeuvre would encounter the conjur woman as a title character, as supporting actress tucked away in the wings of cluttered street scenes, and as a central metaphor for racial kinship across time and space.

Long before the conjur woman made her way into Bearden's collages, African-derived spiritual practices—hoodoo—were central to Black life. Hoodoo, also called rootworking, witch doctoring, and Obeah, is a form of traditional Black folk spiritual practice with its source in the Deep South that derives from the syncretism of West African, Native American, and European beliefs. The varied uses of hoodoo and conjuring in slave communities ranged from healing to hexes, and because many slaves relied on hoodoo for herbal remedies and contact with their ancestors in the spirit realm, slave owners and Christians attempted to outlaw it. Furthermore, there is evidence that hoodoo practice and conjurers played important roles in slave rebellions and everyday individual resistance.

Hoodoo encompasses conceptions of time and futurity, conjuring and spells, as well as the ability to shape shift, and the presence of the hoodoo aesthetic in Black religion, literature, and visual art from the Black diaspora has been heavily documented. Hoodoo, modernism, and alternative expressions of time are foundational to a great number of the literary and visual works made by Black artists during the years of the Harlem Renaissance, when Alain Locke encouraged Black artists to look to African ancestral arts for inspiration. So-called outsider, vernacular, and self-taught artists such as Sam Doyle, Benny Andrews, and Sister Gertrude Morgan used hoodoo as source material for their artworks. Charles Chestnutt's well-known book of short stories titled The Conjure Woman, first published in 1899, was re-released in 1926, marking hoodoo's official entrance into twentieth-century Black cultural production.

Hoodoo is present in Zora Neale Hurston's tales of Black folk life in the Southern U.S. and the focus of her anthropological studies of Haitian vodun and other African-rooted spiritual practices of the Black Caribbean diaspora. Hoodoo also forms the background for George Schuyler's 1931 satirical novel **Black No More** set in Harlem, in which Dr. Crookman, a Black scientist, invents a procedure that "whitens" dark skin tones. While technological manipulation, alternative 'medicine,' and the potential for a genetically engineered 'raceless' future are all the makings of science fiction, the novel depicts the Black experience as science fiction, a kind of pre-cyborg techno-sphere central to Astro-Blackness.

Though the Harlem Renaissance is typically catalogued as occurring between 1925 and 1935, the trends set in motion by Locke's New Negro Movement and the development of "the Black aesthetic" continued though the mid-1940s. Twenty years later, the notion of a Black aesthetic, and the ways in which spirituality constitutes it, carried over into the Black Arts Movement. The most influential instance of this continuance is Ishmael Reed's conception of NeoHooDoo, a phrase that describes the valence of ritualism in more contemporary works of literature and art and its significance to present-day artists of African decent.

Around the time Reed published Conjure (1972), his first collection of poems that expounds on hoodoo's importance to Black artistic production, Bearden's conjur woman appears numerous times, most notably in The Conjur Woman of 1971. In Bearden's collage, black-and-white photo-fragments comprise the conjur woman, who appears part-human and part-animal. Portions of the green paperboard that forms the piece's background frame her face. Amid cut-paper and magazine clippings of a coiling snake as well as trees, leaves, and other fauna, her eyes peer at the bird in her oversized hand as our eyes survey the image's surface, attempting to make sense of the amalgamation before us.

Similar to Chestnutt, Hurston, and Reed, the conjur woman is an autoethnographic subject for Bearden, a figure that connects him to a broader Black diasporic community across time and space. Furthermore, Bearden's conjur women represent an alternate sphere of supernatural vision, an other world that draws on traditional forms of Black culture for strength and solidarity to imagine new racial futures. This is evident in Bearden's turn to collage at a time when the medium was far removed from its own avant-garde roots at the turn of the twentieth century. For Pablo Picasso, George Braque, Hannah Höch, and other early twentieth-century artists using collage, the medium was not only a way to radically transform painting and the pictorial surface but also a vehicle for social critique during the interwar period. As art historian Rachael DeLue attests, "the cutting, slicing, fragmenting, and reconstituting involved in making a collage or photomontage provid[ed] apt metaphors for the trauma and violence of war and political oppression, the evisceration of the status quo, and the piecing together of new societal forms." This melding of artistic and political intervention as a response to collective trauma and oppression was particularly attractive to Bearden.

In 1963, a few months before Martin Luther King's historic march on Washington, Bearden and other Black artists formed Spiral, a group that would meet in Bearden's Canal Street studio to discuss potential collaborations, exhibitions, and the social responsibility of Black artists in midst of the civil rights struggle. "At one such meeting, in 1963," DeLue recounts, "Bearden suggested that the group collaborate on an art project, and he showed his colleagues a stack of clippings from newspapers and magazines that he hoped could be used in the collective creation of a collage, an activity he believed could model the kind of collective action the group wished to pursue in the political realm." The project was never realized, but Bearden pursued collage and photomontage exclusively from this point on. Bearden believed modernist collage had a certain affirmative, transformative power. To him, the fragments of photographs, paper, and identity coincided with rifts in the pictorial surface, time, and race relations. Through collage these elements could be reconstituted into new forms.

This supernatural vision—the power to see the world anew and imagine alternative futures using different technologies—grows out of a desire for recreating the self. In this purpose, hoodoo and conjuring share ties with what we now refer to as Afrofuturism. Drawing on the writings of Alondra Nelson, Greg Tate, and Kodwo Eshun, "Afrofuturism," Lisa Yaszek asserts, "is not just about reclaiming the history of the past, but about reclaiming the history of the future as well." Just as Bearden turned to collage as a means of conjuring social transformation, present-day Black artists who explore Afrofuturism employ hoodoo imagery in their literary and visual works for the same purpose: to imagine a world in which Black liberation is possible, in both aesthetic and structural terms. These alternative visions, however, are not necessarily affirmative or reparative. Sometimes, the transformations they picture conjure a more radical engagement with both art and social life, an engagement that refuses to both adhere to and uphold narratives of progress and redemption—a whole new world.

ARTHUR TANGA // DIFFICULTY LEEVEL HARD

ANDRE LEROY DAVIS // WU=TANG ASSEMBLE

スペヌ女性

SHOMARI HARRINGTON // DESERT

Genesis

Reynaldo Anderson

It was born out of betrayal and an evil business deal.
A castle marinated in the darkness of a slave dungeon.
Pit home to quiet desperation listened
to the faint sound of ocean waves and the uninterrupted
screams and sighs of the insane,
the cries of men, women, and children
with sinking hearts traded across sand and wave
shackled in wooden sailing temples dedicated to unholy profits
with hymns lifted to wicked cracker and desert gods
or dumped overboard to greedy waiting jaws in the ocean
to be refined on Caribbean, American, Latin, and Arab fields,
personalities baptized into niggers, singing sambos, kaffirs, abid,
and dreams of fake jihads
whose collaborators and conditioned coons close their imaginations to freedom
with crystallized feeling of hatred and resolve.

Love Under Surveillance

Reynaldo Anderson

In a hidden hotel they
sipped cheap coffee and
they thought they had more time.
<space>
Fingerprints of eroticism
fading into private deposits of hidden love.
Forbidden desire foreshadowing
taste of dreaded separation.
<space>
Heartbeats slowing down,
conscious of no particular track of time,
indifferent to strangers and alien technology,
they found contentment in excitement.
<space>
Sensuous soft brown terrain with sensitive sighs,
fleeting memories of black velvet steel pulsing,
with high frequency,
after a night of cosmic union.

OUTBREAK! OUTBREAK! OUTBREAK! OUTBREAK! OUTBREAK!

WARNING

OUTBREAK! OUTBREAK! OUTBREAK! OUTBREAK! OUTBREAK!

OUTBREAK! OUTBREAK! OUTBREAK! OUTBREAK! OUTBREAK!

QUARANTINE
JES' GREW

OUTBREAK! OUTBREAK! OUTBREAK! OUTBREAK! OUTBREAK!

An epidemic is sweeping the nation. You have probably not heard about it because powers that be find it in their best interests to keep you in the dark. People you know may have even detected inklings of its presence, but kept quiet, hoping that ignoring it would make it disappear. Nothing could be further from the truth. This epidemic is called **jes' grew**, and you might have it already.

Symptoms of jes' grew include: mediocrity intolerance, chronic questioning of authority, and uncontrollable shaking of the hips and butt. As of this writing, medical science remains baffled. They can not point to a viral or bacterial pathogen responsible for the disease. Some unorthodox researchers have suggested that it may be neither, and that jes' grew may be caused by something else entirely. So far, however, no papers have been published in any major medical journals on the subject.

The origins of jes' grew are extremely murky. We do know this, however - jes' grew is hardly new. The earliest recorded cases date back to the Colonial Era, when, simultaneously, the first slaves were forcibly brought over from Africa and Native Americans were being driven off their ancient lands. Methods of social control concomitant with maintaining kept-labor and oppressing culture helped to suppress the outbreak. These methods included destroying the family structure and replacing indigenous belief systems with Christianity. From this point in history on, it has flared up at numerous times in our nation's past. Notable flare-ups include: **1890's, 1920's, 1960's, and late 1970's/early 1980's.**

CONTACT **1-800-NEO-HOO-DOOO** FOR FOR MORE INFORMATION!

JOHN JENNIGS // JES GREW

WHAT SHALL I TEACH THEM? MUSINGS OF AN AFROFUTURIST EDUCATOR

Deirdre Hollman

This bridge called my back is made of vibranium. On my back I carry our children, atavistic beings, crossing between the infinities of the past and of the future. What shall I teach them?

I wonder how I can enrich them, nourish them, encourage them to traverse into adulthood without falling prey to the trappings of our dystopian reality. The must beware of the traps. The traps. The textbooks, the television shows, the clothing lines, the radio stations, the fairy tales, the census data, the police reports, the singular vocabulary, the hair products, the factory jobs, the emojis, the smog, the credit scores - all the manufactured images that experiences that corrupt their sense who they are. Their black bodies are negated by the traps, distorted and disqualified by the traps, fractured by the traps, deaded by the traps. What shall I teach them?

When the traps condition them to dull their thoughts, lower their expectations, give zero fucks, and self-annihilate...What shall I un-teach them? And re-teach them?

We are inalienable. We have power. We will survive.

I teach Afrofuturism.

Afrofuturism is the epistemology of black survival. It questions and affirms how will we survive in the future, not if we will. In practice, it asks what do we need to know, how do we need to adapt, what knowledges do we need to take with us, what new ways of being do we need to create, and how do we retain our ancestral memory?

Afrofuturism is a timeless archive. The archive is built on both imaginings and actions. It documents what was and what is to come, and through its study, it informs the present thought, generates the present act, and propels us. Maya Angelou's poem "Still I Rise" captures this future/past and dream/reality aspect of afrofuturism in the line "Bringing the gifts that my ancestors gave, I am the dream and the hope of the slave."

The study of history, art, and culture is essential to afrofuturism in education. Students must experience great books of literature, expressive works of art, and living folklife traditions to unleash their ability to see themselves as part of a lineage of super beings. It is about teaching them to access that part of their spirit that is resilient, that part that recognizes that we are the descendants of survivors.

Afrofuturism is creation. It is design thinking. It is inquiry and engineering. It is interdisciplinary by nature and politics. It engages multiple literacies and innovates new forms of expression. Black speculative fiction, art, and comics full of rich vocabulary, visual, historical, and cultural literacies. These works contain discourses on power, class, government, culture, language, race, gender, conflict and resolution, global unification, etc. Comics, for instance, are mirrors of reality, and spaces for the creation of new realities. Black comics are a part of a larger tradition of black speculative arts that has roots in folklore, spirituality, and radical politics that predates the arrival of Africans on the shores of the Americas.

We are inalienable. We have power. We will survive.

I teach Afrofuturism.

For me, Afrofuturism is aesthetics, philosophy, pedagogy and passion. It is the lens through which I have come to understand my own educational theories and practice. I meet many young people who are thriving in their teens and so many more who fight hopelessness on a daily basis with every breath. Where in the soul do we go in the absence of hope? How do we escape the wicked convalescence of weariness, the immobility of doubt/fear and the trappings of the American dream? These spaces are the landscapes of adolescence. It is my aim to teach into those spaces - to awaken and affirm, and surprise, and incite, and defend, and celebrate, and encourage, and hold space, and be kind, and project love into those spaces of teaching and learning.

What will they teach me?

Bio: With over twenty years of experience engaging youth and teachers in the study of black history, art, and culture, Deirdre Hollman is an avid educator, curator, and cultural arts producer. She served as Director of Education and Exhibitions at the Schomburg Center for Research in Black Culture for fifteen years where she created and sustained innovative programs serving over ten thousand attendees annually, including the Junior Scholars Program, the Teen Curators Program, the Black History 360° Summer Education Institute, and the Black Comic Book Festival. Deirdre is the founder of The Black Comics Collective and she is a consultant to several arts and education organizations. A graduate of Princeton University and Bank Street College, she is currently pursuing her doctoral degree in education at Teachers College, Columbia University. Deirdre lives in Harlem, New York with her teenage son.

189

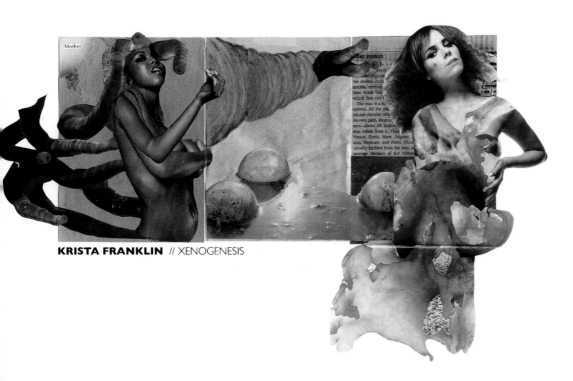

KRISTA FRANKLIN // XENOGENESIS

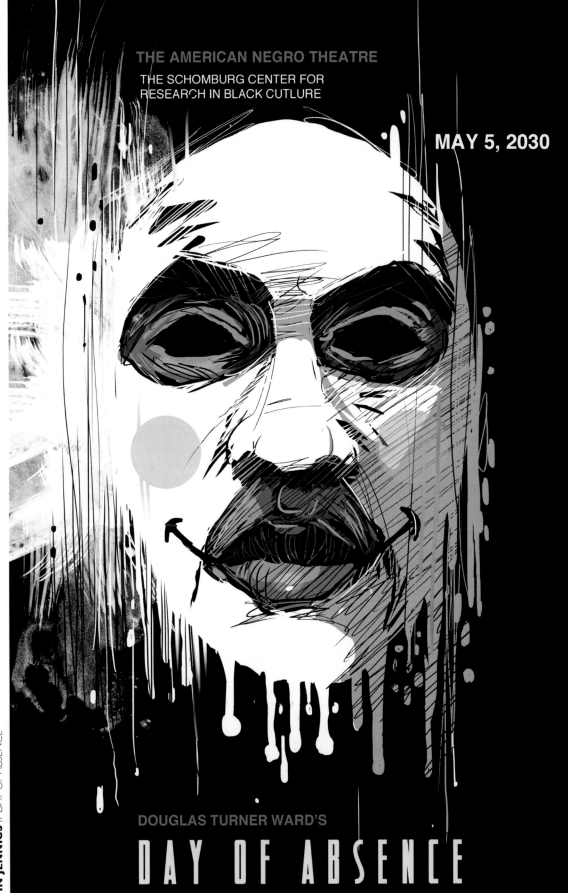

THE AMERICAN NEGRO THEATRE

THE SCHOMBURG CENTER FOR
RESEARCH IN BLACK CUTLURE

MAY 5, 2030

JOHN JENNIGS // DAY OF ABSENCE

DOUGLAS TURNER WARD'S

DAY OF ABSENCE

MATTHEW CLARKE // HARD EARS

MATTHEW CLARKE // HARD EARS

THEORETICAL

ELEVATORS

JAMES FULTON

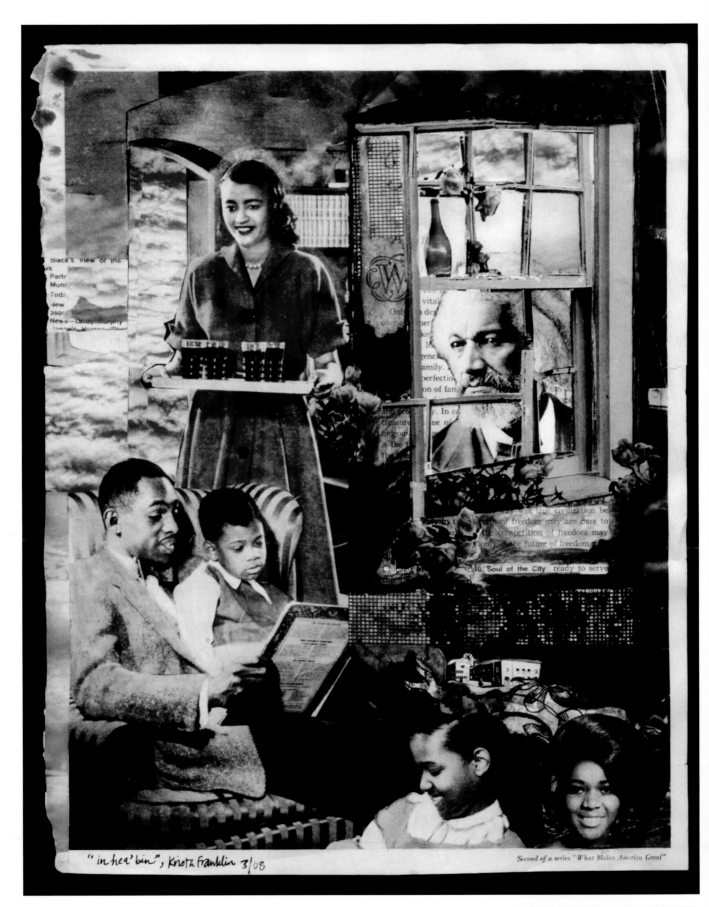

"in hea' bin", Krista Franklin 3/08

Second of a series "What Makes America Great"

ÒGÚN: PRIMORDIAL ARCHITECT OF A LIBERATED BLACK FUTURE

Darasia Selby-Adebisi (Ifatoyin Alaade Ojekemi)

Mythology has always been a rich source of inspiration for humanity, an island of concretized thought in the ocean of the collective consciousness. The creation story of the Yorùbá people - a people from what we now refer to as southwest Nigeria, is no exception. The Yorùbá creation story teems with metaphor that has been imbedded (programmed?) in the minds of African people throughout the Diaspora, providing a roadmap back to the Old World and instructions on how to navigate through and rebuild us in the New World.

The Yorùbá Creation Story

In the beginning there was just the sky above and the waters below. Olorun, Owner of the Sky, ruled above and Olokun, Owner of the Ocean, ruled below. The irunmole, the primordial energies of creation, reside in the sky with Olorun after forming the Universe through a massive explosion, cooling the Universe down so that matter can form, and creating the stars and planets and the orbits to prevent them from colliding. Olódùmarè, a super-irunmole who emerged out of a cauldron and was assigned as the supreme ruler of our solar system, commissioned some of the irunmole to begin forming the earth.

Obatala (King of the White Cloth), an irunmole of light, was sent down to begin the initial tasks of earthly creation. He went to Òrúnmìlà, the irunmole of wisdom, to learn how best to complete his mission. He was told he would need a bag with a gold chain big enough for him to reach below, a snail's shell full of sand, a white hen, a black cat and a palm nut. He was to use the gold chain to climb down from heaven into the waters below to create dry land. As Obatala began descending down the golden chain, he realized that the path was dense and that he would need support in completing his mission. He enlisted the help of Ògún, the irunmole of metals and creativity, to utilize his tools to clear the path.

The golden chain that Obatala descended is symbolic of the double helix of DNA, the genetic coding within all living organisms. The journey from heaven to earth, then, is a reference to the emergence of hidden or latent potential into manifest reality. Thus, Ogun as the clearer of the path down the chain, is symbolic of the force that clears away obstructions in the transformation of potential energy into reality.

Ògún: Orisha of Technology

Ògún in Yorùbá mythology is an irunmole, a primordial energy, as well as an orisha, a force within nature. In the Yorùbá worldview, everything is alive and is animated with a force, or ashe. Ògún is the orisha of iron and technology, the ultimate architect and master builder who utilizes his tools to build and progress society. While Obatala is the creator irunmole, Ògún in the role of the path clearer suggests that Ògún is the expansive and inevitable energy of evolution of creation, the force of change, progress, and advancement. Ògún keeps matter in motion, always working, always progressing. Ògún as the orisha of technology is not only symbolic or metaphoric; from the perspective of the Yorùbá, technology is a manifestation of Ògún's unique ashe. Without Ògún, technology could not exist.

Ògún is personified as a hunter and a blacksmith, using the tools he owns to provide sustenance for his people and to smelt iron to be used to develop society. In this context, Ògún could be considered one of the first Afro-futurists, if not the original Afro-futurist: he provides the basis for human advancement and technology, and also provides a blueprint for how this technology can be used to creatively shape society. Ògún is not just a divine being or a primordial force of creation. Understanding Ògún's role in the initial creation of the world reveals his potential as the one who clears the path of obstructions in the creation of a new world.

"Afrofuturism as a concept, practice and movement that requires Africana people to ubiquitously conceptualize and deduce time from the past, present and future from an African cultural center. This cultural center operates as the technological component of African futures from which African people can architect their agency in memory and in practice."

Ògún's manifestations and influence in the African Diaspora is akin to the idea of Sankofa; the concept of going back to the past to reclaim an understanding of the present that can be used to shape the future. The golden chain from heaven to earth can also be symbolic of the link between the Old World of Africa and the New World of the African Diaspora. As Ògún cleared the path for the creation of the world, Ògún has also cleared and continued to clear the path for a liberated Black future, free of the obstructions and obstacles to freedom and self-determination.

Ògún as the owner of metals has always been represented by metal and in particular, the machete. In West Africa, his shrines typically consist of an assortment of metals. In the New World, Ògún's shrines are usually contained within an iron cauldron filled with various metal tools. The adaptation of Ògún's shrine from a pile of metal to a metal pot is usually explained by the need to have transportable shrines in the Diaspora. While that is a very plausible explanation, understanding the idea that a pot or a cauldron in the Yorùbá worldview is a symbol of the womb also points to Ògún's role in birthing or creating, a key element in the construction of liberated Black future. Ògún uses his tools to bring new ideas and tools into our world, or rather, new manifestations of the old.

While the understanding of Ògún as the orisha of war was a concept already known in West Africa, the context of slavery and oppression deepened and heightened this awareness in the New World. Ògún is one of the ebora in West Africa, which is often translated as "hunter," along with the orishas Eshu and Oshosi. In the New World, these orishas are collectively known as "The Warriors" and their shrines are usually among the first to be received among practitioners of Yorùbá tradition in the Diaspora. "The Warriors" is a strictly New World concept. Only indigenous Yorùbá with previous communication with practitioners in the Diaspora utilize this nomenclature to refer to these orishas. However, this New World perspective highlights how an understanding of the orishas is based on the old but transformed by the new.

Ògún as a warrior and liberator can be understood most clearly and saliently through the Haitian Revolution. Born in Jamaica, Boukman Dutty was one of the most visible leaders in the Haitian Revolution in 1791. Several historical accounts cite that Dutty, a Vodou priest, presided over a Vodou ceremony, along with priestess Cécile Fatiman in service to Ògún (called Papa Ogu in Haitian Vodou) to ask for Ògún's strength and ashe to free enslaved Africans from their oppressors.

Ògún: Reclaiming and Forging New Futures

"We are alchemists in this city of steel, akin to the Yoruba god Ogun, fusing metal to metal."

At the heart of Afrofuturism is the "intersection of imagination, technology, the future, and liberation." This imagination is often aglow with memories of our ancient past. and An understanding of Ògún in his role as a master architect, provides us with an impetus and catalyst for forging a future built on the values of harmony, balance, and sustainability taught to us by our ancestors. As many Afrofuturists have pointed out, the capture of Africans into the Americas and then being granted non-human status is analogous to alien metaphor, complete with a sense of alienation and not belonging. Though there is no record of Ògún as having ever been enslaved or abducted, there are stories within Yorùbá mythology of Ògún being misunderstood, even by other orishas; his brute force and strength often mistaken as an inability to anything more than a non-emotive workhorse. In all of these stories, Ògún's ashe proves to be invaluable to society and only after Ògún lends his tools and ashe does society begin to flourish and prosper.

Ògún egbe lehin eni a nda loro, ba san bap on ao lana to. Ashe.
Ògún, the protector of those who are injured, cut down the obstacles on the road. Ashe.

197

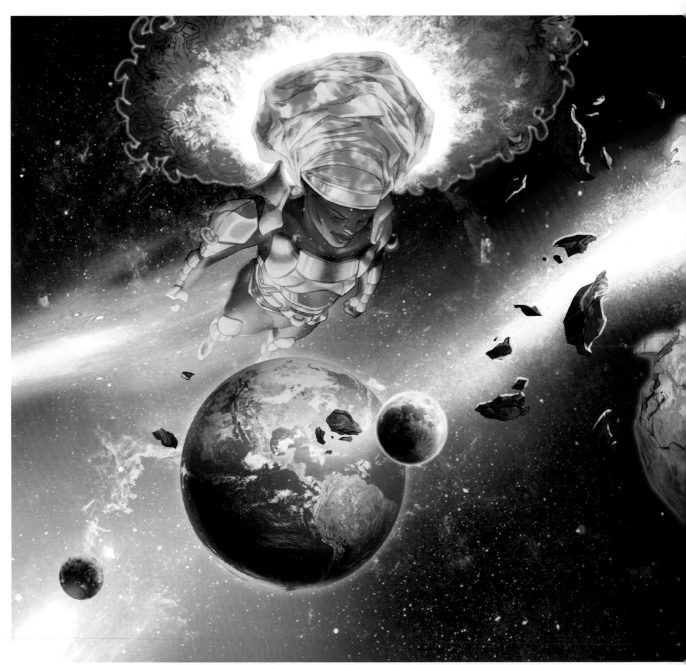

JASON REEVES // START OVER

AN AFRO FUTURE IN THE MIDST OF UPHEAVAL

Damon Davis

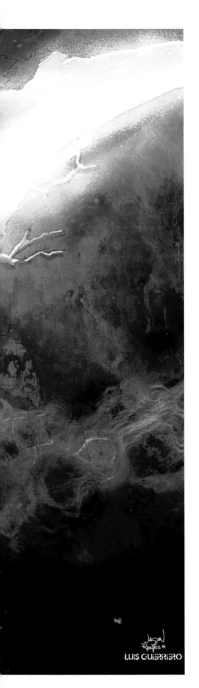

"You can be anything you want to be", says the mama to her little Black child. But does either of them believe that? What does the future hold for that child? What does the past scream to that mother? Where do they meet?

When I speak in terms of afrofuturism, I think of Black and brown people choosing the future and their place in it. If that is the case, then we can choose the past and our place in it. Those of fairer skin have practiced this since time immemorial. This country and empires before it picked and chose parts of their history to retell and glorify, and which to ignore and cast into obscurity. History is told by the victor and force-fed to the captive and colonized. What does it mean to be "African American"? Where does their history begin? This country and its people implicitly agree that our history starts in bondage; being brought here like cattle from the belly of slave ships onto the shores of America. I choose to disagree with that. If I choose to believe in an afrofuture then I must choose to believe in an afro-past - in that I know our history does not start in chains but in the cradle of civilization. And our past - the same as our oppressors and every other human life, starts with us. That knowledge allows me to imagine what Black can be in the future.

Fast forward to a hot, August Saturday in Ferguson Missouri, the year is 2014. An unarmed boy's death awakens a sleeping giant in the soul of Black folks. His death at the hands of the state. That same state that has brutalized its "American" citizens of African descent since its inception, reminds those brutalized people that the future hasn't happened yet and, we can write a new history here and now. The uprising that happened in the place where I come from is a reflection of what afrofuturism really is: Black people not accepting a fate, but creating it.

Afrofuturism is imagining what the future looks like with you in it, in the way that you want it, and manifesting it through any and all means at your disposal. And if we create our future in the same regard, we do not for a second have to accept the past as it has been told to us. Afrofuturism should be past, present and future.

The ideology that claimed the life of Michael Brown and countless others, subscribes to a selective cataloging of events and stories that make up its history. The ideology that I speak of is white supremacy. That philosophy uplifts and upholds everything that portrays the culture of whiteness in an immaculate light and superhuman goodness and intellect. It neglects, erases or reimagines all remnants of wrongdoing in its history. As we speak, the word "slavery" is at risk of being removed from American History textbooks because the enslavement of Africans is precisely what built this country – a contribution they prefer to erase.

When most people think of Americans, the image that comes to mind is of a White male, a European immigrant or conqueror, not the original Natives. But ask a person on the street what the Trail of Tears is and the answers are disturbing. The transatlantic slave trade, the trail of tears, Jim Crow, and countless events are neither discussed nor reimagined in a palatable context for those that have been raised in the system of White Supremacy.

An ability to write one's history is the privilege of the free. For our people to be truly free we must write our own stories, remember history with us in it, and not as the victim but as the victor. That is what the Ferguson Uprising was for me andcountless others who lived it; a victorious moment in history of a proud resilient people that stood up in the face of tyranny and oppression; who did not waiver or cower; who stood with feet planted firmly on the ground and; demanded their justice and humanity. That is the way I remember it and how I will tell this story to generations to come. It does not change the reality that the empire did not acknowledge us on our terms but I'm sure the American Revolution is not written about in Britain with the same admiration that American historians portray it.

So from here on out we write and repeat the history as we see it, and we do so in truth and humility. This is our truth, our history, our freedom. That is Afrofuturism in its truest form. And so in that, I see Afrofuturism as more than fiction. The tenets within it, hold the soul food needed for true liberation. See yourself as you are, as you can be, and make it so. Afrofuturism is Afro-Freedom.

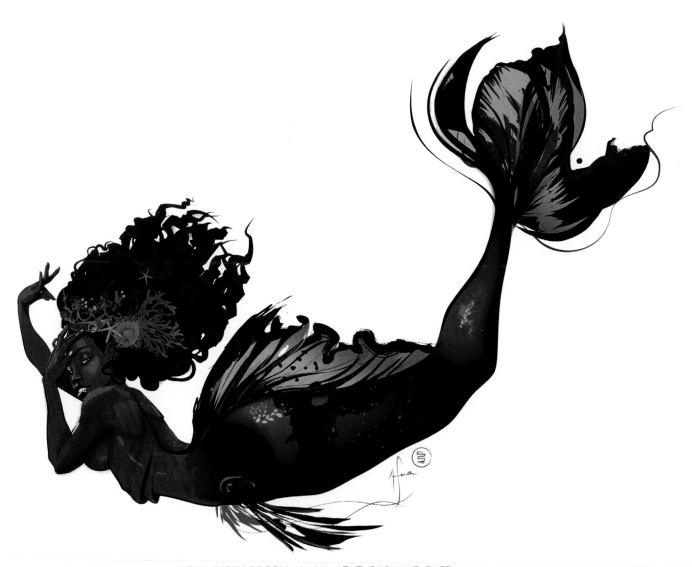

AFUA RICHARDSON // MAMI WATA THE KOI MAID QUEEN

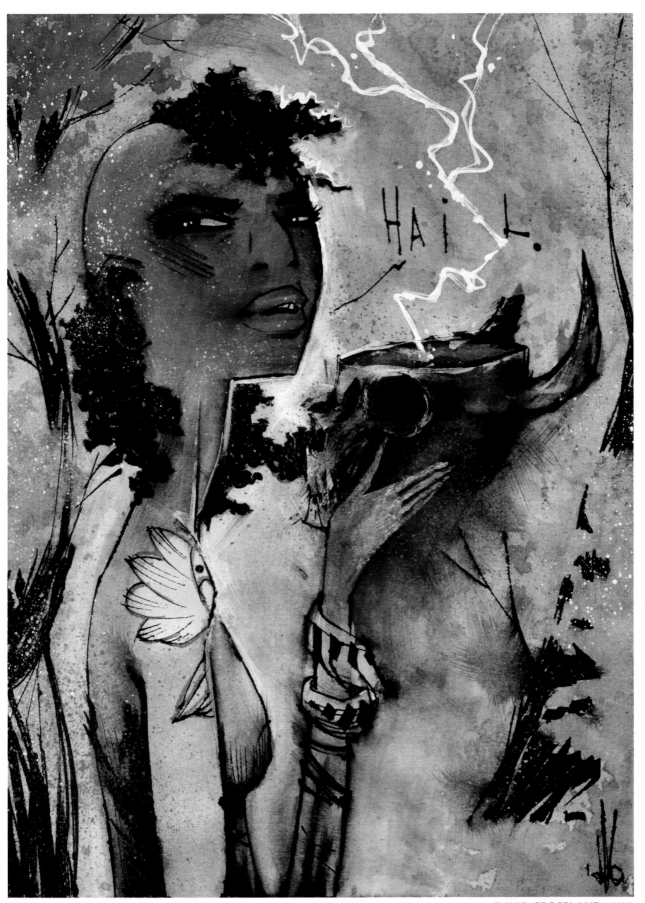

DAVID CROSSLAND // HAIL

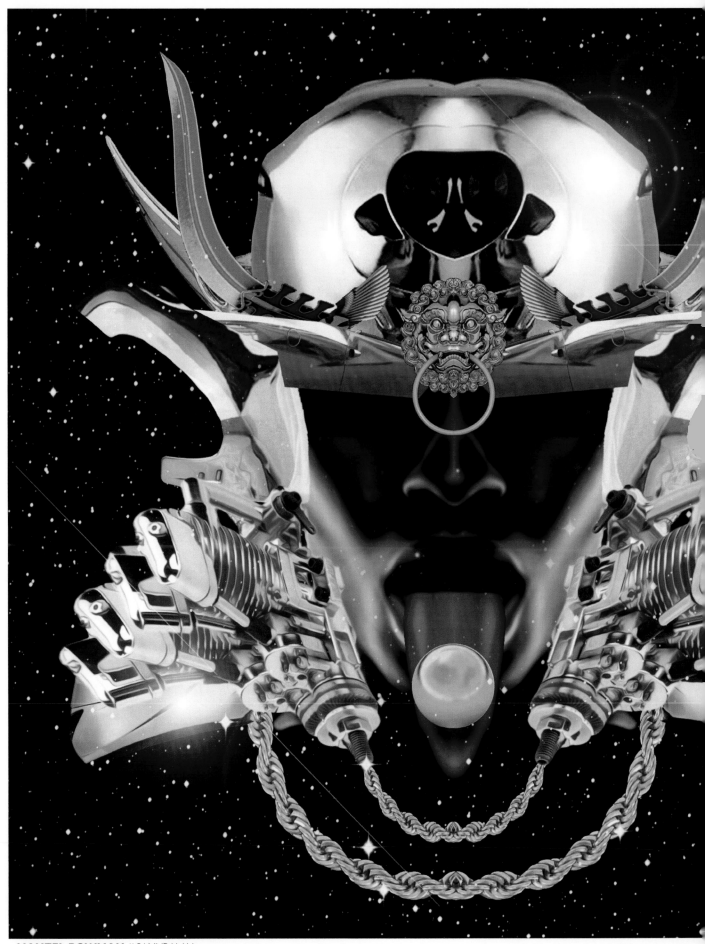

FROM DARK WATER TO DARK MATTER: an interview with JOHN JENNINGS

Tiffany Barber

This conversation was transcribed from a Skype conversation regarding the curation of the art exhibtion Unveiling Visions: The Alchemy of the Black Imagination which was featured at the Schomburg Center and co-curated by Reynaldo Anderson and John Jennings

TB: Tell me about the curatorial vision for the show.

JJ: One of the constructions Kevin Young puts forth in The Grey Album: On the Blackness of Blackness is the notion of the shadow book. He defines it as this fictitious artifact, this book that haunts the existence of an existing book – for instance, the Encyclopedia Africana that W.E.B. Du Bois never finished, or Ralph Ellison's second novel. So it's this book that actually should have happened, or could have happened, but didn't. And the memory of it haunts the existence of an existing book. I love that idea. I started thinking, there are whole libraries of books that could be like that – Schomburg's library! So my mind went to these different spaces, and I wondered, what about shadow objects and shadow worlds? That's how we came up with these diegetic prototypes that were influenced by actual things. One of them was The Theoretical Elevator's Book from Colson Whitehead's The Intuitionist ---

TB: Oh yea!

JJ: That's not a real book, but I created a cover for it.

TB: Right, right.

JJ: Or these objects that people have described in black speculative fiction, like the flying shoes with the propellers in Amiri Baraka's short story "Mchawi." Or the chair from George Schuyler's Black No More. Our whole thing was creating fictitious, shadow objects in line with what these types of speculative, interventionist technologies would look like.

TB: Very cool.

JJ: One thing we didn't get a chance to do was the bop gun.

TB: The what?

JJ: The bop gun from George Clinton / Parliament Funkadelic.

TB: Ahhhh! Next time. [laughter]

JJ: Yea it was on our minds.

TB: Ok, so you talked about the shadow book. But Unveiling Visions also draws on key concepts put forth by W.E.B. Du Bois in the first half of the 20th century, namely double consciousness and the veil. How did these concepts give rise to yours and Reynaldo's curatorial vision for the show?

JJ: Yes. The title Unveiling Visions comes directly from the construct of the veil, from Du Bois's classic treatise on black identity, The Souls of Black Folk. He also talks about writing from within the veil in Darkwater. The veil is an extension; it's a technology. I mean, think about if the veil was an app, or a prosthetic that we could peer through. We regard Du Bois's veil not as this negative apparatus that splits us and makes us see things differently, but as a superpower. How does that shift the perspective of black people, particularly in a black space like the Schomburg? In this vein, we started thinking about the Schomburg as a time capsule, looking at it as a spaceship or some other type of apparatus. So these shadow objects we're talking about – what does it mean to introduce people to these different concepts around black speculative culture that have been around forever?

People who are working in these black speculative spaces are saying, you know what? Not only have we been imagining these spaces before; we don't necessarily have to draw from a Westernized ideology as far as how we're creating these stories. We have other pillars we rely on. Take Sheree Renée Thomas's work, for example. I didn't realize until we posted the books from the show on Facebook that her primary research was conducted at the Schomburg. So it comes full circle, because her ideas in that book are fundamental to what we're talking about in the show – how do you even define what is black speculative culture? Where does it stop; where does it start? What does it mean to speculate? That kind of thing.

TB: Yea, in the exhibition text you and Reynaldo talk about how the work in the exhibition explores not only the notion of blackness's two-ness, but also how these concepts have so long been mired in a drive toward assimilation or acceptance. Most, if not all of the work in the show, points to other possibilities. What is the relationship between these historical concepts and imagining new racial futures? Can you also talk about the relationship between the past, present, and future that emerges in the show?

JJ: It's almost like this show became more powerful in the black space of the Schomburg because of how it connects the past to the present, and these ideas of future stories to be told. It just felt like a great confluence of a lot of different ideas.

It also started us thinking about race, which is one of the biggest speculations, right? It's a diegetic prototype that has taken hold and dovetails with a lot of what we're talking about: what is technology, how does it function, what are the blueprints for these kinds of systemic issues (like racism), and how do the images [in the show] become touchstones for possible answers to these questions, i.e. possible futures? They could be right beside each other. That's actually what I think this notion of double consciousness affords us; we can think in multiple dimensions. And when you add Fanonian triple consciousness, it splinters into quantum ideas, to borrow from Rasheedah Phillips' idea of Black Quantum Futurism.

So the more we explored these concepts and spaces, the more the show expanded. There are 87 artists in the show, and what made that possible was the technology available to us. We used mostly digital work, prints, and virtual constructions. And we did most of the exhibition design remotely. Turns out Isissa Komada-John is a master at Sketch Up, and she built a virtual replica of the Latimer/Edison gallery using that software. I created these teeny-tiny jpegs to scale according to the model she put together and placed them along the wall of the virtual model. Another tool we used, when we were gathering images at the beginning, was Kapsul, which was created for curation. We used that as a way to start sorting the categories for how we eventually arranged the images in the gallery. So essentially, we were using cutting-edge, up-to-the-minute technology to put the show together.

TB: Wow! So much innovation! I want to come back to this idea about the different technologies that you all used to construct the show. But first I want to talk about how the show also highlights surreptitious practices people of African descent have deployed to resist oppressive forces, whether that's through image-making or the use of various technologies. Can you say more about this and offer a few examples that illustrate this focus?

JJ: The book itself is such an amazing technology. So black folk writing, to start with, is foundational; and all of these particular spaces are rooted in the literary.

TB: Right, and there are so many authors represented in the show!

JJ: Yes, and that was something that was really key to the Schomburg's involvement. A lot of those books were from their collection. We also examined film. Look at something like Daughters of the Dust. It's brilliant, just brilliant. When Julie Dash uses moving image technologies to expose various types of traditional technologies from the culture that comes over from Africa that then situates itself within the Gullah peoples' culture – we can look at that as this idea of a haunted technology, how the spirit haunts technology. One of my favorite moments from that film is when the gentleman is taking the photo of the family, and he sees the little girl who's not yet born. The future is literally haunting the present.

So ideas about how we use various modes of technology, whether it's a cell phone or race itself as a technology – remediated technology stacked on top of each other – were very much a part of the show. Take, for instance, Manzell Bowman, who made the image we used to promote the exhibition (the mind blown image). He doesn't even have a website. Instead he has an Instagram page, and he has thousands and thousands of followers. He's making this beautiful work on an iPad.

TB: Such beautiful work.

JJ: Or people like Stanford Carpenter who hacks into an app on his phone to make all his cartoons and then downloads them. People are borrowing technology and hacking into it to change the ways it's supposed to work.

TB: I like the idea of hacking and I want to keep going with that. In the exhibition text you and Reynaldo talk about the data thief who's drawn from the Black Audio Film Collective's The Last Angel of History of 1996. The data thief, the griot, the shaman, and the DJ are all kinds of hacker figures – key cultural figures that show up in one way, shape, or form in the visual and literary texts in Unveiling Visions. The show also, as you said, includes a range objects from the Schomburg's archives. So in a sense, you and Reynaldo took on the role of data thief, griot, shaman, and DJ. But those figures also populate a lot of the works that are in the show. The DJ in particular is interesting because in hip hop culture, DJs crate dig. They sort through records to find and play the illest, most obscure, most body rocking tracks to connect with their respective crowds of listeners. Can you talk about stepping into those roles and your curatorial practice as a kind of hacking? What was it like "crate-digging" through the Schomburg's materials?

JJ: That's a great observation! You know, it's funny; I'm not trained as a curator. So I stumbled into it by thinking of curation as just another design problem. Design is my wheelhouse. But a lot of the practices we employed – utilizing digital prints for instance – came from curatorial exercises I had done making and publishing comics with Damion Duffy. The idea was that, well, a lot of things are popular culture materials; they're meant to be consumed. They are not precious in the same ways as the Mona Lisa by Leonardo da Vinci or The Banjo Lesson by Claude McKay. A lot of the people making this stuff are inspired by pop culture, by sci-fi, by Octavia Butler and George Clinton. These are the things fueling the fine art, if you want to make those distinctions. I don't because the work crosses high and low culture quite a bit.

In terms of our curatorial process, it was the opposite of what we typically think of as curation. It was more of like a hoarding – like ok, let's get as much stuff in here as possible!

TB: Right, instead of a funneling or a refining –

JJ: Or a distillation. Isissa brought that kind of finessed structure to the table, thankfully [laughter], because we are data thieves. I was in a mental state where I just wanted all of it! That was the mode of thinking: a data thief collecting stuff for a time capsule to take somewhere or to pass on to future generations. So when Isissa came up with the idea to do the iPads as a kind of movable data screen, it was brilliant because it totally played into the sci-fi aspect of the exhibition. Even the way the Latimer/Edison gallery is built feels like a capsule because it's round. It has the feel of a rocket ship, a capsule, of time travel. You can see through [the windows of the gallery] to the Schomburg's archives downstairs.

TB: Yes! That was so dope!

JJ: You can see Aaron Douglas's murals; so you can see the past as a reminder. But also what he was painting was very futuristic. He was already modernizing the black form. It is just mind-boggling how many connections were made – historically, visually – just from being in that space. There has always been folks borrowing from other traditions and remixing things, you know, and they become living indices for all of these historical moments and different things simultaneously. This impulse fueled the curatorial choices we made and the method by which we put stuff together.

TB: Very cool. Some terms that come up a lot in reference to this show are Afrofuturism and the black speculative imagination. Additionally, over the past fifteen years, there have been a slew of exhibitions and writings on these terms. Can you briefly define what these terms mean to you and how this exhibition fits within this cultural milieu?

JJ: Afrofuturism is a term coined by Mark Dery, a white cultural critic who was trying to put his finger on something he had stumbled across. He identified themes such as black people in the future and technology, metaphors of alienation and displacement, and interviewed people like Tricia Rose and Samuel Delany to comment on this confluence as part of the piece of writing that features his definition. But even in the definition – he writes "for lack of a better term" – he leaves space for speculation. And we've always used our imaginations as liberation technologies, as storytelling, as speaking things into existence, analyzing technology that can actually give us freedom in a particular space. I think the oppressed always understand the systems better than the oppressors.

So for me Afrofuturism is a node in an ongoing system of black speculative culture that has been used for generations to imagine a better space, but also to actively create a better space. For instance, we closed Unveiling Visions the same day as the Black Comic Book Festival, created by Jonathan Gayles, Jerry Craft, Dierdre Hollman, and myself. When you entered that space, black people were the default. Period. Seven thousand of us in a space. So essentially through imagination we created a parallel universe where if you step up in there and you anything else but black, you are not the default. It's pure imagination from the diaspora, whether it is scholars, artists, or people selling t-shirts; it is blickety black from top to bottom. And that is really powerful to me.

The other thing is there are all these children who will never have to go through life not seeing themselves in the future ever again. I love that idea. It's a core element of the show, to empower people through their own storytelling. In thinking about the Black Speculative Arts Movement with Reynaldo, we wanted to untether ourselves from having to rely on other people's imaginations of us. So in Unveiling Visions, we wanted to show that not only are these people imagining an alternative past. But we're constructing the future by story, by art, by movement, by coding. These new constructions are why the idea of the data thief digging through the detritus of time and space and repositioning what blackness is radical to me.

TB: That goes back to the question of the design problem, too, on the level of form in the curation of the exhibition itself because what strikes me about Unveiling Visions, and we've talked about this before, is the fact that there is so much material culture represented versus this notion of fine(r) arts that appear in a lot of the other visual art exhibitions that have been staged about black speculative culture.

JJ: Right, we were really thinking about how libraries function …

TB: … and the hub for black archives is obviously the Schomburg Library, part of Arturo Schomburg's legacy.

JJ: Right, and Unveiling Visions is an extension of an archival project.

TB: Yea, it's so interesting to think about how you all ballooned the notion of curating as collecting, or situating, or drawing refined connections between objects on display. Sure, there were things that aligned, and those connections were purposeful. But there were a lot of connections that were unexpected.

JJ: Yes, the objects speak to each other in a particular way when you're using the materiality of blackness distilled through a pop culture lens.

TB: But it's the maintenance of an older kind of materialism within a digital, or post-digital age that swarms with new materialisms, affect theory, and the idea that we're no longer of our bodies.

JJ: As a designer, one of the things I thought about in relation to that and your previous comment about curation, is space. People don't realize how much space labels and wall text take up. So we printed all of the information on to the posters. We controlled all the space. There were very few things left to chance.

Also, we installed with magnets for an easy, clean install; we didn't have to worry about frames or shipping. What I love about it is the fact that it's virtual. So if we wanted to, we could mount this show in many locations simultaneously, because of the ubiquitous nature of the digital. So not only are we hacking into how people curate shows, and hacking into the archive; we're repurposing the digital – remixing. It was highly interdisciplinary, collaborative, and creative. I'm very proud of the show.

TB: It was a great show! Earlier we started touching on this idea of critical making without naming it. Critical making is central to your own practice, not only in terms of how you put the show together with Reynaldo and Isissa but also in the work you create as a graphic artist and scholar. Can you talk a little about your notion of critical making and how it comes to bear in the show?

JJ: As a graphic designer and illustrator by trade, I'm always thinking about the artifact, the deliverable, and the systems that produce that deliverable. That epistemology can be applied to almost anything, and critical making essentially is design thinking. It's thinking about the planning of a particular space or an intervention that often ends up being visual. It's not just, "Oh, I need a logo!" Why do you need that logo? How does it function? So I'll create a story, make an emblem, or design a costume, some visual artifact that answers these questions. Usually it's something that is going to be consumed, but it doesn't have to be. Designers deal with systems so we don't necessarily have to create an object – most times it is – but we also investigate how branding systems work. Apply that to race, gender, or religion, and it gets really interesting. This thinking led me to what I call critical race design studies, a conflation of critical race theory, design history, critical making, visual anthropology – a mishmash of different ways to think about race and how it functions. Because we know race is a construct, but what are the blueprints? What does it look like? Critical making and visual thinking helps us get at these questions and helps me resist the hypercapitalist nature of design because I apply design tools to social justice issues, or a curatorial project in this case.

TB: Awesome. OK, last question: What are your hopes for the afterlife of Unveiling Visions?

JJ: Well, it will have its own archive and, like a lot of shows, it will live on through the exhibition catalog, a talking book to which I eventually want to add augmented reality. That was actually supposed to be part of the show – we were planning to do an app called the veil in which certain artifacts would solely exist – but we ran out of time. As for the archive, the Schomburg is giving the exhibition posters their own space so anyone who wants to study Afrofuturism or anything and anyone in the show –

TB: Or black intellectual thought in general –

JJ: Right, people can visit the Unveiling Visions archive for that.

TB: That's dope! What an exciting contribution. Thank you!

AFROFUTURISM 2.0 AND THE BLACK SPECULATIVE ARTS MOVEMENT: NOTES ON A MANIFESTO

Reynaldo Anderson

Over the last decade, an embryonic movement examining the overlap between race, art, science and design has been stirring and growing beneath the surface. Afrofuturism is the current name for a body of systematic Black speculative and creative thought originating in the 1990s as a response to postmodernity that has blossomed into a global movement the last five years. Although contemporary Black Speculative thought has historical roots at the nexus of 19th century scientific racism, technology and the struggle for African self-determination and creative expression, it has now matured into an emerging global phenomenon. Afrofuturism 2.0 is the beginning of both a move away and an answer to the Eurocentric perspective of the 20th century's early formulation of Afrofuturism. A perspective that wondered if the history of African peoples, especially in North America, had been deliberately eliminated. Or to put it more plainly, future-oriented Black scholars, artists and activists are not only reclaiming their right to tell their own stories, but also to critique the European/American digerati class of their narratives about cultural others, past, present and future and, challenging their presumed authority to be the sole interpreters of Black experiences and Black futures. Kodwo Eshun asserts: "Afrofuturism may be characterized as a program for recovering the histories of counter-futures created in a century hostile to Afrodiasporic projection and as a space within which the critical work of manufacturing tools capable of intervention within the current political dispensation may be undertaken" (2003, p. 288). One example of several approaches within this current wave of Afrofuturism, is the strategic formulation reflecting Afrofuturism is a critical project with the mission of laying the groundwork for a humanity that is not bound up with the ideals of white Enlightenment universalism, Eurocentric Critical Theory, science or technology (Anderson, 2015, Ani, 1994, Jones, 2015, Rabaka, 2010, Rollefson, 2008, p. 91). More recently, according to Anderson and Jones (2016):

"Contemporary expressions of Afrofuturism emerging in the areas of metaphysics, speculative philosophy, religion, visual studies, performance, art and philosophy of science or technology that are described as "2.0," in response to the emergence of social media and other technological advances since the middle of the last decade" (p. ix).

Additionally, the authors define Afrofuturism 2.0 as:
The early twenty-first century technogenesis of Black identity reflecting counter histories, hacking and or appropriating the influence of network software, database logic, cultural analytics, deep remixability, neurosciences, enhancement and augmentation, gender fluidity, posthuman possibility, the speculative sphere with transdisciplinary applications and has grown into an important Diasporic techno-cultural Pan African movement" (p. x).

Therefore, propelled by new thoughts and creative energy, members of this Black speculative movement have been in creative dialogue with the boundary of space-time, the exterior of the macro-cosmos and the interior of the micro-cosmos. Yet, there is historical precedent for this movement around the concepts of the color line, the color curtain, and the digital divide. In 1903, W. E. B. Du Bois published his great work, - *The Souls of Black Folk*, drawing on the disciplines of sociology, anthropology, autobiography and history, and made his argument in the era of Jim Crow and imperialism noting: "The problem of the twentieth century is the problem of the color-line, the relation of the darker races of men in Asia and Africa, in America and the islands of the sea" (2007, p. 18). Furthermore, Du Bois suggested, due to their unique experience, African Americans had developed a metaphysical perspective or Veil that bestowed a certain insight upon them on life in the West. The Veil was a literary and philosophical translation of the inner life of people of African descent in the Americas (Du Bois, 2007). Two years later, Albert Einstein (1905) proposed his Special Theory of Relativity that conceptualized the relationship between space and time, postulating that the laws of physics are invariant in all inertial systems and the speed of light in a vacuum is the same for all observers. Between 1908 and 1910, Du Bois drew upon ideas from natural science, humanities and social science to write a speculative short fiction story, - "The Princess Steel." Du Bois developed this story with a character that invented a Mega-scope that could see across space and time that would amplify his ideas to study the boundary of space-time creatively, "into a means for perceiving material history" (Brown & Rusert, 2015, p. 820). The creative ideas of Du Bois and others during this period would be decisive in aesthetic and socio-political formulations of the non-white world of the twentieth century. Later in the twentieth century, Achmed Sukarno, the president of Indonesia and other leaders organized the Bandung conference, a meeting for the Dark World that called for the de-occidentalization of the earth. Kwame Nkrumah, the foremost African leader to promote Pan-Africanism in the post-World War II era was an ardent supporter of this 1955 conference. The author, Richard Wright, a conference attendee, reported on the ideas promoted and discussed them at length in his work, - *The Color Curtain* (1956). This event would influence the imagination of activists like Claudia Jones, Malcolm X, Steve Biko, Thomas Sankara and others, in pursuit of the liberation of the Dark World.

AARON SUTTON // BSAM LOGO

Over the course of a generation, many of these radical initiatives would be repressed or betrayed. However, the seeds for a Black speculative movement challenging white racist normativity and Black parochialism, would be sown by creative intellectuals, mystics and artists like Sun Ra, Fela Kuti, George Clinton, Max Beauvoir, Octavia E. Butler, John Coltrane, Alice Coltrane, Samuel R. Delany, Jimi Hendrix, Jean Michel Basquiat and many others. At the end of the twentieth century, scholars such as Molefi Kete Asante, Audre Lorde, Chinua Achebe, Ngugi wa Thiong'o, Greg Tate, bell hooks, Sylvia Wynter, Lewis Gordon, Cornel West and other academics and activists catalogued the increasing deterioration and anomie of Black cultural production and dislocation in relation to the transition to a neoliberal, multi-national, political-economic matrix. Furthermore, Anna Everett, Alondra Nelson, Paul D. Miller, Alex Weheliye, Kali Tal and others, via an online forum during the early conceptual development of Afrofuturism, analyzed an emerging global digital divide that reflected technical, economic and social inequality. This phenomenon was primarily responsible for the interruption of Africa, its Diaspora, and other countries of the global south, from attaining optimal growth or enhancement in political, economic, social or cultural capital. On the other side of the Atlantic, work by Kodwo Eshun, as a member the Cybernetic Culture Research Unit (CCRU), and John Akomfrah, co-founder of the Black Audio Film collective were crucial to the global theoretical genesis of Black cyber-culture. However, during this time and into the early 21st century, several disparate strands of a new creative Africanist matrix emerged, influenced by speculative design and world building, as well as a renewed radicalized socio-political stance, and the Social Physics of Blackness (the interface of African peoples, myth-forms, technology, behavioral science, ethics and social world). Indispensable to this manifesto is the groundbreaking work done on the Black Speculative phenomenon by Sheree Renee Thomas. In the late 90s, in a hostile environment toward Black Speculative work, Thomas gathered obscure documents with the support of interviews from Octavia Butler, Amiri Baraka, Charles Saunders, Samuel Delaney and his then wife Marilyn Hacker (Thomas, 2016). Furthermore, these interviews and information gave Thomas the insight to revisit the term speculative fiction and create a project that led to the genesis of her anthology *Dark Matter: A Century of Speculative Fiction from the African Diaspora* in 2000 and *Dark Matter: Reading the Bones* in 2004 (Thomas).

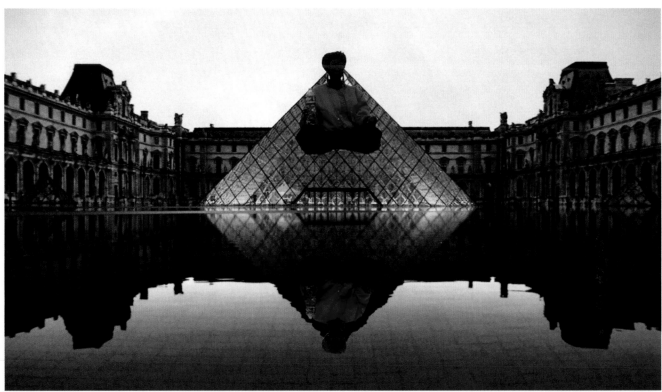

MAWENA YEHOUESSI // Nû L'éviter

This manifesto assembles and recognizes the ideas developed between 2005 and 2015, as the inspiration for the Black Speculative Arts Movement (BSAM) and the event *Unveiling Visions: The Alchemy of The Black Imagination* that established its existence. Black Speculative Art is a creative, aesthetic practice that integrates African or Africana diasporic worldviews with science or technology and seeks to interpret, engage, design or alter reality for the re-imagination of the past, the contested present, and as a catalyst for the future. Moreover, this manifesto explores the question, "What is the responsibility of the Black artist in the 21st century?" Within the Afrofuturist 2.0 frame of inquiry, Tiffany Barber asserts:

"What is compelling about Afrofuturism is that it is historical in its gesture back to previous debates about social responsibility, radical politics, and black artistic production that surged during the Black Arts Movement or BAM of the 60s and 70s. But it rearticulates these debates and expands our understandings of blackness's multi-dimensionality, the good and the bad, the respectable and the undesirable."

Afrofuturism 2.0 and the Black Speculative Arts Movement are indebted to previous movements like BAM, Negritude, The Harlem Renaissance, and other continental and diasporic African speculative movements. Moreover, it is a continuation of the historical behavior within the Veil to engage the philosophies of thinkers such as Dubois, Wright, Everett and others, in piercing the Color Line, the Color Curtain, and understanding the Digital Divide in the face of similarly relevant 21st century challenges. For example, contemporary artists like Kapwani Kiwanga are revisiting the ideas of Kwame Nkrumah to envision an Afro-Galactic future. Moreover, the goals of the Black Speculative Art Movement manifesto are structured as a pursuit or open sourced path of inquiry to transform the anomie or collapse in ethics and increasing sense of dystopia in the Diaspora and African communities that were displaced by exigencies of the Modern World System and the collapse of space-time.

211

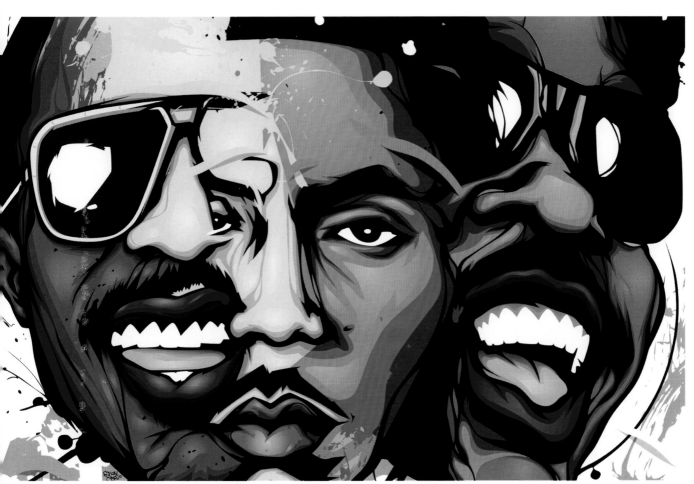

FLUX SINGLETON

Several events between 2005 and 2015 shaped the development of BSAM, including the explosion in social media platforms illustrated by Facebook, Youtube, and Twitter (Van Dijck, 2013), and three seminal publications *The Big Short* (Jabko & Massoc, 2012, Lewis, 2015) documenting the global market collapse of Anglo capitalism, Bill Bishop's (2009) The Big Sort detailing re-segregation of people and Michelle Alexander's *The New Jim Crow* (2011). Tributary events were the election of the United States' first African American president, Barack Obama, racist reactions and subsequent collapse of the liberal post-racial project, the increased use of crowdfunding and other new technologies to design creative projects, escalating environmental stress, and the New Scramble for Africa (Kimeyi & Zenia, 2011). Furthermore, the resurgence of Pan Africanism and outreach to the African Diaspora (now incorporated as the 6th zone) by the African Union; the appearance of state sanctioned deaths of Black people through police brutality, such as the Marikana massacre, and; the current global black social protest response to localized forms of injustice intensified the current social context. BSAM is not a unified school of thought. BSAM is a loose umbrella term which represents different positions or basis of inquiry: Afrofuturism 2.0 (and its several Africanist manifestations, i.e. Black Quantum Futurism, African Futurism, and Afrofuturismo), Astro Blackness, Afro-Surrealism, Afro-Pessimism, EthnoGothic, Black Digital Humanities, Black (Afro-future female or African Centered) Science Fiction, The Black Fantastic, Magical Realism, and The Esoteric. Although these positions may be incompatible in some instances, they overlap around the term speculative and design, and interact around the nexus of technology and ethics. Individuals or organizations whose work represents pillars of BSAM would include and are not limited to: Martin Delaney, Paschal B. Randolph, Toni Morrison, Sun Ra, Amiri Baraka,Tananarive Due, Ben Okri, Nnedi Okorafor, W. E. B. Dubois, The Afrofuturist Affair, Samuel Delany, Minister Faust, Jean-Pierre Bekolo, Jarita Holbrook, Milton Davis, Ishmael Reed, Wanuri Kahiu, Sheree Renee Thomas, Andrea Hairston, Janelle Monae, Sanford Biggers, John Jennings, Octavia E. Butler, Octavia's Brood, Nalo Hopkinson, Cyrus Kabiru, D. Scott Miller, Pamela Phatsimo Sunstrum, Steven Barnes, N.K. Jemison, D. Denenge Akpem, Ytasha Womack, Kapwani Kiwanga, John Akomfrah, and Kodwo Eshun.

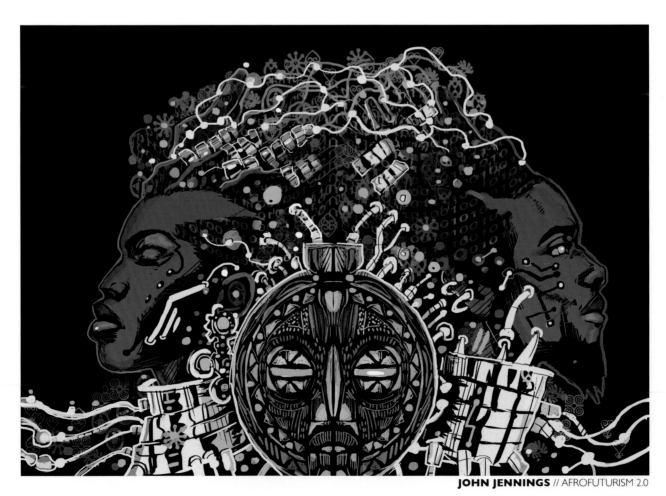

JOHN JENNINGS // AFROFUTURISM 2.0

In the occidental realm, the epistemic boundaries of speculative design is limited largely to objects, how they mediate the human experience and are primarily interpreted through ideas originating with the Frankfurt school of critical theory (a body of thought usually dismissive, in the case of Theodor Adorno, silent or Eurocentric in regards to Black cultural knowledge production and performance). Furthermore, this occidental approach limits the framework of the speculative to Western philosophy and science. For example, Anthony Dunne and Fiona Raby (2013) argue that, in relation to speculative design, only the present, probable, preferable, plausible and possible should be zones of concern, noting:

Beyond this lies the zone of fantasy, an area we have little interest in. Fantasy exists in its own world, with few if any links to the world we live in...This is the world of fairy tales, goblins, superheroes, and space opera (p. 4).

However, this approach eschews or avoids alternative speculative cultural worldviews and attempts to establish a system where Europe assumes the teacher position and all others as the recipients and consequently users of this limited perspective. For example, there is historical evidence that demonstrates, via the route of alchemy, that magic is a gateway into the study of science. In contrast to Dunn and Raby, Lewis Mumford (1934) previously noted:

Between fantasy and exact knowledge, between drama and technology, there is an intermediate station: that of magic. It was in magic that the general conquest of the external environment was decisively instituted. For the magicians not only believed in marvels but audaciously sought to work them: by their straining after the exceptional, the natural philosophers who followed them were first given a clue to the regular (p. 36-37).

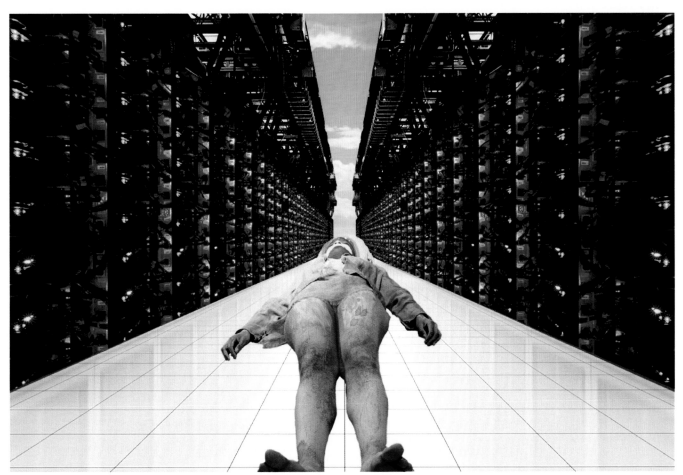

MAWENA YEHOUESSI //Y'A BON ENTENDOUR

Another Western outlier of this position is the work of philosopher Paul Feyeraband. An Africanist example of this phenomenon is the work of Max Beauvoir, a trained biochemist and Voudou priest who synthesized these approaches in medical treatments, as a healer and activist. Digital scientist Nettrice Gaskins, building on and moving beyond previous work done by Ron Eglash with African fractals, along with other contemporary scholars, demonstrate the possibilities of re-conceptualizing African Cosmograms as cultural tools to interact with digital technology, augmented space and augmented reality. Moreover, there are implications for culturally situated learning, STEAM, and holistic health. Nnedi Okorafor's novel, Akata Witch (2011), reveals the overlap or merger between magic and technology as a case for these implications. Therefore, in contrast to the occidental speculative design approach, BSAM freely embraces the Africanist approach to speculative design and incorporates earthly and unearthly intuitive aspects of Esoterica, Animism and Magical Realism. This integration generates overlapping zones with other knowledge formations when formulating or conceptualizing theory and practice in relation to material reality. The brevity of this manifesto does not permit deeper exploration of the global multifaceted dimensions of Black art, however, we would be remiss if we did not discuss an important argument that Black artists in the West have wrestled with for several generations – their relationship and contributions to radical politics.

The role of Black artists in relation to politics is a century long debate. Prominent in these debates is W. E. B. Dubois's Criteria for Negro Art, published in 1926, which specifically focused on the politics of beauty, propaganda, and social recognition:

What do we want? What is the thing we are after? As it was phrased last night it had a certain truth. We want to be Americans, full-fledged Americans, with all the rights of other American citizens. But is that all? Do we want simply to be Americans? Once in a while through all of us there flashes some clairvoyance, some clear idea, of what America really is. We who are dark can see America in a way that white Americans cannot. And seeing our country thus, are we satisfied with its present goals and ideals? (p. 290).

The socio-political world Du Bois articulated was also argued by Hubert Harrison and similarly by Langston Hughes in his work *The Negro Artist and the Racial Mountain* (1926). Oswald Spengler also characterized this socio-political environment several years later in his book *The Hour of Decision: Germany and World Historical Evolution* (1963). Spengler, noting the internal crisis in White Western civilization, in relation to the rest of the world, commented:

It crosses the horizontal struggle between states and nations by a vertical between ruling classes of the white nations...and in the background the far more dangerous second part of this revolution has already set in...the whites in general are under attack by the collective mass of the "colored" population of the earth, which is slowly becoming conscious of its community (p. 81).

Other writers, including Spengler and Lathrop Stoddard were responding to recent movements of people of color, such as Pan African leaders Marcus Garvey and Amy Jacques Garvey of the U.N.I.A., Sun Yat Sen of China, Gandhi of India, The Frente Negra Brasileira of Brazil, The African National Congress of South Africa, Sultan Pasha al-Atrash of Syria and Zapata of Mexico. These names and organizations do not represent an exhaustive list of liberationists. Liberal Humanist Pearl Buck, author of The Good Earth (1931), among others, warned Westerners of the rising anger of non-Westerners against racism, imperialism and colonialism. A decade later, at the 1942 Yenan forum, revolutionary leader Mao Tse Tung of China, supported the political significance of literature, art, social change and the influence of the gun and the pen.

The era was characterized by complete transition from the Pre-WWI era into a new international order exemplified by "the collapse of the League of Nations in favor of autarchic empires, protectionism, nation-state economies, and their associated empires, rise of fascism in Europe, Soviet 5 year plans and the American New Deal" (Arrighi, 1994, p. 293). However, in the African diaspora, and on the African continent, the ideological struggle centered largely on the tenets of Marxism and Nationalism in pursuit of freedom, liberty and national liberation. During this time, elements of the Black Speculative Arts perspective remained vibrant, sometimes underground and contested, with approaches from the dark arts represented by Rollo Ahmed, advisor of voodoo and

spiritual subjects to British occult novelist, military intelligence officer Dennis Wheatley, the esoteric practices and hoodoo influenced writings of Zora Neale Hurston, and the magic of Garveyite supporter Black Herman. The art of Aaron Douglas, and writer George Schuyler in his literary works *Black Empire* (1933-1940) and *Black No More* (1931) and various Black literati were exposed to the philosophies and mysticism of George Gurdjieff and Peter D. Ouspensky. The 1939 work of D. O. Fagunwa in his novel *Forest of a Thousand Daemons: A Hunter's saga*, impacted future generations of Nigerian writers. The engagement between Africanist Hoodoo practitioners and Asiatic esoteric philosophies was not unusual, as a significant number of conjure men and women would engage the work of alchemists like Cornelius Agrippa, Paracelsus, or John Dee, in their work. Hurston's work during this period would be persuasive in its account of Black folklore, magic and the connection to Africa. Despite her victimization by the chauvinism around race, sex and knowledge of the times, intellectuals like the novelist Alice Walker, ultimately rediscovered Hurston's remarkable and meaningful works. Moreover, scientists vindicated Hurston's work as Jarita Holbrook and others authenticated the relationship between culture, astronomy, and esoteric practices with research on indigenous cultures like the Dogon people of Mali, West Africa and their interpretation of the Axis Mundi (cosmic axis). More significantly, it was during this important juncture, during the modern advent of Black speculative production, that the flawed education African Americans received in relation to the broader society came under scrutiny. The scholar, Carter G. Woodson (2006) noted:

If you can control a man's thinking you do not have to worry about his action. When you determine what a man shall think you do not have to concern yourself about what he will do. If you make a man feel that he is inferior, you do not have to compel him to accept an inferior status, for he will seek it himself. If you make a man think that he is justly an outcast, you do not have to order him to the back door. He will go without being told; and if there is no back door, his very nature will demand one (p. 71).

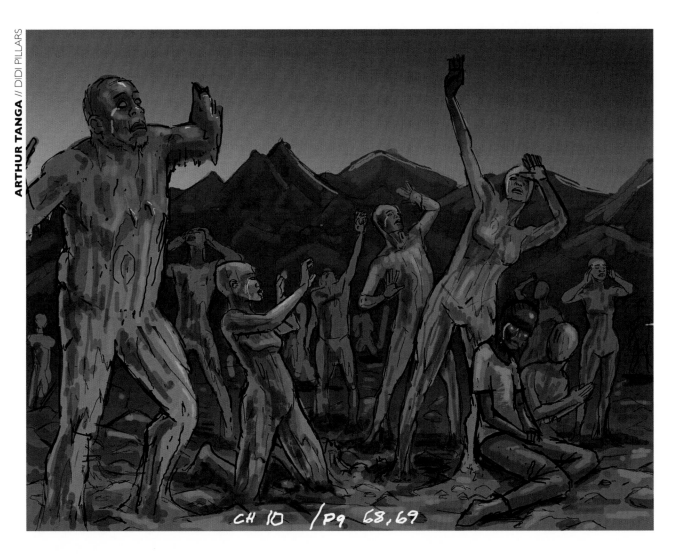

ARTHUR TANGA // DIDI PILLARS

CH 10 /pg 68,69

Woodson was referring to the newly urbanized African American population the philosopher Alain Locke referred to as The New Negro. This reference was descriptive in the African Americans' interaction or engagement with modern foundations, think tanks, international or domestic finance, and emerging mass media propaganda. For example, Edward Bernays (1928) further articulated the ideas of his uncle Sigmund Freud in explaining the impact of crowd psychology and engineering consent on African Americans and the broader American society relative to corporate interests and government. For example, Woodson was aware The New Negro was not receiving an education orienting them to prioritize Black interests in development or politics. He observed, "The oppressor has always indoctrinated the weak with his interpretation of the crimes of the strong" (2006, p. 131). Furthermore, Woodson understood that the New Negro was harmed by Jim Crow theology and Share Cropper philosophy, which were products of White Eurocentric seminaries and higher educational institutions designed to coerce and maintain Black dependence on White hegemony. An illustration of this phenomenon was the reported quote by Woodson that, "Harvard has ruined more Negroes than bad whiskey." The ramifications of Woodson's observations demonstrated in ideological battles over politics and the cultural sphere between intellectuals and artists over real and imagined communities of interest. In addition, this mis-education and alienation was also prevalent in the colonial sphere throughout the Black world in Africa and its diaspora, as articulated by Aime Cesaire, Suzanne Cesaire, Frantz Fanon, Amy Jacques Garvey, George Padmore, Claudia Jones and other intellectuals.

In fact, leading up to and after WWII, these politically imagined communities or ideological camps of Marxism, liberalism, and nationalism would influence the politics surrounding art for the remainder of the 20th century. The Marxist's visualized communities of interest asserted that human inequality was a derivative problem caused by material conditions; liberal communities argued inequality was a philosophical problem, and nationalist thinkers believed in particular cultural characteristics, imagined communities with the goal of political sovereignty. Following WWII, these philosophical positions and art were influenced by the new world order ushered in after the nuclear violence of Nagasaki and Hiroshima, the Bretton Woods international financial system, and the new United Nations charter (Arrighi, 1994). A cinematic illustration of the racial and sexual anxieties of the era (that resembled the storyline of W. E. B. Dubois's *The Comet*) was the film *The World, The Flesh and The Devil* starring civil rights activist Harry Belafonte portraying a post-apocalyptic America in the wake of a nuclear holocaust (Larrieux, 2010).

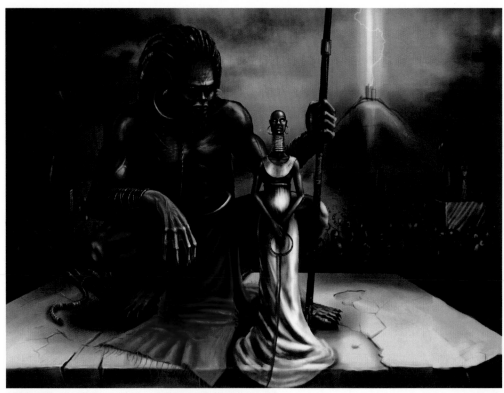

ARTHUR TANGA // DREAD WOMAN AND GIANT GUARD

Elsewhere, Afrodiasporan artists, such as Wilfredo Lam, Namba Roy, and the Afro-Brazilian Yoruba priest-artist, Deoscóredes Maximiliano dos Santos, characterized the growing Africanist agency in Diaspora art. Four African American artists important to this argument were Paul Robeson, Richard Wright, Ralph Ellison, and Lorraine Hansberry. Robeson, Wright, Ellison and Hansberry, with varying levels of interest, were at the center of debates focused on the merits of nationalism, communism and leftist impulses. Ellison asserted that, as far as ideological commitment, African Americans were only interested,

"to the extent that they are helped to see the bright star of their own hopes through the fog of their daily experiences...it will only be solved by a... leadership that is aware of the psychological attitudes and incipient forms of action which the black masses reveal in their emotion-charged myths, symbols, and wartime folklore"(1943, p. 302).

Despite Richard Wright's prose surrounding the topic of Black Power and the Bandung conference, his perspective on African/Black folk culture and practices biased him to the mytho-forms that Ellison and Hansberry were sensitive to in their artistic creations. Moreover, if Richard Wright had lived long enough to see the emergence of the Black Power Movement and Black Arts Movement, he may have had to revise his earlier position on African cultural practices.

For example, Amos Tutuola, influenced by the work of F.O. Fagunwa wrote the Nigerian speculative novel *The Palm-Wine Drinkard* and *My Life in the Bush of Ghosts* in 1952. Furthermore, in response to the uninformed beliefs of other Western scholars, Nigerian novelist Chinua Achebe produced a powerful trilogy of novels; *Things Falls Apart* (1958), *No Longer at Ease* (1960), and *Arrow of God* (1964), which would emphatically destroy the Eurocentric notion of a history-less Africa, before the coming of White people, imperialism and colonialism. Extending this critique further, on the Wright/ Ellison conflict, Larry Neal, a co-founder of the Black Arts movement, noted posthumously that there was the recognition by members of BAM that the Black and White literary left never forgave Ralph Ellison for promoting the rejection of White controlled left wing politics (1989).

The primary purpose of the Black Power movement, the Black Arts movement, and anti-colonial struggle was to address both the political and cultural imbalances imposed by White supremacy and the mis-education Woodson and other anti-colonial scholars referenced decades previously. These movements focused on the fact that a Jim Crow education, and or colonial training abetted by western media, had crippled the ability of the African Diaspora and Africans to govern or intelligently pursue their own interests in their societies. African American revolutionary Malcolm X succinctly summed up the situation shortly before his assassination, when he noted: If you're not careful, the newspapers will have you hating the people who are being oppressed, and loving the people who are doing the oppressing (Breitman, 1965, p. 93).

Conversely, in the second half of the 20th century, as the Dark World moved on a global horizontal plane to end Jim Crow and colonialism, White Western leadership moved on a vertical axis to incorporate a few token people of color who would help them maintain their supremacy. For over two generations, a group of African American and African leaders comprised of individuals such as Ralph Bunche, Mobutu Sese Seko, Franklin H. Williams, Blaise Compaoré, Felix Houphouet Boigny, Colin Powell, Condoleezza Rice and Susan Rice for example, assisted the West in undermining or overthrowing progressive governments, especially if these governments' leadership supported Pan African Unity or autonomy. Furthermore, these individuals were rewarded with either Nobel peace prizes (in the case of Bunche) or with quasi-influential relationships with Western corporate/ political interests.

Nevertheless, by the middle of the 1960s, with the start of the decline of the American civil rights movement and the struggle between neocolonialism and the African revolution, a new generation of writers, artists and creatives added to the Black speculative tradition. Notable radical literati John A. Williams, and Sam Greenlee were a part of this phenomenon. Williams and Greenlee's work contrasted the liberal humanism and production of race in projects such as Gene Rodenberry's Star Trek (Bernardi, 1997). Speculative novels and cinema, such as *The Man Who Cried I Am* (1967) and *The Spook Who Sat By The Door* (1969, 1973), represented a move away from the earlier works of James Baldwin and other early writers. Furthermore, radicals of the era consumed Gillo Pontecorvo's 1967 movie *The Battle of Algiers* in an effort to translate and materialize their vision into

real urban guerilla warfare (Kaufman, 2003). However, the Black Power movement signaled a rejection of the Civil Rights movement and advanced against the backdrop of the historical genocide of the indigenous Indian civilization, the living memory of Japanese internment camps, German Nazi death camps and Title II of the Internal Security Act of 1950, also known as the McCarran Act. These works represented a tradition started by Martin Delany, in the middle of the 19th century, with his speculative work *Blake* (1859-1962, 1970), and continued by Sutton Griggs in the 1890s with *Imperium in Imperio* (1899) and George Schuyler's *Black Empire* (1936-1938, 1993). Furthermore, the speculative works of Ishmael Reed, Amiri Baraka, Sun Ra, Betye Saar, and later Octavia Butler and Toni Morrison were developed against the backdrop of the American aerospace program, the Cold War, concern over peak oil production, and the environment. Moreover, neo-fascist science fiction written by Robert Heinlein, and to a lesser extent Isaac Asimov, resonated with the concerns of the Black creative community. Of special note during this time was the intersection between science fiction, speculative imagination, social realism and the future, in the work of Samuel Delany's *Nova*, and the missed opportunity for rapprochement between the artist Sun Ra and The Black Panther Party. Published in 1968, *Nova*, set in the 31st century, speculatively describes future means of production, sexual identity, cyborg technology, artistic creativity, and the agency of people of African descent. In contrast, in 1971, a philosophical conflict emerged between modern jazz artist Sun Ra and the Black Panther Party over how to re-appropriate technology to impact the consciousness of African Americans, revealing ideological differences over approaches to struggle (Kreiss, 2008).

Other Afrodiasporan artists, such as Jamaican Everald Brown, with his fusion of Rastafarianism and Ethiopian church motifs, and continental African writers, also put forth speculative ideas based upon their approaches. These respective styles sought to capture the transition of former colonies and Africa from colonial rule, in pursuit of a future with creative productions by Ghanaian writer Ayi Kwei Armah, via his novels *The Beautyful Ones Are Not Yet Born (*1968), *Fragments* (1971), and *Two Thousand Seasons* (1973) and Ama Ata Aidoo's play *Anowa* (1965). Creative African intellectuals, such as Ousmane Sembene, produced social realist work in film and literature that could overlap with speculative practice and commented on White imperialist hegemony and Black/African elite corruption or betrayal. A similar sentiment reverberated in the radical practice of Afrodiasporic artists, such as Emory Douglass and Lorraine Hansberry's character Beneatha, in Act III of the play Raisin in the Sun, who said,

What about all the crooks and thieves and just plain idiots who will come to power to steal and plunder the same as before, only now they will be [B]lack and do it in the name of the new independence..." (p. 133)?

However, by the early 1970s, the drive for Black/African autonomy was derailed by assassinations, the intentional influx of drugs by the U.S. government into the anti-war movement and the African/Black community, and the rise of the Black Anglo Saxon. The term Black Anglo Saxon and a book by scholar Nathan Hare (1965, 1970, 1990), does not refer to direct familial relationships of American Africans to Anglo Saxons, but to a certain social type that disassociates from the broader Afrodiasporic community and instead, identifies with white Anglo Saxon protestant elites or WASPs. The Martinique born revolutionary psychiatrist, Frantz Fanon, had them in mind when he wrote *Black Skin, White Mask* (1952), chronicling the need for this social stratum of colonial Blacks to be accepted by Whites and equating Eurocentric ideas about civilization, education and culture with progress. A prime example is the behavior of Carl Rowan. Rowan was appointed Deputy Assistant Secretary of State by John F. Kennedy, Director of The United States Information Agency by Lyndon B. Johnson, and was the first African American to hold a seat on the National Security Council. Rowan spent much of his time in the 1960s attempting to discredit the activities of Malcolm X to African leaders. The same social stratum helped to undermine or neutralize grassroots organizers from the mid-1960s onward and along with White Liberals, conspired or worked to co-opt the energy and dynamism of the era. The domestic intent was to undermine initiatives for autonomy, which were carried out by the Mississippi Freedom Democratic Party of Fannie Lou Hamer and other local Black activists (Payne, 2005, p. xii). However, the international intent for the Black Anglo Saxon is to be one of the selected as agents of The Five Eyes. The Five Eyes is the international intelligence-gathering network with ties to a global entertainment-military –industrial complex is comprised of the five Anglo speaking countries that were victorious in WWII, including The United Kingdom, The United States, Canada, New Zealand, and Australia (Cox, 2012). This behavior is illustrated when White political/economic behavior, foreign or domestic, acts in aggregate to promote issues central

to their whiteness, is considered rational public policy. On the contrary, in protesting this aggregate behavior, Blacks or other cultural groups are portrayed as irrational in conduct. Consequently, the colored leadership or help intervene in shutting down the loud Blacks responsible for unrest as they challenge discriminatory public policies (for more information see critiques of the Obama administration and the POTUS). For example, until Colin Kaepernick recently protested the American national anthem, the contemporary promotion of Black athletes in corporate media, such as Kareem Abdul Jabbar in Time magazine, and Michael Jordan are to act as cool out agents for the Five Eyes with the African American population. However, the revolts surrounding the killings of Philando Castile and Alton Sterling are eerily similar to events of a generation ago. Eldridge Cleaver commented on this behavior in his 1968 book Soul on Ice: The effect was to take the "problem" out of a political and economic and philosophical context and place it on the misty level of "goodwill," "charitable harmonious race relations," and "good sportsmanlike conduct." (Cleaver, p. 112). Furthermore, the recent declaration by Michelle Obama (FLOTUS) pronouncing America as a Great nation is linked to the fact her family lives in the White House, a building built by slaves. However noble the intent, this assertion by Ms. Obama is insufficient and is contrasted by the fact of high incarceration rates of black and brown people, infant mortality rates, and the maintenance of international hegemony of America over weaker nations to maintain the American way of life. Almost 50 years ago, the writer James Baldwin described this phenomenon in his 1969 essay *The Price May Be Too High*. Baldwin remarked: ...What is being attempted is a way of involving, or incorporating, the black face into the national fantasy in such a way that the fantasy will be left unchanged and the social structure left untouched (p. 108).

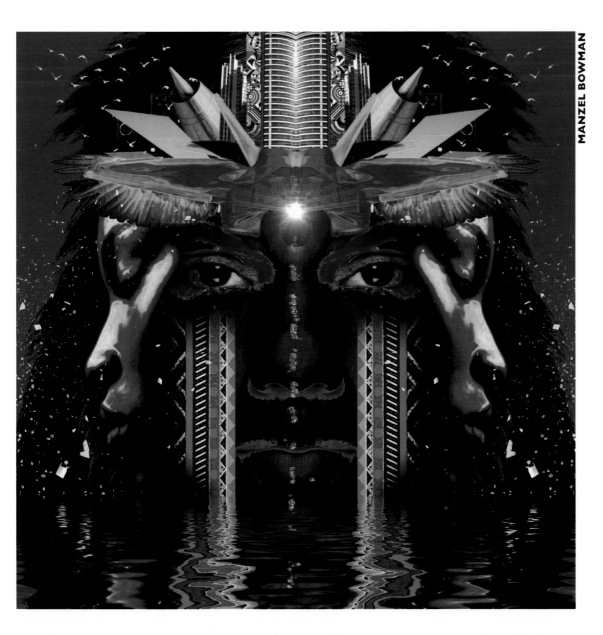

MANZEL BOWMAN

Paradoxically, an equivalent social stratum worked toward inclusion within the White academy, the Democrat and Republican Parties and what can legitimately be called the non-profit industrial complex., The emerging knowledge class of the late 20th century, with a similar agenda, worried about being characterized with descriptions of essentialism, embraced the Eurocentric aspects of postmodernism. Despite occasional flickers of aesthetic brilliance from performers such as disco artist Sylvester, Grace Jones, Frankie Knuckles, Grand Master Flash and the Furious Five, or the genius of artist Jean Michel Basquiat, the socio-political scene of Black creative autonomy was in serious decline by the 1980s. A singularly brilliant example of post-industrial Afrofuturism was the work by Detroit Techno pioneers Jeff Mills and Mike Banks with the formation of the Techno collective Underground Resistance. Furthermore, the work of Derrick May, Juan Atkins and Kevin Saunderson artistically captured the forces of capitalist accelerationism blending the European sounds of Kraftwerk and Depeche Mode with the P-Funk of George Clinton and Parliament Funkadelic (Noyes, 2014). Correspondingly, by the mid-1980s, this liberal stratum within the Black community attempted to de-politicize blackness and embrace the liberal agenda of color-blindness in the name of a type of diversity that ensconced Whiteness. For instance, the promotion of diversity initiatives in the last quarter of the 20th century frequently left intact the very structures that oppressed Black people - insulating White elites from charges of White supremacy, which became the linchpin for post-civil rights racism.

Starting in the mid-1980s, through the war on drugs, global structural adjustment for Africa, and The Cosby Show, warm fuzzy visuals promoted non-threatening smiling Black people. Leaders like Nelson Mandela, and clean fair complexioned, (as described by his future vice president Joe Biden) political operatives such as Barack Obama – represented the post-Black perspective in select urban elite settings, think tanks, liberal enclaves and swank art salons. The economic crash of 2008 exposed these concepts as having the political value of a sub-prime mortgage in the face of the racist backlash that allowed for the election of the country's first Black president. Another illustration of this behavior occurred during the now famous Beer-Gate controversy on July 30, 2009. Beer-Gate was an incident in which a sitting President of the United States, Barack Obama, had to have a White House meeting over a beer with a prominent Black scholar and the cop who racially profiled him. The shame of it was as though the racial problem could be discussed over something as trite as a mug of beer. Again, a similar social stratum of Black elected officials, liberal multiculturalists, labor, religious leaders, media, and non-profit organizations were used to pacify the Black community and bargain for symbolic gains like government appointments, commissions, and Black faces on money. Similar actions this stratum believed should and would placate the public, after the killings of Mike Brown, Eric Garner, Renisha McBride, Freddy Gray, Tamir Rice, The Charleston 9, Sandra Bland, Alton Sterling, and Philando Castile. However, the recent attempt by media to construct the behaviors of accused assassins Ismaaiyl Brinsley, Micah Johnson, Gavin Long, and Korryn Gaines as deranged and suicidal deserves more scrutiny.

Previously, Black Panther leader Huey Newton examined this phenomenon from the perspective of reactionary suicide (a person who takes their own life in response to social conditions) and revolutionary suicide (a person who knowingly loses their life to oppose forces that drive them to self-murder) (Newton, 1973). Therefore, for the sake of discussion it is necessary to pursue this vein of inquiry to examine why these Black men and woman chose their path. Revolutionary Suicide does not mean these people have a death wish but a strong desire to live with dignity and hope that requires they oppose oppressive forces at the risk of death (Newton, 1973). Therefore, it is because America is NOT a great nation yet, but has the potential to be one; these young Black millennials, and other groups like The Huey P. Newton Gun Club, have taken up arms. However, prior to these recent events, at the end of the 20th century, a convergence around technology and creativity had profound implications on the Social Physics of Blackness for Africa and its Diaspora.

In America, the cybernetic revolution articulated by Norbert Weiner in the late 1940s and militarized as Arpanet by the U.S. government during the cold war, came of age in the 1980s with the personal computer. Young Black people who grew up in the video gaming era playing Pac Man, Sega Genesis or Pong, a game designed by the Atari Corporation and released in the fall of 1972, were early adopters of the internet. They were familiar with Japanese anime, loved Parliament Funkadelic, watched Blaxploitation flicks and Star Wars, or played with a Rubik's cube, and collected comic books. Moreover, they listened to rap music on their Sony Walkman or boombox and were sucked into the convergence of media, art, computers, post-industrialization, hypermedia and its resultant impact on the global division of labor following the end of the Cold War and South African Apartheid. By the 1990s, writers, such as Octavia Butler (USA), in her *Parable of The Sower* series (2000), Nalo Hopkinson (Canada), Jewelle Gomez (USA), Peter Kalu (England), with Black Star Rising (1997), Ayi Kwei Armah (Ghana) Osiris Rising (1995), cultural critic Greg Tate (USA), and publications like Milestone Comics began to make their speculative presence felt in response to the emerging age. Angelique Kidjoe (Benin) and her Vodun influenced music, John Akomfrah and the Black Audio Film Collective, the Afrocentric aesthetics of rapper Paris and X-Clan, the rap group the Ultramagnetic MC's, the techno group Cybotron, Drexciya, Outkast, and Deltron 3030, were prominent examples of the new emerging performance aesthetic. However, this generation was largely unaware that Black people were living in the middle of a global transition of Social Physics and the social construction of Blackness influenced by The Californian Ideology and The Dark Enlightenment.

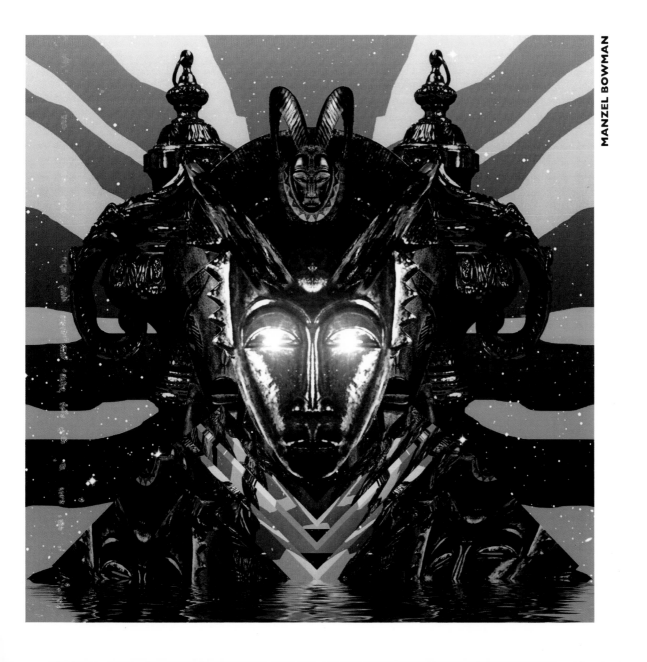

MANZEL BOWMAN

221

Alex Pentland defines Social Physics as: a quantitative social science that describes reliable, mathematical connections between information and idea flow on the one hand and people behavior on the other (2014, p. 4). Furthermore, Social Physics examines how the flow of ideas and productivity influence social norms and networks (Pentland, 2014). Extending and intersecting the argument of Social Physics in relation to Africa and its diaspora, the scholar Michelle Wright, in her text Physics of Blackness: Beyond the Middle Passage Epistemology (2014), argues for a:

Blackness that operates as a construct (implicitly or explicitly defined as a shared set of physical and behavioral characteristics and as phenomenological (imagined through individual perceptions in various ways depending on the context) (p. 4).

This manifesto conceptually hacks both texts and asserts the Social Physics of Blackness of the 21st century is informed by cultural analytics, resource depletion, economic collapse, and genocide, as the world transitions from a Western dominated world system to a multi-polarized one, in the near future. Ultimately, the world will face a stark set of potentially dystopian choices for survival. How then, will The Dark Enlightenment influence the Social Physics of Blackness?

The Dark Enlightenment (a phrase coined by Nick Land) paralleled the emergence of The Californian Ideology. The Californian Ideology is a hybrid philosophy of libertarian individualism and technological determinism understood by cognitive scientists, software developers, engineers, bloggers and Silicon Valley entrepreneurs who embrace classical economic liberalism and individual liberty as an alternative to collective freedom (Barbrook & Cameron, 1996). On the other hand, the Dark Enlightenment reflects a desire to return to older social norms in government and gender roles, while embracing a libertarian or reactionary conservative worldview to economics (Bartlett, 2014). A contemporary illustration of this is the Silicon Valley libertarian futurist billionaire and co-founder of PayPal, Peter Thiel (a supporter of presidential candidate Donald Trump). This perspective embraces the emerging hypermedia of a retro-utopia return to past forms of classical economics and politics amplified by the visions of science fiction writers like Isaac Asimov or Robert Heinlen; or on the other hand pursued Eurocentric visions of utopia, emblematic of science fiction novelists like Kim Stanley Robinson or Ernest Callenbach (Barbrook & Cameron, 1996). The irony of The California Ideology and its derivative, The Dark Enlightenment, is the Jeffersonian Democracy that it idealizes was based upon the right to own people as private property, demonstrating that freedom for White People required the enslavement of Black people (Barbrook & Cameron, 1996). Furthermore, the contemporary proliferation of this perspective extends from the American prison-industrial complex to the mining of rare minerals and corporate land grabs in Africa. Most of all, The Californian Ideology, and dystopian aspects of The Dark Enlightenment (although ostensibly anti-capitalist), are casting their shadows in areas of human augmentation or transhumanism, a resurgence of fascism or crypto fascism, amplified by social media, a fear of the underclass, seeking self-fulfillment in the electronic market place or electronic agora, (a virtual place free from censorship and free expression) (Barsook et al., Roudinesco, 2009). Ultimately, these belief systems regards human beings as surplus flesh, and some of their adherents participate in a revitalized Pro-Western atavistic occult practice, and a desire for creation and control of the artificial intelligence of "The Golem...a strong loyal slave whose skin is the color of the earth" (Barsook, 1996, p. 14).

As a final point, the level of energy driving the contemporary creative environment surrounding the emergence of Afrofuturism, Black Speculative art+design, a renewed radical politics, and the social physics of Blackness will be in direct proportion to the dystopian aspects of global change occurring now into the near future. For example, in light of recent events in Turkey, Great Britain's departure from the European Union, the rise of the Economic Freedom Fighters in South Africa, the dark impulses of Trump-ism in America, and the emerging geo-political struggle between the United States and China, the faint outline of a new social context is arising out of the slow de-composition of the existing world order. The take away from this phenomenon is this epoch transition will require a proportional response from Black creative intellectuals and friends, to meet the challenges of the next few decades as faith in traditional institutional structures declines. For example, across Africa and its global diaspora, a Garveyistic fervor is rising among the grassroots in the ghettoes, favelas, barrios, and shantytowns, in response to the current clash of civilizations. Therefore, the ability to recognize contradictions and stay focused on a liberatory project will be paramount during the transformation. For example, Black political economy must intersect critically with Afrofuturism to engage the challenges of race and digital labour, and critique or disrupt the power of capital and reliable futures developed in the interest of multinational conglomerates and elites (Clegg, P. &Pantojas-Garcia, E.

2009, Adebajo, A. 2013, Cornelissen, Scarlett, Fantu Cheru, & T. Shaw, 2016, Marable, M. 2015, Eshun, K. 2003). Furthermore, the practice of Quantum Mapping and Black Quantum Futurism can re-map temporal processes and re-calculate relations between body, space, memory and methods now to re-shape the future (Phillips, 2015). On the other hand the work of Lonny Avi Brooks utilizes Africological tools in re-imagining the future in regards to framing and forecasting (Brooks, 2016). Moreover, the speculative strategies of resilience identified in the works of Nnedi Okorafor, Nalo Hopkinson, and Octavia Butler, identified by Esther Jones offers another valuable approach (2015). Jones outlines their collective works along "intersection of race, gender, disability, and ideology", "reconstructing the cult of tradition away from practices of militarized rape, forced impregnation, and female genital cutting" and "healing in hostile environments" (p. 147, 148, 149). Finally, in the emerging near future post capitalist society, Africa and its diaspora must master the technology of blockchain technology, the sharing economy, virtual currencies, bio-ethics and transhumanism, peer-to-peer networks, smart contracts, De-centralized Autonomous Organizations (DAOs) and Distributed Mobile Applications. The long-term implication is that Africa, and its diaspora, will swiftly have to incorporate, hack and master emerging technologies and strategies required for survival in a multi-polar, potentially social Darwinist era. In conclusion, resource depletion, environmental collapse, food and water shortages and possible postmodern genocide; militarily delivered by biotechnology such as CRISPR (Clustered regularly interspaced short palindromic repeats) or the intellectual pitfall of accelerationism or teleoplexy (a self-reinforcing cybernetic intensification) will challenge the grit, imagination and creative abilities of the people within the Veil.

The author would like to thank Tiffany Barber, Damion Scott, Tobias C. van Veen, Sheree Rene Thomas, Rasheedah Phillips, Andrew Rollins, Clint Fluker and Sudarsen Kant, for their valuable comments offered in the development of this document. An earlier excerpt if this document was published in Obsidian: Literature & Arts in the African Diaspora.

223

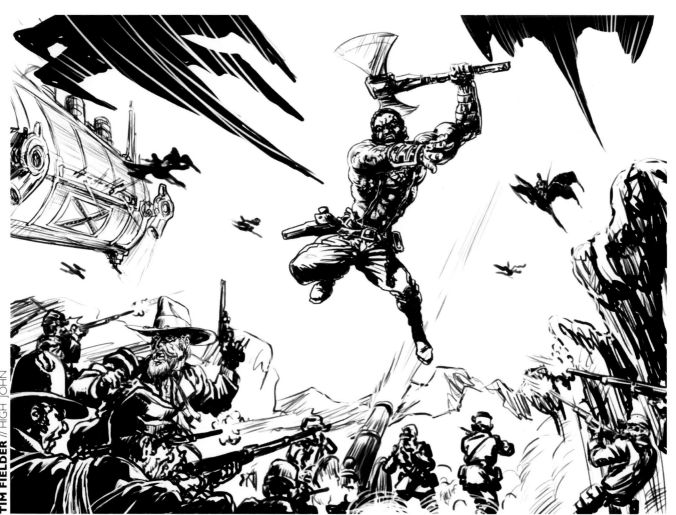

TIM FIELDER // HIGH JOHN

Works Cited

Achebe, Chinua. Things fall apart. Allied Publishers. 1958.

Achebe, Chinua. No longer at ease. Vol. 3. East African Publishers, 1960.

Achebe, Chinua. Arrow of god. Anchor Canada, 2010.

Adebayo, Adekeye. The curse of Berlin: Africa after the cold war. New York: Oxford University Press, 2013.

Aidoo, Ama Ata. Anowa. Longman Publishing Group, 1970.

Alexander, Michelle. "The New Jim Crow." Ohio St. J. Crim. L. 9 (2011): 7.

Anderson, Reynaldo. Critical Afrofuturism: A Case Study in Visual Rhetoric, Sequential Art, and Post-Apocalyptic Black Identity. In THE BLACKER THE INK: The Politics of Black Identity in Comics and Sequential Art. Eds. Gateward, F., Jennings, J. Rutgers University Press, 2015.

Anderson, Reynaldo, Jones Charles E. Afrofuturism 2.0: The Rise of Astro-Blackness. Lexington books. 2016.

Ani, Marimba. Yurugu: An African-centered critique of European cultural thought and behavior. Africa World Press, 1994.

Armah, Ayi Kwei. The beautyful ones are not yet born. Heinemann, 1988.

Armah, Ayi Kwei. Fragments. 1969. (1979).

Armah, Ayi Kwei. "Two Thousand Seasons. 1973." London & Ibadan: Heinemann (1979).

Armah, Ayi Kwei. Osiris rising: A novel of Africa past, present and future. Per Ankh, 1995.

Arrighi, Giovanni. The long twentieth century: Money, power, and the origins of our times. Verso, 1994.

Baldwin, James. "The price may be too high." The cross of redemption: Uncollected writings (2010): 105-108.

Barber, Tiffany E. Electronic communication. 2016.

Bartlett, Jamie (20 January 2014). "Meet The Dark Enlightenment: sophisticated neo-fascism that's spreading fast on the net". The Daily Telegraph.

Bernardi, Daniel. " Star Trek" in the 1960s: Liberal-Humanism and the Production of Race." Science Fiction Studies (1997): 209-225.

Bishop, Bill. The big sort: Why the clustering of like-minded America is tearing us apart. Houghton Mifflin Harcourt, 2009.

Delany, Martin Robison, and Floyd J. Miller. Blake: Or, The Huts of America, a Novel. Vol. 363. Beacon Press, 1970.

Cornelissen, Scarlett, Fantu Cheru, and T. Shaw, eds. Africa and international relations in the 21st century. Springer, 2016.

Barbrook, Richard, and Andy Cameron. "The californian ideology." Science as Culture 6.1 (1996): 44-72.

Bernays, E. (1928). Propaganda. Routledge.

Breitman, George, ed. Malcom X Speaks: Selected Speeches and Statements. Grove Press, 1965.

Brooks, Lonny Avi. "Playing a Minority Forecaster in Search of Afrofuturism." Afrofuturism 2.0: The Rise of Astro-Blackness (2016): 149.

Buck, Pearl S. The good earth. Vol. 1. Open Road Media, 2012.

Butler, Octavia E. Parable of the Sower. Open Road Media, 2012.

Cleaver, Eldridge. "Soul on Ice. 1968." New York: Delta (1999).

Clegg, Peter, and Emilio Pantojas-Garcia. Governance in the Non-independent Caribbean: Challenges and Opportunities in the 21st Century. Ian Randle, 2009.

Cox, James. Canada and the five eyes intelligence community. Canadian Defence & Foreign Affairs Institute, 2012.

Delany, Martin Robison, and Floyd J. Miller. Blake: Or, The Huts of America, a Novel. Vol. 363. Beacon Press, 1970.

Du Bois, William Edward Burghardt. "Criteria of Negro art." Crisis 32.6 (1926): 290-297.

Du Bois, William Edward Burghardt, and Brent Hayes Edwards. The souls of black folk. Oxford University Press, 2007.

Du Bois, W. E. B., Adrienne Brown, and Britt Rusert. "The Princess Steel." PMLA 130.3 (2015): 819-829.

Dunne, Anthony, and Fiona Raby. Speculative everything: design, fiction, and social dreaming. MIT Press, 2013.

Einstein, Albert. "The Special Theory of Relativity." Ann. Phys 17 (1905): 891-921.
Eshun, Kodwo. "Further considerations of Afrofuturism." CR: The New Centennial Review 3.2 (2003): 287-302.
Fagunwa, Daniel Olorunfemi. Forest of a Thousand Daemons: A Hunter's Saga. City Lights Publishers, 2013.
Fanon, Frantz. "Black Skin, White Masks. 1952." New York (1967).
Greenlee, Sam. "The Spook Who Sat by the Door. 1969." Detroit: Wayne State UP (1990).
Griggs, Sutton. Imperium in imperio. Modern Library, 2007.
Hansberry, Lorraine. A Raisin in the Sun. Signet, 1959.
Hare, Nathan. The Black Anglo-Saxons. Marzani & Munsell, 1965.
Hughes, Langston. "The Negro Artist and the Racial Mountain." 1926." The Collected Works of Langston Hughes 9 (1773): 31-36.
Jabko, Nicolas, and Elsa Massoc. "French capitalism under stress: How Nicolas Sarkozy rescued the banks 1." Review of International Political Economy 19.4 (2012): 562-585.
Jones, Esther L. Medicine and Ethics in Black Women's Speculative Fiction. Palgrave Macmillan, 2015.
Kalu, Peter. Black Star Rising. 1997. The X-Press
Kaufman, Michael T. "The World: Film Studies; What Does the Pentagon See in 'Battle of Algiers'?." New York Times 7 (2003).
Kimenyi, Mwangi S., and Zenia Lewis. "The BRICs and the new scramble for Africa." Foresight Africa (2011): 19.

Kreiss, Daniel. "Appropriating the Master's Tools: Sun Ra, the Black Panthers, and Black Consciousness, 1952-1973." Black Music Research Journal 28.1 (2008): 57-81.

Land, Nick. 'The Dark Enlightenment.' 2013. http://www.thedarkenlightenment.com/the-dark-enlightenment-by-nick-land/.

Larrieux, Stéphanie. "The World, the Flesh, and the Devil: The Politics of Race, Gender, and Power in Post-Apocalyptic Hollywood Cinema." Quarterly Review of Film and Video 27.2 (2010): 133-143.

Lewis, Michael. The Big Short: Inside the Doomsday Machine (movie tie-in)(Movie Tie-in Editions). WW Norton & Company, 2015.

Locke, Alain. The New Negro. Simon and Schuster, 1925.
Marable, Manning. How capitalism underdeveloped black America: Problems in race, political economy, and society. Haymarket Books, 2015.
Mumford, Lewis. "Technics and Civilization (New York, 1934)." Lewis Mumford, The City in History (New York, 1961) (2005).

Neal, Larry, et al. Visions of a liberated future: Black arts movement writings. Ed. Michael Schwartz. Thunder's Mouth Press, 1989.

Newton, Huey P. Revolutionary Suicide: 1973 (Penguin Classics Deluxe Edition). Penguin, 2009.

Noys, Benjamin. Malign velocities: Accelerationism and capitalism. John Hunt Publishing, 2014.

Okorafor, Nnedi. Akata Witch. Penguin, 2011.
Payne, Charles. Forward. Cited in Theoharis, Jeanne, and Komozi Woodard. Groundwork: Local Black Freedom Movements in America. NYU Press, 2005.

Pentland, Alex. Social physics: how good ideas spread-the lessons from a new science. Penguin, 2014.

Phillips, Rasheedah. Black Quantum Futurism: Theory and Practice. Afrofuturist Affair. 2015.

Rabaka, Reiland. Africana critical theory: reconstructing the black radical tradition, from WEB Du Bois and CLR James to Frantz Fanon and Amilcar Cabral. Lexington Books, 2010.

Rollefson, J. Griffith. "The" Robot Voodoo Power" Thesis: Afrofuturism and Anti-Anti-Essentialism from Sun Ra to Kool Keith." Black Music Research Journal 28.1 (2008): 83-109.

Roudinesco, Elisabeth. "THE ENLIGHTENMENT AND ITS PERVERSION IN THE WEST 1." Psychoanalysis and History 11.1 (2009): 91-108.

Schuyler, George S. "Black No More. 1931." New York: Modern Library (1999).

Schuyler, George Samuel, Robert A. Hill, and R. Kent Rasmussen. Black empire. UPNE, 1993.
Spengler, Oswald. The hour of decision, part one: Germany and world-historical evolution. Vol. 1 AA Knopf, 1963.

Thomas, Sheree R. Electronic communication. 2016.

Thomas, Sheree R. Dark Matter: Reading the bones. Aspect, 2004.

Thomas, Sheree R. Dark Matter: A Century of Speculative Fiction from the African Diaspora. New York: Warner/Aspect, 2000.

Tutuola, Amos. The Palm-wine Drinkard; And, My Life in the Bush of Ghosts. Grove Press, 1994.

Unsigned Editorial Comment, Negro Quarterly 1.4, (1943): 295-302.
Williams, John A. The Man Who Cried I Am. 1967. Reprint, New York: Thundermouth (1995).
Wright, Michelle M. Physics of Blackness: Beyond the Middle Passage Epistemology. 2015.
Wright, Richard. The color curtain: a report on the Bandung Conference. Univ. Press of Mississippi, 1956.

Woodson, Carter G. The mis-education of the Negro. Book Tree, 2006.
Zedong, Mao. "Talks at the Yan'an Forum on Literature and Art." Selected Works of Mao Zedong 3 (1942).

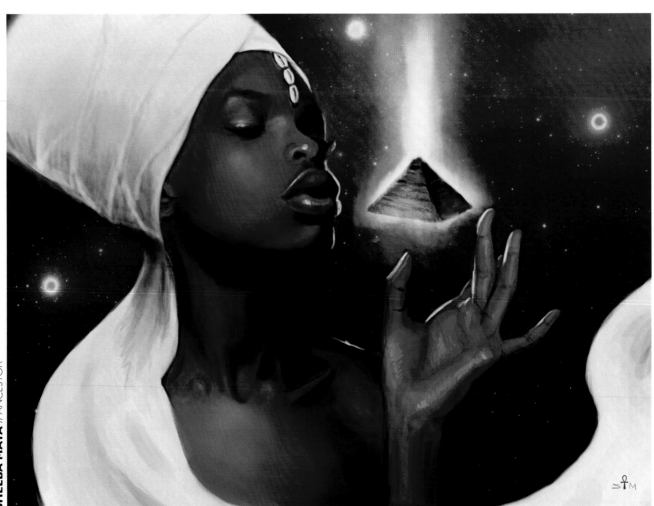

SHEEBA MAYA // ANCESTOR

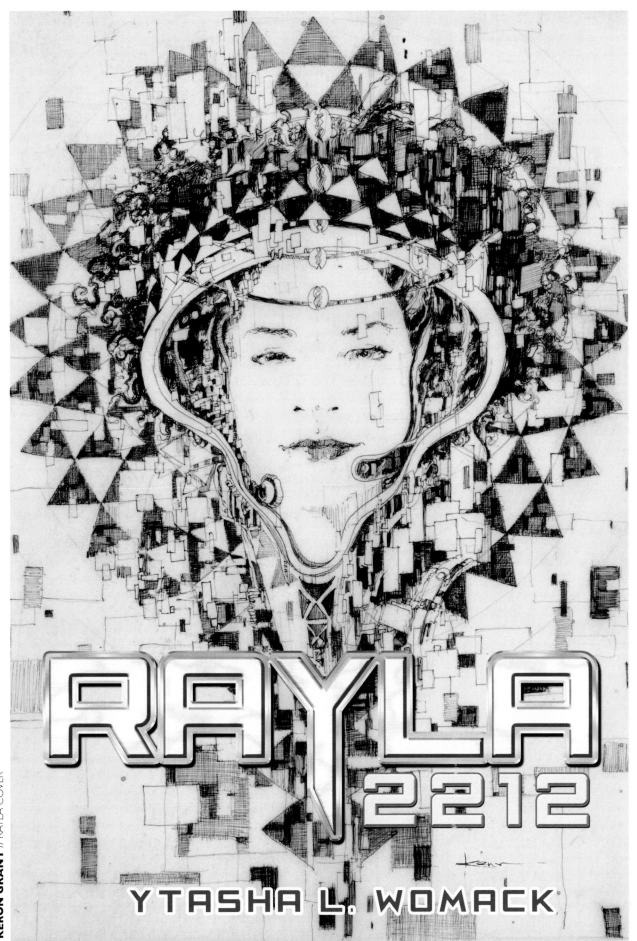

KERON GRANT // RAYLA COVER

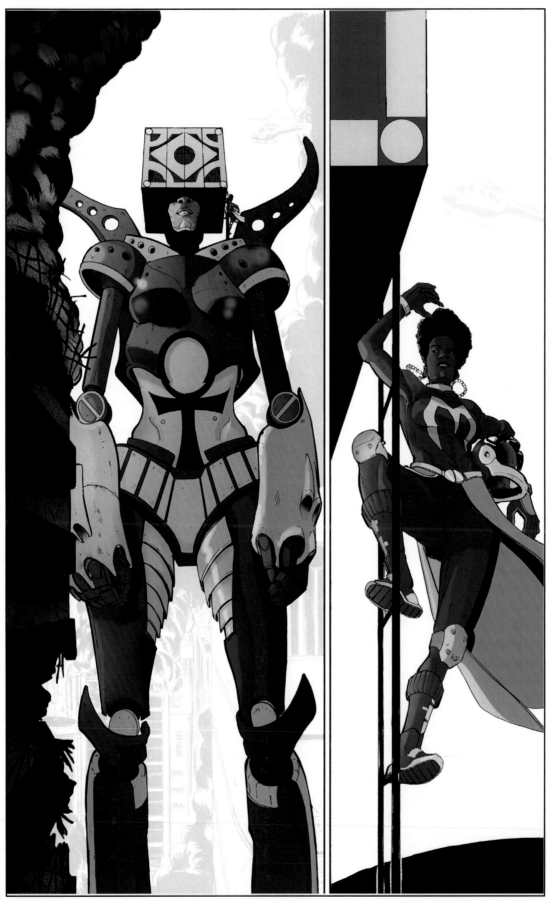

N. STEVEN HARRIS // MECCA CON POSTER

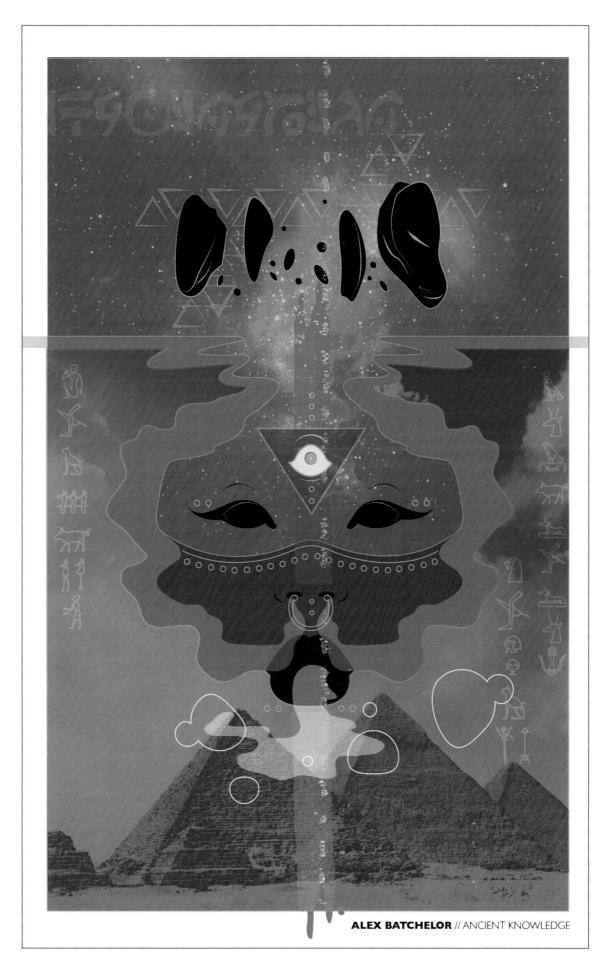

ALEX BATCHELOR // ANCIENT KNOWLEDGE

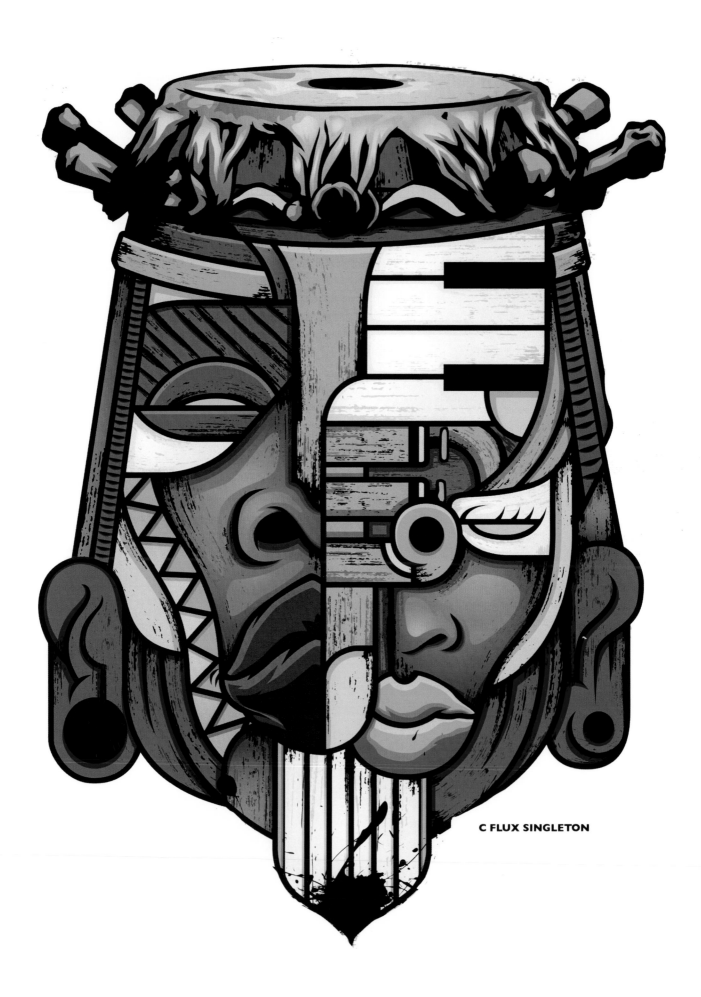

C FLUX SINGLETON

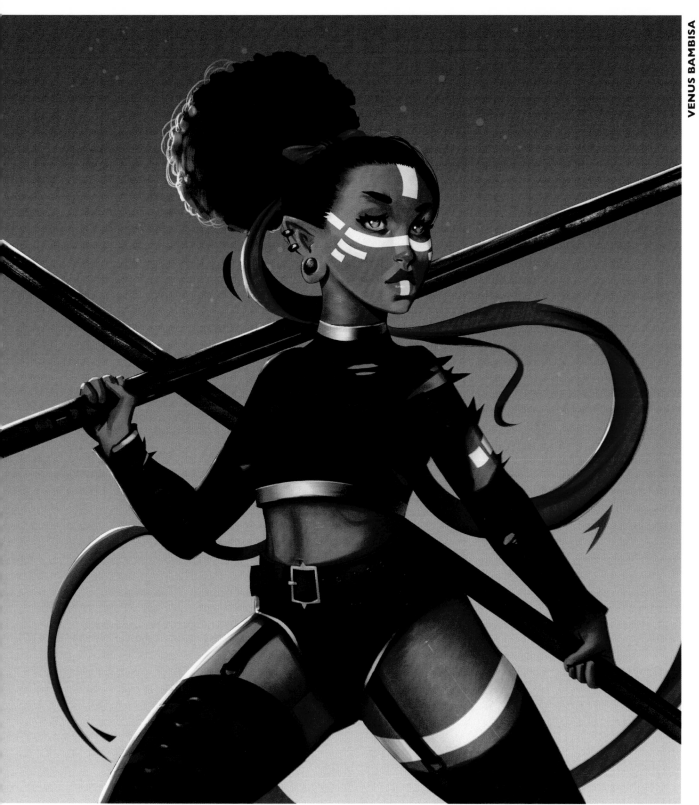

SONET // TSIATDAPOCITAITTPOA

SONET // TSIATDAPOCITAITTPOA

MALICIOUZ //SLIGHT SLEEP SERIES

MALICIOUZ //SOMEWHERE AT THE BOTTOM OF THE RIVER BETWEEN VEGA AND ALTAIR

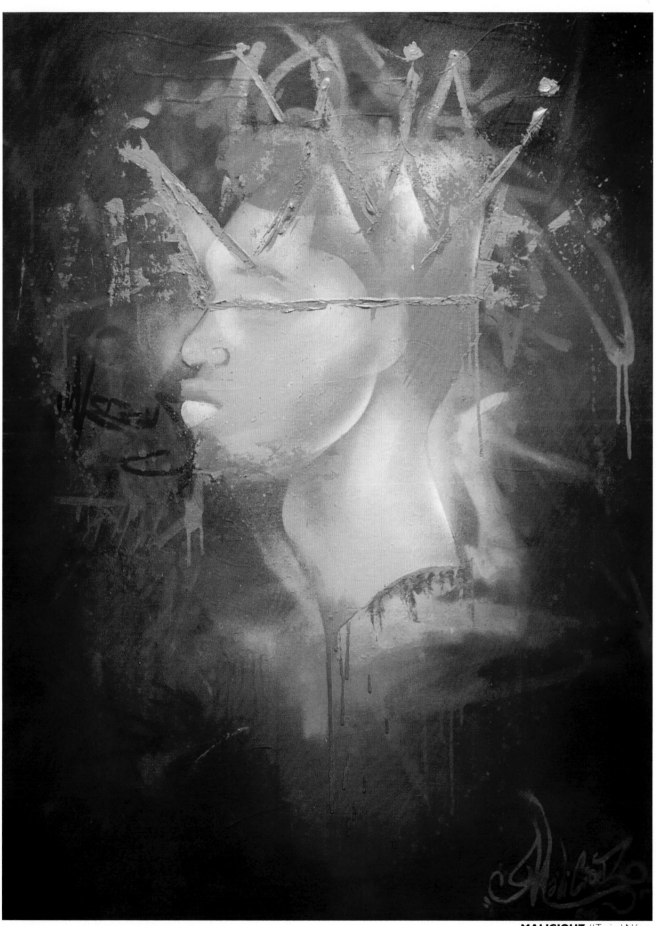

MALICIOUZ // Typical Négus

C'ECELIA BRACMORT // GHOST SERIES NO. 7

SOLOMON WILLIAMSON // UNTITLED

EDITOR/AUTHOR BIOS

DR. REYNALDO ANDERSON currently serves as an Associate Professor of Communications and Chair of the Humanities department at Harris-Stowe State University in Saint Louis Missouri. Reynaldo has earned several awards for leadership and teaching excellence and he is currently the Chair of the Black Caucus of the National Communication Association (NCA). Reynaldo has not only served as an executive board member of the Missouri Arts Council, he has previously served at an international level working for prison reform with C.U.R.E. International in Douala Cameroon, and as a development ambassador recently assisting in the completion of a library project for the Sekyere Afram Plains district in the country of Ghana. Reynaldo recently co-curated the acclaimed exhibition, Unveiling Visions: The Alchemy of The Black Imagination at the Schomburg Center for research in Black Culture in Harlem New York. Reynaldo publishes extensively in the area of Afrofuturism, communications studies, and the African diaspora experience. Reynaldo is currently the executive director and co-founder of the Black Speculative Arts Movement (BSAM) a network of artists, curators, intellectuals and activists. Finally, he is the co-editor of the book *Afrofuturism 2.0: The Rise of Astro-Blackness* published by Lexington books in December 2015, co-editor of forthcoming volume *The Black Speculative Art Movement: Black Futurity, Art+Design* to be released in 2017, and the co-editor of *"Black Lives, Black Politics, Black Futures,"* a forthcoming special issue of TOPIA: Canadian Journal of Cultural Studies.

JOHN JENNINGS is a Professor of Media and Cultural Studies at the University of California at Riverside. His work centers around intersectional narratives regarding identity politics and popular media. Jennings is co-editor of the Eisner Award winning collection *The Blacker the Ink: Constructions of Black Identity in Comics and Sequential Art* and co-founder/organizer of The Schomburg Center's Black Comic Book Festival in Harlem. He is co-founder and organizer of the MLK NorCal's Black Comix Arts Festival in San Francisco and also SOL-CON: The Brown and Black Comix Expo at the Ohio State University. Jennings is a 2016 Nasir Jones Hip Hop Studies Fellow with the Hutchins Center at Harvard University. Jennings' current projects include the art collection *Black Kirby: In Search of the Motherboxx Connection,* The horror anthology *Box of Bones,* the supernatural crime noir story *Blue Hand Mojo,* and the New York Times best-selling graphic novel adaptation of Octavia Butler's classic dark fantasy novel *Kindred.*

GREG TATE is a music and popular culture critic and journalist whose work has appeared in many publications, including the *Village Voice, Vibe, Spin, the Wire,* and *Downbeat.* He is the author of *Flyboy in the Buttermilk: Essays on Contemporary America* and *Midnight Lightning: Jimi Hendrix and the Black Experience* and the editor of *Everything but the Burden: What White People Are Taking from Black Culture.* Tate, via guitar and baton, also leads the conducted improvisation ensemble Burnt Sugar the Arkestra Chamber, who tour internationally.